P9-DBZ-555

*KODAK Guide to*
# 35 mm Photography

**EASTMAN KODAK COMPANY**
**ROCHESTER, NEW YORK 14650**

Neil Montanus

KODAK EKTAR 25 Film is so fine grained that
the grain is virtually invisible even in enlarge-
ments as big as 20 x 30 inches.

Front cover photo by Dorit Lombroso

KODAK Publication No. AC-95
© Eastman Kodak Company, 1980, 1984, 1989
Sixth Edition, 1989 printing
Library of Congress Catalog Card Number 88-83024
ISBN 0-87985-613-0 (U.S.)
ISBN 0 901023 33 7 (U.K.)

# KODAK GUIDE TO
# 35 mm PHOTOGRAPHY

Kodak wants to help you make really good pictures with your 35 mm camera. This book was written with you in mind— whether you're just beginning in 35 mm photography or just beginning to get serious about it. Even if you're an advanced photohobbyist, you can use this book to brush up on the basics.

This book will help you understand and use autofocusing, automatic cameras as well as cameras with manual controls. You'll learn when, where, and how to capitalize on camera features such as fast lenses, interchangeable lenses, a wide range of shutter speeds and lens openings, exposure meters, and automatic exposure controls. The book presents picture-taking techniques, information on selecting a Kodak film, discussion of outdoor and indoor lighting, guidelines for composition, how-to information for photographing many different kinds of subjects, and hundreds of colorful examples of good pictures, all of which will enlarge the scope of your picture-taking abilities to help you take better pictures.

The results described in this book are possible with 35 mm and other advanced cameras. There are dozens of camera models available today, each of which is unique in some way. So start by studying your instruction manual—with your camera in hand—before reading this book.

Then practice the techniques the book describes one at a time—and take lots of pictures. Study the pictures you take, learn from them, and go on to new techniques. But above all, enjoy your pictures and share them with others. You'll find that photography can be a truly fulfilling hobby.

The Editors

Overleaf photo by Steve Kelly

# CONTENTS

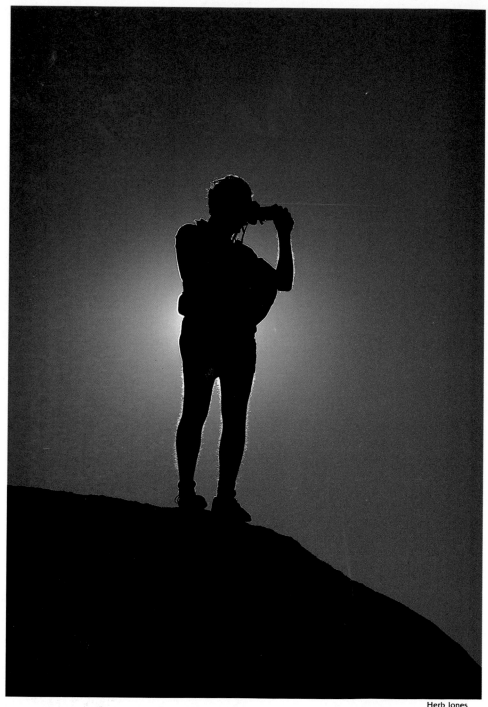

Herb Jones

# Camera Handling–page 17

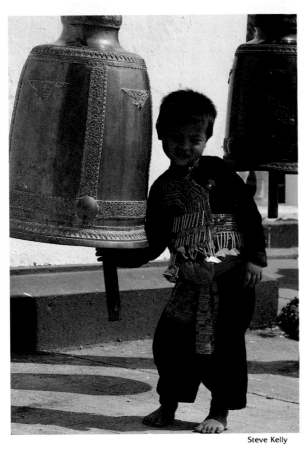

Steve Kelly

# KODAK Films
–page 41

Randolph Phalen

Phillip Lisik

# Exposure –page 60

Stephen Childs

# Daylight Photography–page 75

Bob Clemens

Flash Photography–page 98

Kent Dannen

# Lenses–page 124

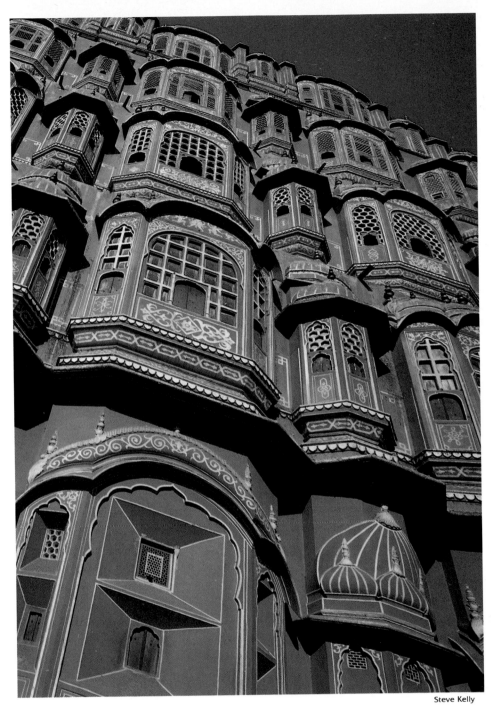

Steve Kelly

Composition–page 144

Bob Clemens

# Action Pictures–page 180

Dick Boden

# Existing-Light Photography–page 195

Jim Franklin

# Filters and Lens Attachments–page 219

Chris Palmer

# Close-Up Photography–page 248

Karen Musitano

Let's begin with the general operation of your camera. Handling your camera with skill and ease may make the difference between getting the picture and being too late or between getting a sharp picture and getting one that's fuzzy. The greatest picture opportunity in the world can go down the drain if a photographer fumbles with the camera, sets the exposure controls improperly, doesn't focus properly, or jiggles the camera as the shutter release is pressed. When handling your camera becomes second nature, the results are consistently better pictures.

A good general rule to follow in handling your camera is not to use force to adjust anything on the camera. Otherwise you could damage your camera or your film. The camera controls should work easily and smoothly.

One of the most important factors in getting sharp, clear pictures is to have a clean camera lens. You've seen what the view is like when you look through a dirty window. Well, your pictures will have a similar hazy, unsharp appearance if you take them through a dirty camera lens. So before you start taking pictures, be sure your camera lens is clean.

If your camera lens needs cleaning, clean the front and back glass surfaces by first carefully blowing away any dust or dirt. Then breathe on the surface of the lens to form a mist and gently wipe the mist away with a soft, clean, lintless cloth or use KODAK Lens Cleaning Paper moistened with KODAK Lens Cleaner.

**CAUTION:** Do not use solvents or solutions unless they are specifically designed for cleaning camera lenses. Don't use chemically treated tissues intended for eyeglasses.

Willie Osterman

**Opposite,** by keeping a loaded camera handy at all times you will be ready when good fortune strikes, as it did for this photographer vacationing in Greece.

# CAMERA HANDLING

Joseph Janowicz

To consistently obtain pictures of high quality, you should develop good camera-handling habits. These include keeping your camera lens clean, adjusting your camera for sharp focus, and holding your camera steady.

# LOADING
# AND UNLOADING
# 35 mm CAMERAS

In this section we'll provide some general information that applies to most 35 mm cameras. For specific instructions for your particular camera, see your camera manual.

Always load and unload your camera in subdued light—not bright sunlight. (This is especially important for very high-speed films.) If there's no shade around, position your body so it casts a shadow over your camera for loading and unloading. This helps prevent bright light from entering the lip of the 35 mm magazine and causing a streak on the first or second picture. If this happens, the streak is usually orange or clear on color slides or prints but dark on negatives. To avoid streaks, keep the film in its lighttight container before and after exposure.

Loading a 35 mm camera is easy. However, it is possible to put a 35 mm magazine into the camera the wrong way. The film slot of the magazine must face the take-up side of the camera; and the light-colored side of the film, the emulsion side, must face the camera lens. If the following loading summaries differ from the instructions in your camera manual, follow your manual.

With a manual-loading camera, thread the film onto the take-up spool. Make sure you've threaded the film correctly for the direction of rotation of the take-up spool. When the film is threaded, it should have enough tension to lie flat. If it doesn't, advance the film slowly until the rewind knob starts to turn. See that the sprocket teeth engage the film perforations before you close the camera back. After you close the back, advance the film three times so you are ready to take the first picture. If you don't do this, you could make the first exposure on the fogged portion of the leader and not get the picture.

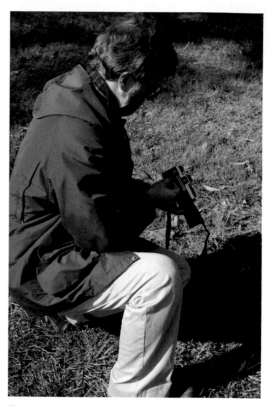

To minimize the chances of bright light fogging the film, always load your camera in subdued light—not in bright sunlight. If it's not convenient to load your camera in the shade, then load the film in the shadow of your body with your back toward the sun.

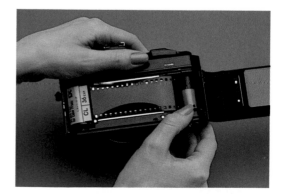

When loading your camera, make sure that the film is firmly secured to the take-up spool and that the film perforations engage the camera sprocket teeth on both sides before closing the camera back. For specific loading instructions, see the camera instruction manual.

With an auto-loading camera, line the end of the film leader up to an index mark along the bottom rail. Check that the advance gear engages the film perforations and that the film lies flat.

Close the back and press the shutter release. The camera will advance the film to the first frame.

Film in 35 mm magazines is loaded in lengths for 12, 24, or 36 exposures. (A half-frame camera yields twice as many exposures on the roll.) Extra film is included for a leader at the beginning of the roll and for a trailer at the end. The processing laboratory needs the leader as well as the trailer when processing the film. If you try to squeeze more than 24 exposures (or 12 or 36 depending on the roll) onto a roll of film, the extras may be lost in the processing.

How do you know if the film is advancing? Auto-loading cameras often have a film-running indicator atop the camera to indicate film is advancing. With a manual-loading camera, you can use the rewind knob to check the film. Turn the rewind knob carefully in the direction of the rewind arrow until you feel a slight tension. This takes up the slack in the film. Now when you advance the film, you should see the rewind knob rotate.

**CAUTION:** Be sure that you never turn the rewind knob the wrong way—opposite the direction for rewinding—when taking up the slack in the film. This could kink or jam the film. After you load the film, it's easy to forget how many exposures are in the magazine. Many cameras offer a window on the film door that lets you see the part of the film magazine that indicates the number of exposures. Other cameras have a memo holder on the film door into which you can insert the end flap

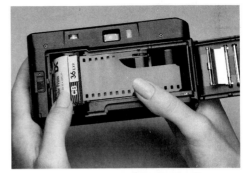

Many cameras offer automatic film loading. Typically you line up the end of the film with an index mark on the bottom rail. Then you make sure the advance gear engages the film perforations. Next you close the camera back and press the shutter release—the film advances to the first frame. Check your manual for the correct procedure.

of the film package; the end flap states the type of film and how many exposures. With a manual-advancing camera, if you think you have 36 exposures but actually have 24, you could damage the film by tearing the perforations or you could pull the film loose from the magazine by trying to advance the film. If you pull the film loose, you can't rewind it back into the magazine.

If you haven't used your camera for a while, you may be uncertain if it contains film. With newer cameras, a window on the film door shows if film is in the camera. Or an LCD panel may display the picture number, even when the camera is turned off.

With older cameras, it's sometimes difficult to tell whether the camera is loaded with film or not. If the film counter indicates an exposure number, there's probably film in the camera. With a manual-advancing camera, **gently** turn the rewind knob in the direction for rewinding without depressing the rewind button. If you feel resistance

to turning the rewind knob, **do not turn it any farther**. Your camera is loaded with film. The film counter in most 35 mm cameras has an S on it that resets when you open the back. If you see the S on the counter, this indicates that the camera back has been opened since the last exposure was made. Therefore, it's safe to open the back again.

With most 35 mm cameras, you must rewind the film from the camera take-up spool back into the original magazine before unloading. If you open the camera back before rewinding the film, the film will be completely exposed, or fogged, as it has no protection from the light. Fogging generally looks like a light, cloudy area covering part or all of a slide or print.

Cameras that load film automatically, usually also rewind it automatically. The camera may automatically rewind the film at the end of the roll, or it may signal you to press a rewind button or switch that begins the rewind. Check your camera manual for specific instructions.

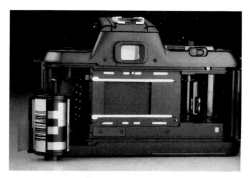

Electrical contacts in the film chamber enable many cameras to read DX-encoded films to automatically set film speed, determine the number of exposures on a roll, and the exposure latitude of the film.

Because auto-load cameras require you to expose less leader film when loading, it is possible that you'll get more than the specified number of exposures on a given roll. But again, be aware that any shots past the specified number of exposures (i.e. 12, 24, or 36) may be lost in processing.

**IMPORTANT:** When using a camera with a manual rewind knob, do not turn the rewind knob in the direction *opposite* that of the rewind arrow. Such action can seriously bend the film and possibly tear it. To prevent torn perforations, keep the rewind button control firmly depressed in the rewind position until you have completely rewound the film. Check you camera manual for specific instructions.

If you don't force the film advance lever, you won't pull the film loose from the magazine, which would prevent the normal rewinding of the film back into the magazine, as mentioned before. Pulling the film loose usually results from a photographer's trying to make more exposures than 24 on a 24-exposure roll (or 12 or 36 depending on the roll) at the end of the film. Forcing the film advance lever can also cause overlapping pictures at the end of the roll. If you do pull the film loose from the magazine and open the camera back in the light, you'll fog the film. The solution is to take your camera to your photo dealer and ask to have the film transferred in a darkroom into a KODAK SNAP-CAP 135 Magazine. It is **important** to mark the film type and number of exposures on the magazine so that the processor can identify the film.

What happens if you wind the leader of unexposed film back into the magazine? You have not lost the film, because your photo dealer can retrieve the leader. If that's not convenient, here's how you can do it yourself.

Each year several thousand magazines of 35 mm film are returned for processing by photographers who have accidentally wound **unexposed** film back into the magazine. The most common reason for this happening is improper loading of 35 mm cameras which can cause the film not to advance through the camera as pictures are taken. After the photographer finishes what is thought to be the end of the roll, the film is rewound. Since the film didn't even go through the camera, no exposures were made and all the pictures are lost. Needless to say, this is a big disappointment.

To minimize the chances of winding the film leader into an unexposed magazine, load your camera according to the instructions in your camera manual. Also follow the tips given in this book about determining whether your film is advancing properly.

## NO FILM LEADER????

If you discover that you have accidentally wound unexposed film back into the magazine, all is not lost. You can still use the film by retrieving the film leader as demonstrated below.

1. Cut a strip about 1 inch wide and 5 inches long from a material such as sheet film or acetate.

2. Attach about 3 inches of double-coated cellophane tape to one side of the strip, covering one end. Round both corners of this end, which you will insert into the magazine, to reduce the chance of scratching your film.

3. Push 2 to 3 inches of the strip through the lips of the magazine. The sticky side of the strip should face the film core.

4. Pull the strip out gently. Usually the leader will attach itself to the sticky tape. If it doesn't, reinsert the strip. Then rotate the core of the magazine counterclockwise with the long end of the core facing you, and try again by pulling out the strip.

---

If you accidentally wind the leader of unexposed film into the magazine, you can save the use of the film by retrieving the film leader. To retrieve the leader, insert into the magazine lips an acetate strip with double-sided cellophane tape on one end of the strip. Insert the strip with the sticky side of the tape facing the film core.

After pushing 2 to 3 inches of the strip into the magazine, gently pull out the strip. Usually the film leader will attach itself to the strip. If the leader doesn't come out with the acetate strip, insert the strip and try again. Rotating the film core counterclockwise with the long end of the core facing you will help attach the film to the tape.

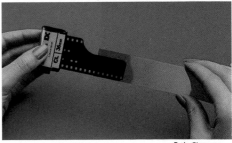

Bob Clemens

## CAMERA HOLDING

The way you hold your camera when you release the shutter is important for sharp pictures. Camera jiggle is the most common cause of unsharp pictures—not the obviously blurred pictures, but those lacking the needle sharpness that indicates the touch of a skilled photographer.

The best way for you to hold your camera is the way that's both comfortable and steady. Try to keep your arms against your body—not suspended in air. Plant your feet firmly on the ground, slightly apart. Hold the camera tightly against your face. Take a breath, hold it, and gently squeeze the shutter release. Chances are that you'll make a picture free of camera movement.

Golfers practice their swing. Target shooters practice squeezing the trigger. Photographers can practice their handling techniques.

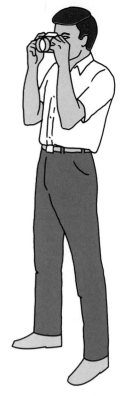

To obtain sharp pictures, you must hold your camera steady. As shown, stand with your feet about shoulder-width apart and your elbows close to your side. For normal and wide-angle lenses, grasp the camera with both hands.

## CAMERA TYPES

The two basic types of 35 mm cameras are single-lens-reflex (SLR) cameras and compact cameras. Compact 35 mm cameras (also known as lens/shutter cameras) include non-SLR autofocus, fixed focus, rangefinder, and "bridge" cameras. With most of these, you view your subject through a viewfinder that is separate from the camera lens. These relatively small cameras have become

When you're using a long-focal-length lens—telephoto or zoom—it's best to hold your camera by supporting the lens with your left hand close to the front of the camera. Hold the camera body with your right hand so you can actuate the shutter release. Be careful not to move the focus or lens opening settings with your left hand supporting the lens after you have set them. A long-focal-length lens requires that you hold your camera very steady for sharp pictures. Some photographers prefer to also use this method to hold their camera steady with normal- and short-focal-length lenses.

Brian Stevens

increasingly popular, and they commonly include features such as automatic film advance and rewind, automatic exposure, and automatic focus. Having virtually point-and-shoot capability, a compact 35 mm camera is an excellent choice for casual photography.

Single-lens-reflex cameras are also extremely popular. One of the major reasons for this is that it's so easy to use interchangeable lenses with them. When you look through the viewfinder of an SLR camera, you're actually looking at your subject through the camera's picture-taking lens. In this way, you can change from one lens to another and immediately see in the viewfinder the image that will be recorded on your film. This also means that you'll see in the viewfinder some of the perspective changes we mention in the section on lenses. A direct optical viewfinder can be made to show approximately what will be included in the picture with various lenses. But it's more difficult to appraise the effect of the lenses on perspective.

Another plus factor of a single-lens-reflex camera is that it's free of parallax—the difference between what the lens sees and what you see through a direct optical viewfinder, especially evident at close distances. We'll talk more about this in the section on close-up photography.

No matter what kind of viewfinding system you use, learn to use it with ease and with discernment. Before you shoot, look behind your subject to be sure you haven't included a distracting object. When possible, move around your subject to choose the best viewpoint. Although this may be like saying fire is hot, we can't overemphasize that your final picture will include everything that lies within the boundaries of your viewfinder. So before you snap the shutter, make sure you see in the viewfinder what you want to see in the resulting picture.

"Bridge" cameras fill the gap between the simple 35 mm cameras and the conventional single-lens-reflex (SLR) cameras. Although unable to accept interchangeable lenses, a bridge camera includes a zoom lens, a built-in flash, great exposure capability, and may even have a mirror that flips up to provide reflex viewing, just like an SLR camera.

A good simple 35 mm camera will include a built-in flash and either a zoom lens or a dual lens, such as the wide-angle and telephoto lenses in the KODAK S Series S900 Camera.

Autofocus SLR cameras have all the convenience of snapshot cameras and the flexibility of accepting a variety of interchangeable lenses.

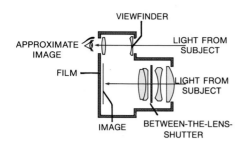

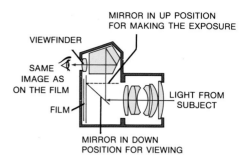

**Camera with Direct Optical Viewfinder**—In lens-shutter cameras, the viewfinder is separate from the camera lens. It shows approximately the same image as the image on the film.

**Camera with SLR Viewfinder**—A hinged mirror reflects the image through a pentaprism in the viewfinder to your eye. When you take a picture, the mirror flips up to let light reach the film and then returns to its original position.

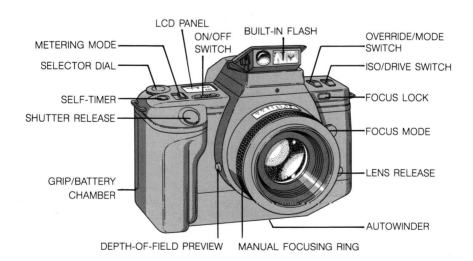

**Autofocus Single-Lens-Reflex (SLR) Camera**—Although almost completely automatic in operation, these cameras usually offer electronic or manual controls that allow you to change any of the exposure or focus settings. Such adjustability sets them apart from most snapshot cameras.

# FOCUSING

The three types of focusing systems common in modern 35 mm cameras are fixed focus, manual focus, and automatic focus. Fixed-focus lenses, common to the simplest compact cameras, are preset to provide sharp focus over a given distance range (typically from a minimum of about 4 feet to infinity). Fixed-focus lenses are fine for taking snapshots of family events or vacation scenics, but they do limit your flexibility and image control. The ability to focus your camera selectively allows you to concentrate attention on a particular area of a scene.

## MANUAL-FOCUSING CAMERAS

Many SLR cameras use manual focusing. To focus a manual SLR camera, you look through the viewfinder while turning the focusing collar on the lens until the area that you want to be sharp comes into focus. The viewfinder in an SLR usually contains a split-image rangefinder, a microprism, and a ground glass to help you in judging sharpest focus (see illustration). A split-image rangefinder does what it says—it splits the image. With split-image rangefinders, you look through the viewfinder at your subject and turn the focusing ring on your camera lens until the split images in the viewfinder line up. The subject is then in focus. Split-image finders work best when there is a prominent vertical line (a telephone pole, for example) in your composition to use as a focusing guide. One disadvantage of the split-image rangefinder is that it sometimes blacks out when you use it with telephoto lenses, obliterating part of the image area. If your camera has a microprism area (see illustration) or a ground glass

for focusing, you just turn the focusing ring until the subject looks sharp in the viewfinder. The microprism is a ring in the center of the viewfinder that exaggerates the unsharpness of out-of-focus subjects and therefore makes correct focusing easier to judge.

Each focusing aid works best in certain situations. For instance, you may prefer split-image focusing when you're photographing a building because there are straight lines to focus on. But if you're taking a picture of a crowd of people where prominent lines are hard to find, the microprism and ground-glass systems of focusing are easier and faster. In addition, the ground glass offers the advantage of showing you what part of the picture is in the plane of sharpest focus relative to other parts of the picture. The ground glass also lets you preview depth of field over the entire image area if your camera has the feature that permits this.

Practice focusing your camera until you do it so naturally that you don't have to give it a second thought.

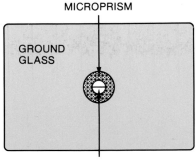

MICROPRISM

GROUND GLASS

SPLIT-IMAGE RANGEFINDER

Typical viewfinder in a manual-focusing single-lens reflex camera that has three focusing aids.

## AUTO-FOCUS CAMERAS

Although the engineering behind an auto-focus camera is complex, using one is easy. In both compact and SLR cameras, the viewfinder has a center target to show what the camera will automatically focus on. To get sharp pictures, aim your camera to superimpose this target on the main subject.

The obvious problem is that you won't always want to put your main subject in the center of the frame. To circumvent this, most auto-focus cameras have a focus lock. With it, you focus on your subject in the center of the viewfinder and then lock the focus. Once you lock the focus, you can recompose the scene.

With most auto-focus cameras, partially depressing the shutter button activates the focus. As long as you do not release the button (or take a picture) focus will remain locked on your chosen subject. Some cameras have a separate button that locks the focus until a picture has been taken. For the focus-lock technique to work, however, the camera-to-subject-distance cannot change. If the distance does change, the subject will likely be out of focus. Refocusing is a simple matter of re-centering your subject and again partially pressing the shutter release button.

More sophisticated SLR auto-focus cameras may offer a choice of two auto-focus modes: single shot and servo. The single-shot mode is better for photographing stationary subjects. The camera will not fire until the camera has confirmed sharp focus. The servo mode works well for photographing moving subjects—a girl on a bicycle, for instance. It will continue to focus until the instant of exposure. One drawback of the servo mode is that many cameras will fire even if the subject is **not** in sharp focus (if the subject has continued to move as the shutter is tripped, for ex-

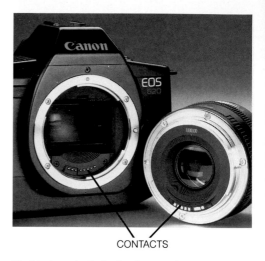

CONTACTS

Electrical contacts in the lens and camera enable the computer in an autofocus SLR to set the autofocus and the aperture, and adjust shutter speed or aperture according to the lens focal length.

ample). Some very advanced SLR cameras are actually able to overcome even this problem by measuring the speed of a moving subject. The camera calculates how far the subject will move during the split second it takes to make an exposure and adjusts the focus accordingly. Consult your manual for advice on photographing moving subjects.

Some situations and subjects can cause focusing errors or failure. For instance, the camera cannot automatically focus on subjects behind other objects, such as a fence or a branch. If you are using a leafy tree limb to frame a barn, you must be certain that the focus area in the viewfinder is not seeing the limb or it will cause the lens to focus on the limb and make your main subject, the barn, out of focus.

Because most auto-focus systems work by comparing the tonal contrasts within a scene, they may balk in both low-light and low-contrast situations such as a foggy scene.

Most cameras will beep or flash an indicator to indicate a focus problem. In dimly lit situations, the camera may tell you to use an accessory flash. Some flash units have infrared emitters that enable the camera to focus automatically in almost total darkness, and the flash provides enough light for picture taking. Brightly backlighted scenes also trouble most SLR auto-focus systems because the contrast in the scene is intense and changes rapidly if you move the camera even slightly.

In SLR auto-focus cameras, the sensors are behind the lens. As long as you have an unobstructed view of your subject, the camera will focus. In compact auto-focus cameras, however, the auto focus sensors are behind windows on the front of the camera. It's very important not to block these windows with a finger or camera strap, or focusing will be impaired.

Finally, some auto-focus SLR cameras have trouble focusing on subjects that contain predominantly horizontal lines—clapboard shingles on a house, for example. You can get around this difficulty by turning the camera on a slight angle, locking in the focus, and then recomposing the scene.

## FOCUS ASSIST

Most SLR auto-focus cameras have an override that allows you to focus the lens manually. This can be an important feature if, for example, you want to manipulate focus for a special effect or to focus on a subject in a difficult situation—such as photographing a zoo animal through the bars of a cage. Many of these cameras have a feature called "focus assist" that will provide an audible or visible signal to tell when the subject is in focus.

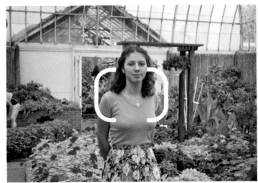

An autofocus camera will focus properly on the subject when you aim the camera so that the subject is positioned in the indicated focus area in the center of the viewfinder.

Caroline Grimes

If you frame the scene so that the subject is off-center for better composition, an autofocus camera will focus on whatever detail is in the center of the viewfinder—the background in this picture which will be sharp—but the subject will be fuzzy. Many autofocus cameras have a focus lock so you can prevent this kind of focus error. See the text above.

# EXPOSURE CONTROLS

The two controls on adjustable cameras that regulate the amount of light reaching the film are shutter speed and lens opening (also called aperture or *f*/stop). Setting these two controls correctly lets you take properly exposed pictures. With manual cameras, you adjust the shutter speed and aperture controls until the camera's meter indicates you have set the proper exposure.

Automatic cameras, on the other hand, adjust the shutter speed or lens opening (or both) automatically, after determining an optimum exposure setting. Automatic cameras equipped to handle film with DX-encoding designations even set themselves for the speed of the film you're using.

Whether your camera uses a built-in meter to guide you in setting aperture and shutter speed or sets them itself, you should understand the basic premise behind shutter speed and aperture to gain greater control over image quality. The shutter speed controls the length of time the film is exposed to light.

On many SLR cameras, you set exposure controls electronically, using push buttons. The camera then displays settings on an LCD panel. This panel shows that the shutter speed is 1/1000 second, the aperture is *f*/1.7, the camera is in the action program mode (action indicated by the runner icon), and that the exposure counter is on frame 3.

Shutter speeds are indicated by the numbers 1, 2, 4, 8, 15, 30, 60, 125, 250, 500, 1000, and 2000. The speeds may be marked on a dial or shown on a liquid crysal display (LCD) panel atop the camera or in the viewfinder. Your camera may not have all of these speeds. The numbers represent fractions of a second (except 1 second) and mean 1/2, 1/4, 1/8, 1/15 second, and so on. You can use the B setting to make time exposures—the shutter will

The lens openings on cameras are indicated by *f*-numbers. The larger the *f*-number, the smaller the lens opening. Each smaller (size) lens opening marked on the lens opening scale lets in one-half the amount of light as the preceding opening. If you change from a small lens opening to the next larger one, the lens will let in twice as much light. On some camera lenses, the maximum lens opening may not let in twice as much light as the next smaller opening. You can also set the lens opening between the marked settings on the lens for finer changes in exposure. The illustrations below the picture show how the lens opening varies with the *f*-number setting.

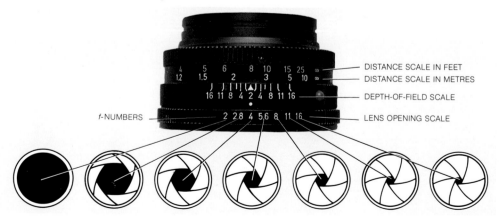

DISTANCE SCALE IN FEET
DISTANCE SCALE IN METRES
DEPTH-OF-FIELD SCALE
*f*-NUMBERS
LENS OPENING SCALE

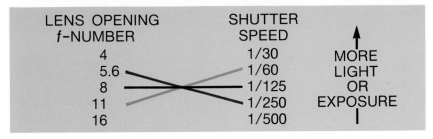

| LENS OPENING<br>f-NUMBER | SHUTTER<br>SPEED | |
|---|---|---|
| 4 | 1/30 | ↑ |
| 5.6 | 1/60 | MORE |
| 8 | 1/125 | LIGHT |
| 11 | 1/250 | OR |
| 16 | 1/500 | EXPOSURE<br>│ |

Using the settings going up each column exposes the film to more light. As the setting in one column is increased, the setting in the other column must be decreased to maintain the same exposure for the lighting conditions in the scene you want to photograph. For example, suppose the correct exposure setting is 1/125 second at f/8. To help stop fast action, you can change the shutter speed to 1/250 second, but you must also change the lens opening to f/5.6 in order to maintain the same exposure. If stopping fast action is not required but you want to increase the depth of field, you could use 1/60 second at f/11 which also maintains the same exposure.

stay open as long as you press the shutter release. For more precise control of time exposures, some advanced cameras allow you to set electronically timed shutter speeds of up to several minutes.

Changing from one shutter speed to a speed that is twice as fast, for example 1/60 to 1/125 second, allows the light to strike the film for half as long; therefore half as much light reaches the film. Changing to a shutter speed that holds the shutter open twice as long, for example 1/60 to 1/30 second, lets twice as much light strike the film.

The size of the lens opening on your camera is the other factor that controls the amount of light that reaches the film. The different sizes of lens openings are indicated by f-numbers. These numbers form a series, such as 1.4, 2, 2.8, 5.6, 8, 11, 16, and 22, marked on the camera lens or shown on an LCD panel. The smallest f-number refers to the biggest opening. The largest f-number is the smallest lens opening.

When you change from one lens opening to the nearest number, you're adjusting the lens by 1 stop. If you move the setting to the next larger one, for example f/11 to f/8, the area of the opening is doubled, so you expose the film to twice as much light. Changing from one lens opening to the next smaller one, for example f/11 to f/16, cuts the light by half.

35 mm cameras have used computer chips to control exposure for many years now. However, now you can even buy a camera in which you can insert computer cards that will adapt the camera for specific situations. A card for sports photography will program the camera to use a high shutter speed, varying the speed according to lens focal length and subject distance. A card for portrait photography will vary the aperture for different subject distances. There are also cards for close-ups, bracketing, data memory, and so on.

Automatic-exposure cameras dominate the camera market. Electronic sensors and microprocessors have not only taken the guesswork out of correct exposure but the labor as well. The camera sets the shutter speed and aperture the moment you press the shutter release. Cameras that measure the light reflecting off of the film itself can even adjust these settings as the exposure is occurring.

## CHOOSING THE BEST COMBINATION OF SHUTTER SPEED AND LENS OPENING

There are many combinations of shutter speed and lens opening that will allow the same amount of light to reach the film for proper exposure. These are known as equivalent exposures. If you change from one shutter speed to the next higher speed, this lets half as much light expose the film. You should keep the total amount of light—the exposure—the same by opening the lens to the next larger lens opening. It also works the other way around. If you change to the next slower shutter speed which lets in twice as much light, you should use the next smaller lens opening to let in the same amount of light as before.

Besides obtaining the proper exposure, you might want to use a particular combination of lens opening and shutter speed for three good reasons:

1. *To reduce the effects of camera motion.* A good, general-purpose shutter speed to achieve this is 1/125 second. A higher shutter speed of 1/250 second may even produce sharper pictures. With telephoto lenses even higher shutter speeds may be necessary.
2. *To stop action.* A shutter speed of 1/125 second helps stop the action of someone walking, for instance. However, there may be times when you want to use a higher shutter speed to stop fast action, such as a person running.
3. *To control depth of field.* By using a small or a large lens opening with the appropriate shutter speed to maintain the correct exposure, you can increase or decrease the range of sharp focus, or the depth of field.

## GUIDELINES FOR SELECTING THE BEST COMBINATION OF f-NUMBER AND SHUTTER SPEED FOR THE PICTURE

### SELECTING THE f-NUMBER

| Lens Opening | Guidelines | Example—50 mm f/2 Lens Normal Focal Length |
|---|---|---|
| Maximum for lens | Good for obtaining enough exposure in poor lighting conditions, such as existing light. Minimum depth of field—very shallow. Poorest image quality for specific lens. | f/2 |
| One stop smaller than maximum lens opening | Good for obtaining enough exposure in poor lighting. Shallow depth of field. Helpful to throw background out of focus to concentrate attention on subject. Good image quality. | f/2.8 |
| Two and three stops smaller than maximum lens opening | Best image quality for specific lens. Better depth of field than with larger lens openings. Good for limited distance range of sharp focus. Good for obtaining proper exposure when lighting conditions are less than optimum, such as on cloudy days or in the shade. | f/4 and f/5.6 |
| Two stops larger than minimum lens opening | Moderate depth of field. Good all around lens opening to use for outdoor daylight pictures. Excellent image quality. | f/8 |
| One stop larger than minimum lens opening | Great depth of field. Good all around lens opening to use for outdoor daylight conditions. Excellent image quality. | f/11 |
| Minimum for lens | Maximum depth of field. Very slight loss of sharpness due to optical effects. When maximum depth of field is important, the benefits from increased depth of field with this lens opening outweigh the disadvantages from an almost imperceptible loss in sharpness. | f/16 |

*Guidelines continued on next page*

# SELECTING THE SHUTTER SPEED

| Shutter Speed | Guidelines |
|---|---|
| B (Bulb) | Use camera support, such as a tripod. Shutter remains open as long as shutter release is depressed. Good for obtaining great depth of field with small lens openings in outdoor night scenes, for photographing fireworks and lightning, and for recording streak patterns from moving lights at night, such as automobile traffic. Long exposures can cause an overall color cast with color films. |
| 1 second and 1/2 second | Use camera support, such as a tripod. Good for obtaining great depth of field with small lens openings and enough exposure under dim lighting conditions, such as existing light or photo-lamps. Good for photographing inanimate objects and stationary subjects. These shutter speeds can cause a very slight color cast with some color films. |
| 1/4 second | Use camera support. Maximum slow shutter speed for portraits of adults. Good for obtaining great depth of field with small lens openings and enough exposure under dim lighting conditions. Good for stationary subjects. |
| 1/8 second | Use camera support. Better shutter speed than ¼ second for photographing adults at close range. Good for obtaining great depth of field with small lens openings and enough exposure under dim lighting conditions. Good for stationary subjects. |
| 1/15 second | Use camera support. Some people can handhold their camera using this shutter speed with a normal or wide-angle lens on the camera. This is possible if the camera is held very steady during the exposure. Good for obtaining increased depth of field with small lens openings and enough exposure under dim lighting conditions, such as existing light. |
| 1/30 second | Slowest recommended shutter speed for handholding your camera with a normal or wide-angle lens. Camera must be held very steady for sharp pictures. Good all around shutter speed for existing-light photography. Good for obtaining increased depth of field with small lens openings on cloudy days or in the shade. |
| 1/60 second | Good shutter speed to use for daylight pictures outdoors when the lighting conditions are less than ideal, such as on cloudy days, in the shade, or for backlighted subjects. Useful shutter speed for increasing depth of field with a smaller lens opening. Also, good shutter speed to use for brighter existing-light scenes. Less chance of camera motion spoiling the picture than with 1/30 second. Recommended shutter speed* for electronic flash with many SLR cameras. |
| 1/125 second | Best all around shutter speed to use for outdoor daylight pictures. Produces good depth of field with medium to small lens openings under bright lighting conditions, minimizes the effects from *slight* camera motion, and stops some moderate kinds of action, such as people walking, children playing, or babies not holding still. This is the minimum safe shutter speed for handholding your camera with a short telephoto lens, such as those shorter in focal length than 105 mm. Recommended shutter speed* for electronic flash with some SLR cameras. |
| 1/250 second | Good for stopping moderate fast action like runners, swimmers, bicyclists at a medium speed, running horses at a distance, parades, running children, sailboats, or baseball and football players moving at a medium pace. Good all around shutter speed for outdoor daylight pictures when you don't require great depth of field and you want to stop some action. Helps minimize the effects of camera motion. Good shutter speed to use for handholding your camera with a telephoto lens up to 250 mm in focal length. |
| 1/500 second | Good for stopping fast action like fast moving runners, running horses at a medium distance, divers, fast moving bicyclists, moving cars in traffic, or basketball players. A good shutter speed to use for stopping all but the fastest kinds of action. Gives better depth of field with the appropriate lens opening than 1/1000 second. Excellent shutter speed to use with telephoto lenses. Good for lenses up to 400 mm in focal length with a handheld camera. |
| 1/1000 second | Good shutter speed for stopping fast action like race cars, motorcycles, airplanes, speedboats, field and track events, tennis players, skiers and golfers, for example. This shutter speed gives little depth of field because it requires a large lens opening. Excellent shutter speed to use with long telephoto lenses up to 400 mm in focal length with a handheld camera. |
| 1/2000 second | Best shutter speed for stopping fast action like motor sports, racquet games, and other endeavors where movement may be quicker than the eye. This shutter speed requires the largest lens opening and gives the least depth of field. Outstanding shutter speed for use with long telephoto lenses up to 400 mm in focal length with a handheld camera. |

**Note:** It's important to hold your camera steady for all the shutter speeds recommended for handholding. You can also use slower shutter speeds than those mentioned for telephoto lenses when you put your camera on a firm support like a tripod. If in doubt about stopping the action, use the highest shutter speed you can for the conditions.

*See your camera manual for recommended shutter speeds for flash pictures.

# DEPTH OF FIELD

Depth of field is the distance range within which objects in a picture look sharp. As you gain a sound understanding of depth of field, you can use it as a very effective control for making better pictures.

What are the primary factors affecting depth of field? Depth of field varies with the size of the lens opening, the distance of the subject focused upon, and the focal length of the lens. Depth of field becomes greater as
- the size of the lens opening decreases.
- the subject distance increases.

- the focal length of the lens decreases and subject distance remains unchanged.

An object at the distance focused upon will be the sharpest thing in the picture. But image sharpness doesn't suddenly disappear at the limits shown. Points closer or farther away than the distance focused upon will be less sharp, but will look acceptably sharp to the eye throughout the depth-of-field zone. Objects close to the depth-of-field zone may appear almost sharp. But the farther an object is from this zone, the more out of focus it will

HOW LENS OPENING AFFECTS DEPTH OF FIELD
Shaded area indicates depth of field—range of acceptably sharp focus.
Same focal length, same subject distance

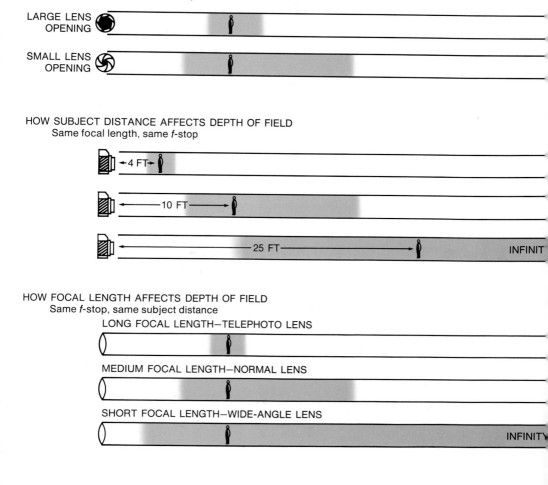

HOW SUBJECT DISTANCE AFFECTS DEPTH OF FIELD
Same focal length, same f-stop

HOW FOCAL LENGTH AFFECTS DEPTH OF FIELD
Same f-stop, same subject distance

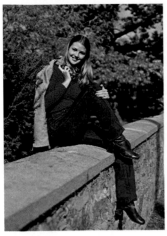
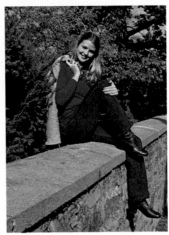

f/2.8 with a 50 mm lens    f/11 with a 50 mm lens

A small lens opening will give greater depth of field than a large lens opening at the same subject distance with the same focal length lens.

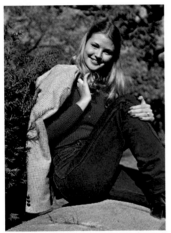
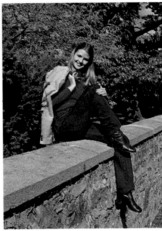

Subject distance 8 feet, f/11 with a 50 mm lens    Subject distance 15 feet, f/11 with a 50 mm lens

Depth of field increases as the subject distance increases when the lens opening and focal length of the lens remain unchanged.

John Menihan, Jr.

50 mm lens at f/11, subject distance 12½ feet    105 mm lens at f/11, subject distance 12½ feet

Depth of field decreases as the focal length of the lens increases when the lens opening and subject distance remain unchanged.

f/2                    f/8                    f/16

As this series shows, using a smaller aperture (larger *f*-number) increases the front-to-back sharpness (depth of field) in a picture. In the first picture, taken at *f*/2, only the foreground rock is sharp. In the last picture, taken at *f*/16, the whole picture is sharp from front to back.

appear. In looking over these illustrations you can see that there are times when accurate focusing is very important because depth of field is slight. These include times when you're using a long-focal-length lens or a large lens opening or when you are close to your subject. Of course, a combination of these factors makes accurate focusing even more important. For example, let's assume you're using a 135 mm telephoto lens on your camera. (For more on lenses, see page 124.) If you're focused on a subject 14 feet away with a lens opening of $f$/4, your depth of field will extend from about 13½ feet to 14½ feet. This doesn't allow much room for focusing error!

You can use depth of field as a control in your pictures. In some shots you'll want as much depth of field as possible. For example, in shooting a scenic picture you may want to include tree branches in the foreground as an interesting frame. To get both the branches and the distant scene in sharp focus, you may use a wide-angle lens and a small lens opening for great depth of field.

In other situations you may not want so much depth of field. You may be photographing a very interesting subject. But what if the background is confusing? You can use a large lens opening, perhaps combined with a long-focal-length lens, to produce shallow depth of field. The disturbing background will be out of focus so as not to detract from your subject. The shallow depth of field will help focus attention on the main subject.

You'll probably want to have the foreground objects in sharp focus in most of your pictures. But you may want to make exceptions now and then to produce creative results. Sometimes an out-of-focus foreground can add interest, excitement, color, glamour, and intrigue to your photograph.

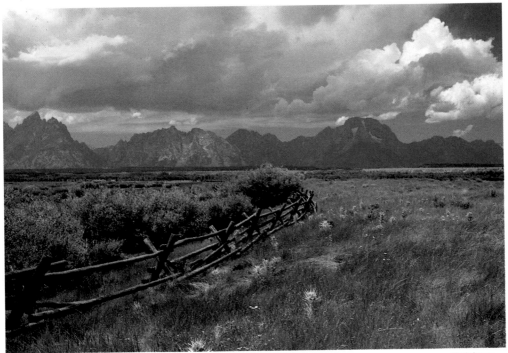

Herb Jones

To get great depth of field in your scenic pictures, use a wide-angle lens and a small lens opening.

If you are using a manual-exposure camera, selecting the proper aperture for creative depth of field control is easy. Most auto-exposure cameras also provide a means to manipulate the aperture/shutter-speed combination to achieve maximum or minimum depth of field. There are several options for accomplishing this.

To achieve extensive depth of field, for instance, some automatic cameras have a special depth-of-field program mode. Once set to this mode, the camera will select a shutter speed and aperture combination that gives priority to choosing the smallest possible aperture. Similarly, many auto-exposure cameras have an aperture-priority mode that enables you to control depth by allowing you to set the specific shooting aperture. Choose a large aperture such as $f/2.8$ for shallow depth; or a small one such as $f/11$ for more depth. The camera will then choose a corresponding shutter speed for correct exposure. Or, if your auto camera allows, you can switch it to full manual and use it as a manual camera. For more on these special features, see "Exposure," on page 60.

## DEPTH-OF-FIELD SCALE/
## HYPERFOCAL DISTANCE

What part of the scene will fall within the depth of field? You can find out by using the depth-of-field scale on your lens. If there's none on the camera or lens, see the depth-of-field tables in your camera or lens instruction manual.

The lens depth-of-field scale not only helps you put the depth of field **where** you want it but also helps you get the **amount** of depth of field you want (see illustration). If you're taking a scenic picture, for example, you'll probably want all the depth of field you can get. If you simply focus on the distant scene, you'll be focused on infinity. But that's wasting a lot of depth of field. To have the most distant object in focus and also as much foreground as possible in focus as well, you can use a technique based on the **hyperfocal distance.**

To figure the hyperfocal distance, first set your lens to infinity. Then use the depth-of-field scale to read the nearest distance that will be in sharp focus at the aperture you are using. When you focus a lens on infinity, the near distance beyond which all objects are in acceptably sharp focus is the hyperfocal distance. For example, with a 50 mm lens set at $f/16$ and focused on infinity,

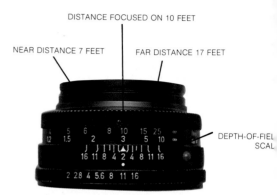

DISTANCE FOCUSED ON 10 FEET

NEAR DISTANCE 7 FEET    FAR DISTANCE 17 FEET

DEPTH-OF-FIEL
SCAL

Many camera lenses have depth-of-field scales printed on them. The most common type of scale is a double series of numbers representing the lens openings, on both sides of the focus indicator. Subjects within the distance range between the marks for the lens opening you're using will appear in sharp focus. Here the lens is set on $f/11$ and everything from about 7 feet to 17 feet will be in focus. (See the orange numbers.)

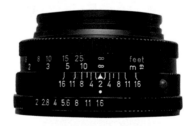

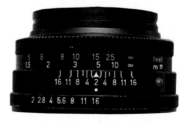

The same lens is set at $f/16$ in both pictures. On the top lens the depth-of-field scale shows that objects from 15 feet to infinity will be in focus. To get maximum depth of field, the infinity mark for the lens on the bottom is set opposite the far depth-of-field limit. This focuses the lens on the hyperfocal distance. At this focus setting, everything from 7½ feet to infinity will be in focus.

Most autofocus lenses also have a depth-of-field scale so you can calculate the range of front-to-back sharpness.

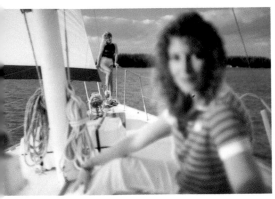

When you focus the lens on infinity, distant objects will be sharp, but the foreground may be fuzzy.

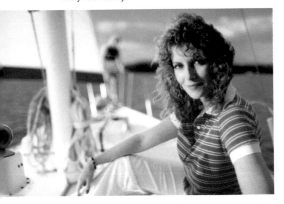

If you focus the lens on the foreground, objects in the distance may be fuzzy.

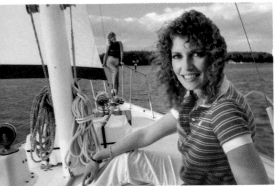

Neil Montanus

By focusing the lens on the hyperfocal distance, you may be able to make everything sharp. This is often desirable in pictures of scenic views.

the near-limit indicator on the depth-of-field scale shows that all objects from 15 feet to infinity will look sharp. The hyperfocal distance is 15 feet.

If you now refocus the lens to the hyperfocal distance (by setting the hyperfocal distance across from the focusing index), 15 feet in this example, objects from half the hyperfocal distance, $7\frac{1}{2}$ feet, to infinity will appear in sharp focus. (See illustration.) Using the hyperfocal distance will always give you the greatest depth of field for that particular lens opening. As you open the lens aperture to larger openings, the hyperfocal distances get farther away and the depth of field decreases.

With an auto-focus camera, you can either use the aperture that the camera has selected, or use an aperture-priority or full-manual exposure mode so that you can select a specific working aperture. Then with your lens focused on infinity, read the hyperfocal distance from the depth-of-field scale. Finally, switch your lens to manual focus and set it for the hyperfocal distance. Not all auto-focus cameras have a depth-of-field scale or allow manual focusing.

Very often it's beneficial to know what distance to focus your camera on to get everything sharp within a range of medium distances. This is especially helpful when you're taking pictures rapidly without enough time to consult the depth-of-field scale or if there is no such scale on your lens. As a general rule, approximately 1/3 of the depth of field is in front of the point of sharpest focus with 2/3 of the depth of field behind. As a result, you should focus on a distance 1/3 of the way from the nearest object you want sharp to the farthest. For example, for objects within a 5-to 20-foot range, you should focus on 10 feet and use the smallest lens opening that you can. This rule does not apply to very close subjects or to those at great distances from the camera, including those at infinity.

## HELPFUL HANDLING HABITS

Here are some tips to help you work more efficiently. When you plan to shoot lots of pictures in a short time, take your film out of the cardboard cartons and put all of the unexposed film into one section of your camera bag. Be sure to keep exposed and unexposed film in separate parts of your bag so you don't waste time trying to find fresh film.

When you finish a roll of film, rewind it immediately. Then if you accidentally open the camera, you won't expose the film. Be sure to wind the end of the film all the way into the magazine so that you don't mistakenly reload it later, thinking it was unexposed film.

As you take your pictures, you'll probably have to adjust focus or exposure settings or modes for some unusual situations. Suppose you go from distant shots of a road race to a close-up of a car refueling nearby. For the distant action shots, you'll probably want to use the servo or continuous focusing mode to track action. For the close-ups, the single-shot mode will be more convenient. As soon as you're through making the close-ups, readjust your focus setting so that you'll be ready for action again. By the same token, you may want to switch exposure modes from a depth mode for the close-ups to a stop-action mode for the racing shots.

When you find an especially good subject, take at least two or three pictures of it. This will give you a choice of viewpoint, pose, expression, or composition, as well as insurance in case one of the negatives or slides gets damaged.

## AUTOWINDERS AND MOTOR DRIVES

When you want to take pictures rapidly, a handy accessory to have is either an autowinder or a motor drive.

Autowinders are a standard feature on many 35 mm cameras. For SLR cameras without an autowinder, you can attach a motor drive to the bottom of the camera. Both built-in winders and accessory motor drives perform the same function: they advance the film to the next frame and cock the shutter after each exposure. The chief difference between winders and motor drives is speed. Autowinders advance the film one or two frames per second, while some motor drives run film as quickly as eight frames per second—far faster than your thumb could do it.

Autowinders let you take a series of pictures of fast-action subjects, such as sports or parades. An autowinder is also great for photographing the ever-changing opportunities for candid pictures of children, pets, or people. For informal portraits, an autowinder will help you avoid missing fleeting expressions or sudden gestures.

Some built-in winders and most motor drives offer you the choice of two modes: single-frame advance and continuous advance. In the single-frame mode, you press the shutter and release it for each picture you take. The camera won't fire a second time until you release the shutter button. In the continuous-firing mode, the motor will advance and fire the camera as long as you hold the shutter button down. The latter mode excels for fast action, like sports, but at three frames-per-second, you can go through a 24-exposure roll of film in only eight seconds!

In addition to advancing the film and readying the camera for the next exposure, both autowinders and motor drives are usually capable of performing other tasks, including auto-film loading and auto rewinding.

Autowinders also simplify close-up photography, especially when shooting live subjects like insects or small animals. Since these subjects move almost continuously, you have to keep them properly framed in the viewfinder and sharply focused, which is much more difficult to achieve if you are continually pulling the camera away from your eye as you cock the shutter.

With an SLR camera, one minor problem is that when the reflex mirror flips up to let light reach the film, it briefly cuts off your view through the viewfinder. When your are shooting several frames per second, the viewfinder will be blocked for much of the picture sequence. Composition and focusing becomes a bit tricky. With direct-optical viewfinders, you'll get a continuous view of the subject because the viewing lens and the taking lens are separate.

Finally, be aware that when you use a built-in flash, the continuous-advance mode may not function because the flash needs a longer time to recharge than the motor will allow.

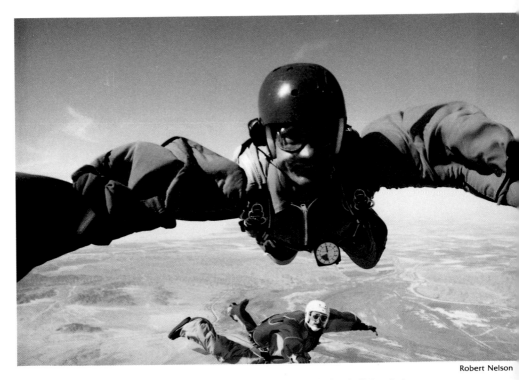

Robert Nelson

When photography isn't the only thing on your mind, a built-in winder can free you to think of more pressing concerns.

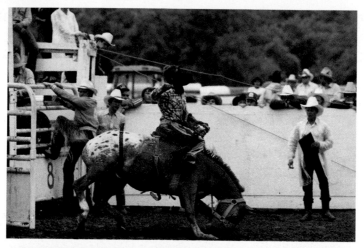

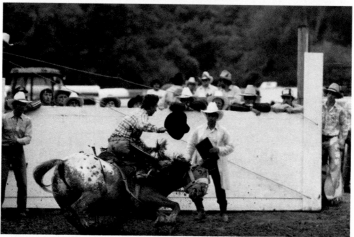

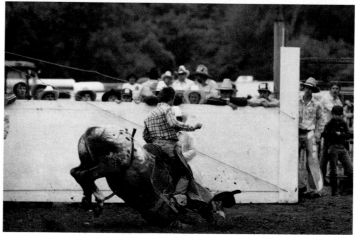

John Menihan

When the action is moving fast and furious, even the slightest distraction, such as pushing a film advance lever, may cause you to miss the climactic moment. It's at such times that an autowinder or motor drive becomes invaluable.

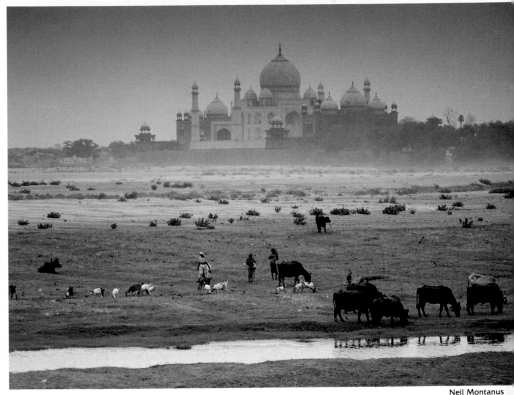

Neil Montanus

KODAK EKTAR 25 Film is the world's sharpest, finest-grained 35 mm color negative film. Use it when you want exceptional quality or are planning to make enlargements. The photographer used a graduated filter to add color to the bland sky of this landscape.

# KODAK FILMS

Before taking pictures you'll want to select the kind of film you plan to use. Do you want color or black-and-white? Prints or slides? Kodak offers a variety of films for 35 mm cameras. The tables in this section describe the characteristics of several Kodak films. Knowing the characteristics of these films will help you select the best one for the kind of pictures you want to take.

## COLOR SLIDE VS. COLOR PRINT FILM

There are a lot of different Kodak color films to choose from, but all of them fall into one of two categories: color slide films (also called transparency or reversal films) and color print (or negative) films. Color slide films are direct positive films; that is, the film that goes in

your camera and the slides you get back are the same film. With color print films, the film that goes in your camera is processed to a negative that the processing lab enlarges into color prints. Which is better? It depends on your needs and your tastes, and also the particular shooting situation.

First, consider your preferences. By far the majority of amateur photographers use color print (negative) films because they are so convenient. With print films, you get back fairly large prints that are easy to view and can be readily shared with others or mounted in an album for later viewing. Print films give excellent enlargements and can be transferred onto video tape. Color slides are used mainly for projection or viewing in hand-held viewers, but you can also use them to make color prints and enlargements, or even have them transferred to video tape. Color slides are

Wes Jones

KODACOLOR GOLD 100 Film offers extremely fine grain and very high sharpness. Use it when you want high quality in a medium-speed film.

also less expensive, since no printing stage is involved. If your primary interest is in giving slide shows, use color slide films.

Each type of film also has technical characteristics that may make one or the other better in a given situation. Color slide films, on the whole, are more contrasty and can therefore add more snap to dull or low-contrast scenes. Correct exposure is also much more critical with color slide films. Color negative films, on the other hand, can record a wider range of contrasts and allow greater room for exposure error.

KODACOLOR GOLD Films, available in ISO speeds 100, 200, 400, and 1600

produce prints with rich, vibrant colors. Their wide exposure latitude makes them excellent general-purpose films that work equally well in SLR cameras as well as simple 35 mm cameras that lack exposure controls. KODAK EKTAR Films, available in ISO speeds 25, 125, and 1000, give outstanding enlargements. They, too, have wide exposure latitude to give excellent results under a variety of lighting conditions. Their extensive use of KODAK T-GRAIN Emulsion and new color couplers have made them sharper and finer grained than any other films of similar speeds. Use EKTAR 25 Film only in SLR or other cameras that can set the speed to ISO 25—some simple cameras can't.

Neil Montanus

KODACOLOR GOLD 200 Film is a logical choice for your general-purpose negative film. It offers plenty of speed (ISO 200) for moderate action and some existing-light applications, as well as extremely fine grain and sharpness nearly as high as that of KODACOLOR GOLD 100 Film.

## COLOR TEMPERATURE

One other technical consideration that you should be aware of when choosing a color film is its **color temperature** or **balance.** All color films are designed to be used in a certain type (often referred to as temperature) of light, and you will get the best results when you are careful to match the film to the existing light source. Using the wrong film/lighting combination will result in distracting or unattractive color casts. Daylight films used indoors with incandescent lamps, for instance, will produce

pictures with an overall reddish or orange cast. Similarly, indoor (tungsten) films used outdoors will have an overall blue color.

Virtually all color negative films sold for amateur use are balanced for daylight and will give best results with that lighting or with electronic flash (both have a color temperature of about 5500 degrees K). Because photofinishers can improve color balance when printing negatives, you can get good results with a variety of light sources, or you can filter the light source during picture-taking to improve color. Color slide films, however, are available for several different temperatures of light, including daylight, tungsten light (3200 K) and photolamps (3400 K). Since no correction can be made in processing of slides, they have less tolerance for error. You should choose a slide film that is balanced for the light you'll be photographing under.

You **can** use slide films balanced for one type of lighting in a different type of lighting if you use color-correction filters. But you will get optimum results if you shoot a particular film with its intended light source.

## FILM SPEED

The film speed indicates relative sensitivity to light. The speed is expressed as an ISO number or an exposure index (EI). The higher the speed, the more sensitive or faster the film; the lower the speed, the less sensitive or slower the film. A fast film requires less light for proper exposure than a low-speed film. For example, a film with a speed of ISO 25 is slower—requires more light— than a film with a speed of ISO 200. To find the speed number for your film, look on the film carton, in the film instructions or on the film magazine. You set the film speed on exposure meters and on cameras with built-in meters to obtain the correct exposure. Some cameras automatically set the film speed by reading a code on DX-encoded films.

ISO speeds have replaced previously used ASA speeds. ISO speed numbers are numerically the same as ASA speed numbers. For example, if the speed of a film is ISO (ASA) 200, you would set 200 on the ISO (ASA) dial of your camera or meter.

## DX-ENCODED FILMS

DX-encoded films were developed by Kodak to help camera manufacturers make automatic cameras even more automatic. DX-encoded films provide compatible auto-exposure cameras with vital information about the film you're using, such as ISO speed, film type, film latitude, and number of exposures. All of this information is encoded in a checkerboard pattern on the film magazine. When you load the magazine into the camera, sensors in the film compartment read the code.

DX-encoded films offer great convenience because they save you from having to set the film speed manually each time you load the camera. More important, they make it impossible to set the wrong film speed or to forget to change film speeds when you switch from one film to another. Also the camera knows when it has reached the end of the roll. And by providing information about the film's exposure latitude, the DX encoding can help the camera make important exposure decisions.

The speed of a film is printed on the film carton and the film magazine. The checkerboard pattern on the magazine is the DX code. Many cameras read the code and automatically set the film speed when you load the film.

DX-compatible cameras are programmed to a specific range of ISO film speeds. This range is quite wide for SLR cameras, typically ISO 25 to ISO 5000. For simple cameras, the range may be narrower. If the camera cannot read the film speed, it will typically set a default speed of ISO 100. While this film-speed range covers most ordinary films that you will be using, there may be occasions when you want to go beyond this range or when you want to set speed different from the manufacturer's designated speed. In such cases, it's usually possible to set a different speed manually. Many cameras display the film speed set by the camera, so you can check that it is correct.

Norm Kerr

The very fine grain of KODAK EKTAR 1000 Film makes it ideal for existing-light photography when you expect to make enlargements.

## FILM GRAIN AND SHARPNESS

Two important aspects of image quality related to film speed are sharpness and graininess. Sharpness refers to the film's ability to record fine detail with good definition. Generally, the lower a film's ISO speed, the greater its ability to render subjects sharply. Graininess is the sand-like or granular texture sometimes noticeable in prints and enlargements. Grain is a by-product of the structure of the films light-sensitive emulsion. It is more apparent in pictures made with faster films. As speed increases, so does the size of the grain pattern.

Enlargement of the negative also affects apparent sharpness and graininess. At moderate print sizes (5 x 7-inch or smaller), grain is barely noticeable, even with fast films. But as enlargement increases, graininess becomes more apparent, and image sharpness diminishes. If you're planning on making extreme enlargements, you'll get the best results with low- and medium-speed films such as KODAK EKTAR 25 and 125 Films (negatives), KODACOLOR GOLD 100 Film (negatives), and KODACHROME 25 Film (slides). KODAK EKTAR 25 Film excels in producing big enlargements. For black-and-white prints, use the medium-speed KODAK T-MAX 100 Professional Film to obtain excellent results even in big enlargements.

Recent improvements in film technology, such as the KODAK T-GRAIN Emulsion, have minimized the problems of graininess, even with very fast films and at high degrees of enlargement. Color films such as KODACOLOR GOLD 400 Film, and black-and-white films like the KODAK T-MAX Films offer a combination of speed and fine grain unavailable before the advent of this technology.

The relationship of film speed to grain and sharpness sometimes forces you to make crucial quality decisions. With action subjects, for example, you have to decide if you want to use a slower film for sharper finer-grained pictures or a faster action-stopping film. If you opt for slower-speed film, you'll lose some action-stopping ability; but if you go for a faster film to halt action, you'll get increased grain. A medium-speed film such as KODACOLOR GOLD 200 Film will give you action-stopping ability and extremely fine grain.

## PROCESSING

Have your film processed promptly after exposure. Return Kodak film to your photo dealer for processing.

You can process many Kodak 35 mm films for general picture-taking yourself. You'll need a film processing tank, a room that you can make totally dark, an accurate thermometer, and chemical kits that are available from your photo dealer. For black-and-white film, obtain the following chemicals: KODAK Developer D-76, KODAK Indicator Stop Bath, KODAK Fixer, and KODAK PHOTO-FLO Solution. The KODAK HOBBY-PAC Color Negative Film Kit for Process C-41 is available to process KODACOLOR GOLD Films. With most KODAK EKTACHROME Films, use the KODAK HOBBY-PAC Color Slide Kit, Process E-6. Incidentally, to expose EKTACHROME P800/1600 Film at either EI 800 or 1600 requires push processing. A higher speed of EI 3200 is obtained with even more push processing, but with some loss of quality. See the processing chemical instructions.

You can't process KODACHROME Films successfully in your own darkroom because the process, which is highly complex, requires commercial photofinishing equipment.

KODAK EKTAR 25 Film      ISO 25            KODACOLOR GOLD 100 Film    ISO 100

As this series shows, graininess increases with film speed. A low-speed film, such as KODAK EKTAR 25 Film, provides exceptionally fine grain, while a high-speed film, is comparatively grainier. Medium-speed films often prove to be the best compromise. They give good results when enlarged yet are fast enough for some action and some existing-light photography. The large photos are magnified 15X.

KODACOLOR GOLD 400 Film    ISO 400         KODAK EKTAR 1000 Film    ISO 1000

47

Sam Dover

KODAK EKTACHROME 100 HC Film gives rich bright colors yet maintains the purity of neutral colors. It's ideal for natural subjects as well as people.

Sam Dover

KODACHROME 64 Film has more than double the speed of KODACHROME 25 Film yet is nearly as sharp and fine grained. It has long been a favorite of pro photographers.

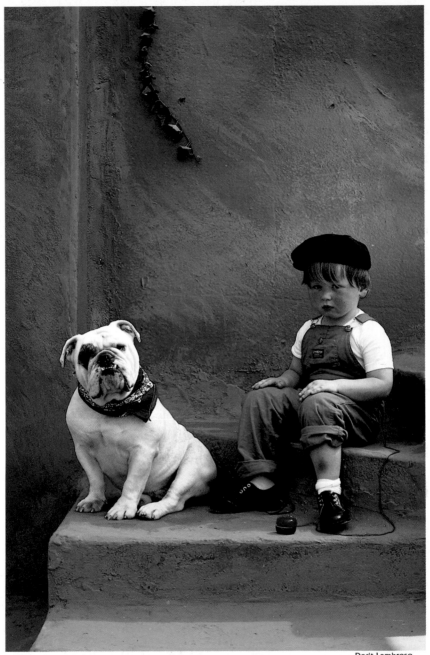

Dorit Lombroso

KODACHROME 25 Film (Daylight) is a superb color-slide film for photographing in bright-light situations where you don't need a lot of film speed and you want the best possible image quality and excellent color rendition. The speed was specified at ISO (ASA) 25 to offer you our highest sharpness and finest grain in a color-slide film for general use.

Derek Doeffinger

On heavy overcast days, the high speed of KODACOLOR GOLD 400 Film helps you be more creative by allowing you to use a wide range of shutter speeds and apertures. Exposure was 1/60 second at *f*/11, 24 mm lens.

Steve Kelly

With its medium speed and micro-fine grain, EKTAR 125 Film is the ideal film for those users who want to get exceptional quality without sacrificing convenience.

Doug Purvis

The wide range of superb Kodak films combined with today's array of sophisticated 35 mm equipment offers the photographer more exciting picture opportunities than ever before. Made on KODACHROME 200 Professional Film.

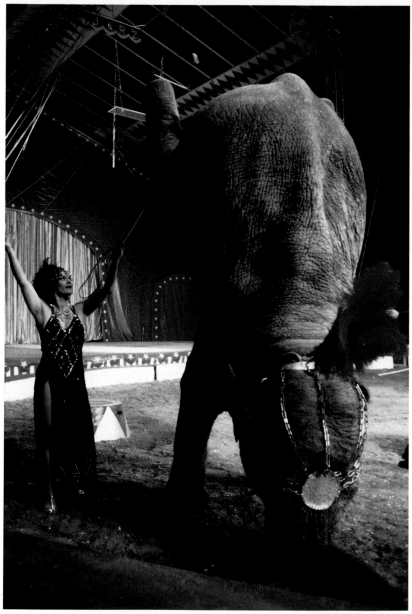

A. Courtois/A. Chastel

KODAK EKTACHROME 400 Film (Daylight) is a high-speed Kodak color-slide film that is great for existing-light photography, for stopping action in poor light or with telephoto lenses, or for extending depth of field without using slow shutter speeds. The color quality of this film produces saturated colors with full tonal values. This film also produces good results under artificial light if color fidelity is not critical.

Steve Kelly

With an ISO of 1600, KODACOLOR GOLD 1600 Film will let you take pictures in an art studio, a night football game, or just about anywhere there's light.

53

Neil Montanus

The micro-fine grain of EKTAR 25 Film yields results unsurpassed by any other 35 mm color negative film. To obtain best results with this film, use a fast shutter speed or tripod and stop down two stops from the lens' largest aperture.

Bob Clemens

With extremely fine grain and very high sharpness, high-speed KODAK T-MAX 400 Professional Film is versatile enough to cover a wide range of lighting conditions. It produces excellent results in bright sunlight, stops the action of moving subjects, and is especially useful for dimly lighted subjects.

Sam Dover

Medium-speed KODAK T-MAX 100 Professional Film excels in providing superior image quality. Use it in bright light or with a tripod when you want to obtain superior enlargements.

## KODAK COLOR FILMS FOR 35 mm CAMERAS

| Kodak Film | Description | To Produce | Use with | ISO Film Speed and Filter | | | | Number of Exposures Available |
|---|---|---|---|---|---|---|---|---|
| | | | | Daylight | Photolamps 3400 K | Tungsten 3200 K | | |

**Color Negative Films**

| Kodak Film | Description | To Produce | Use with | Daylight | Photolamps 3400 K | Tungsten 3200 K | Number of Exposures Available |
|---|---|---|---|---|---|---|---|
| Kodak Ektar 25 (CK) | SLR cameras only. This is Kodak's sharpest and finest grain color negative film. Use it when you want to obtain outstanding big enlargements. Expose it carefully since it has less latitude than Kodacolor Gold Films. | Color prints | Daylight, Electronic Flash, or Blue Flash | 25 | 8 No. 80B | 6 No. 80A | 135-12 135-24 135-36 |
| Kodacolor Gold 100 (GA) | This film features very high sharpness and extremely fine grain to allow for a high degree of enlargement and wide exposure latitude. It is an excellent film for use in general lighting conditions. | Color prints | Daylight, Electronic Flash, or Blue Flash | 100 | 32 No. 80B | 25 No. 80A | 135-12 135-24 135-36 |
| Kodak Ektar 125 (CW) | With micro-fine grain and extremely high sharpness, this medium-speed film makes an excellent film for users requiring high-quality prints. | Color prints | Daylight, Electronic Flash, or Blue Flash | 125 | 40 No. 80B | 30 No. 80A | 135-24 135-36 |
| Kodacolor Gold 200 (GB) | With the same extremely fine grain and nearly as high sharpness as Kodacolor Gold 100 Film, this film provides twice the speed. It is a good choice for general lighting conditions when higher shutter speeds for capturing action or smaller apertures for increased depth of field are desired. | Color prints | Daylight, Electronic Flash, or Blue Flash | 200 | 64 No. 80B | 50 No. 80A | 135-12 135-24 135-36 |
| Kodacolor Gold 400 (GC) | A high-speed film for existing-light situations, fast action, great depth of field, and extended flash-distance ranges. Medium sharpness and extremely fine grain offer good quality. | Color prints | Existing Light, Daylight, Electronic Flash, or Blue Flash | 400 | 125 No. 80B | 100 No. 80A | 135-12 135-24 135-36 |
| Kodak Ektar 1000 (CJ) | This high-speed film offers very fine grain. Use it in dim lighting when you want to make enlargements and don't need the extra speed of Kodacolor Gold 1600 Film. | Color prints | Existing Light, Daylight, Electronic Flash, or Blue Flash | 1000 | 320 No. 80B | 250 No. 80A | 135-12 135-24 135-36 |
| Kodacolor Gold 1600 (GF) | Very high speed with very fine grain and medium sharpness. Use it in very dim lighting or for very fast action subjects. | Color prints | Existing Light, Daylight, Electronic Flash, or Blue Flash | 1600 | 500 No. 80B | 400 No. 80A | 135-12 135-24 135-36 |

**Color Slide Films**

| Kodak Film | Description | To Produce | Use with | Daylight | Photolamps 3400 K | Tungsten 3200 K | Number of Exposures Available |
|---|---|---|---|---|---|---|---|
| Kodachrome 25 (Daylight) (KM) | A popular film noted for excellent color and high sharpness. It has extremely fine grain and good exposure latitude. | Color slides | Daylight, Electronic Flash, or Blue Flash | 25 | 8 No. 80B | 6 No. 80A | 135-24 135-36* |

| Film | Description | For | Use the film with these light sources | Daylight | Photolamp 3400 K | Tungsten 3200 K | Sizes |
|---|---|---|---|---|---|---|---|
| KODACHROME 40 5070 (Type A) (KPA) | A film designed for use with 3400 K photolamps. This film is excellent for informal portraits, close-ups, title slides, and for copying color originals. | Color slides | Photolamps 3400 K | 25 No. 85 | 40 | 32 No. 82A | 135-36 |
| KODACHROME 64 (Daylight) (KR) | A medium-speed, general-purpose film. Exhibits remarkable sharpness and freedom from graininess. Color rendition of this film is excellent. | Color slides | Daylight, Electronic Flash, or Blue Flash | 64 | 20 No. 80B | 16 No. 80A | 135-24 135-36* |
| KODACHROME 200 (Daylight) (KL) | This film features very high sharpness and fine grain. Allows faster shutter speeds for hand-holding longer lenses, smaller lens openings for increased depth of field, and use in low-light situations. | Color slides | Daylight, Electronic Flash, Blue Flash, or Existing Daylight | 200 | 64 No. 80B | 50 No. 80A | 135-36 |
| EKTACHROME 100 HC (Daylight) | A medium-speed film for general all-around use. It has sufficient speed to let you use higher shutter speeds or smaller lens openings in normal lighting. This film produces rich colors rendition and has excellent sharpness and graininess characteristics. | Color slides | Daylight, Electronic Flash, or Blue Flash | 100 | 32 No. 80B | 25 No. 80A | 135-24 135-36* |
| EKTACHROME 200 (Daylight) (ED) | A medium-speed film for existing light, fast action, subjects requiring good depth of field or high shutter speeds, and for extending the flash-distance range. It has very fine grain and excellent sharpness. This film can be push-processed to double the speed. | Color slides | Daylight, Electronic Flash, Blue Flash, or Existing Daylight | 200<br>400‡ | 64 No. 80B<br>125‡ No. 80B | 50 No. 80A<br>100‡ No. 80A | 135-24 135-36* |
| EKTACHROME 160 (Tungsten) (ET) | A medium-speed film for use with 3200 K tungsten lamps and existing tungsten light. It features the same very fine grain and excellent sharpness as the 200-speed daylight film. This film can be push-processed to double the speed. | Color slides | Tungsten Lamps 3200 K or Existing Tungsten Light | 100 No. 85B<br>200‡ No. 85B | 125 No. 81A<br>250‡ No. 81A | 160<br>320‡ | 135-24 135-36* |
| EKTACHROME 400 (Daylight) (EL) | A high-speed film for existing light, fast action, subjects requiring good depth of field and high shutter speeds, and for extending the flash-distance range. It has fine grain and good sharpness and can be push-processed to double the speed. | Color slides | Daylight, Electronic Flash, Blue Flash, or Existing Daylight | 400<br>800‡ | 125 No. 80B<br>250‡ No. 80B | 100 No. 80A<br>200‡ No. 80A | 135-24 135-36* |
| EKTACHROME P800/1600 Professional Film (Daylight) (EES) | A very high-speed film for existing light and fast action. This film exposed at EI 800 or EI 1600 provides good results in adverse lighting conditions. It can be push-processed as high as EI 3200. | Color slides | Existing Daylight, Daylight, Electronic Flash, or Blue Flash | EI 800§<br>EI 1600¶ | 250§ No. 80B<br>500¶ No. 80B | 200§ No. 80A<br>400¶ No. 80A | 135-36 |

*Professional versions of these films are available in 35 mm and 120 sizes. KODACHROME 25 Professional Film is available only in 35 mm size.

‡Use these speed settings to expose these films when you want your film push processed one stop.

§Use these speed settings to expose EKTACHROME P800/1600 Film for push processing in Process E-6P, Push 1.

¶Use these speed settings to expose EKTACHROME P800/1600 Film for push processing in Process E-6P, Push 2.

## KODAK BLACK-AND-WHITE FILMS FOR 35 mm CAMERAS

| KODAK Film | Description | ISO Film Speed | Number of Exposures Available |
|---|---|---|---|
| T-MAX 100 Professional | A medium-speed panchromatic film with extremely fine grain and nearly the same speed as KODAK PLUS-X Pan Film. Particularly good for detailed subjects, film also features extremely high sharpness and very high resolving power, and allows a high degree of enlargement. | EI 100 | 135-36 |
| PLUS-X Pan | An excellent general-purpose panchromatic film that offers medium speed and extremely fine grain. | 125 | 135-24<br>135-36 |
| TRI-X Pan | A high-speed panchromatic film especially useful for photographing existing light subjects, fast action, subjects requiring good depth of field and high shutter speeds, and for extending the flash-distance range. This film has fine grain and excellent quality for such a high speed. | 400 | 135-24<br>135-36 |
| T-MAX 400 Professional | A panchromatic film that offers the same film speed as KODAK TRI-X Pan Film and finer grain than KODAK PLUS-X Pan Film. Especially useful for photographing subjects in low light, stopping action, or expanding depth of field, this film allows a high degree of enlargement. It can be exposed at speeds of EI 800 and EI 1600 with very acceptable results. | EI 400 | 135-36 |
| T-MAX P3200 Professional | An extremely high speed, fine grain panchromatic film for use in existing light, such as sports stadiums and night events. With push processing, you can expose it at EI 3200 and EI 6400 with good results and up to EI 25,000 with acceptable results. | EI 1000–25,000 | 135-36 |
| High Speed Infrared 2481 | An infrared-sensitive film which produces striking and unusual results. With a red filter, blue sky photographs almost black and clouds look white. With this film and filter, live grass and trees will appear as though they are covered by snow. This film has fine grain. | 125 tungsten* | 135-36 |
| Technical Pan 2415 | A panchromatic film with extremely fine grain and extremely high resolving power that gives large-format performance with 35 mm convenience. Great enlargeability is possible. It is suitable for a wide number of general and scientific applications, such as photomicrography, precision copying, titling, and pictorial photography, depending on the exposure and processing used. | EI 25** | 135-36 |

*Use this speed as a basis for determining your exposures with tungsten light when you expose the film through a No. 25 filter. In daylight, follow the exposure suggestions on the film instruction sheet.

**Use this speed for daylight pictorial photography only when processed in KODAK TECHNIDOL Developer, or the equivalent. Other speeds for different applications require alternative developers and give appropriate results. See the instructions packaged with the film.

Note: Panchromatic means that the film is sensitive to all visible colors.

## SPEED BOOSTER FOR *EKTACHROME* FILMS

There will undoubtedly be times when you'll want to use a very high-speed 35 mm color-slide film. This may be when you're shooting by existing light, when you want to use a fast shutter speed combined with a small lens opening, or when you need a small lens opening to get good depth of field under dim lighting conditions. A photofinisher can use push-processing to double the speeds of these 135-size films—from ISO 400 to ISO 800 for EKTACHROME 400 Film (Daylight); from ISO 200 to ISO 400 for EKTACHROME 200 Film (Daylight); and from ISO 160 to ISO 320 for EKTACHROME 160 Film (Tungsten). When necessary, you can also use push processing to increase the speed of EKTACHROME 100 HC Film (Daylight) from ISO 100 to ISO 200.

Push processing is required for EKTACHROME P800/P1600 Professional Film (Daylight) exposed at EI 800 or 1600. Many labs offer push processing for both speeds. A film speed of EI 3200 is possible with push processing available from some independent processors. If desired, some labs will process EKTACHROME P800/1600 Film normally for a film speed of EI 400. [Color balance and other variables are optimized in manufacture for the EI 800-1600 range. Use a CC10Y yellow filter if you need to expose EKTACHROME P800/1600 Film at EI 400.]

Mark an exposed magazine of EKTACHROME P800/1600 Film in the appropriate place for the EI used—P1 (Push 1) for EI 800 or P2 (Push 2) for EI 1600.

You can also increase the speed of KODAK EKTACHROME 400, 200, 160, and 100 Films by push-processing the films yourself with KODAK HOBBY-PAC Color Slide Kit, Process E-6. Simply increase the developing time in the first developer as recommended in the processing instructions that come with the chemicals. For all the other steps, just follow the normal processing times in the instructions. The procedure that gives a one-stop push process for most EKTACHROME Films, Process E-6, will give an EI 800 film speed for EKTACHROME P800/1600 Film. Follow the processing instructions for greater increases in speed.

## VERSATILITY OF *KODAK* COLOR FILMS

While the color films in the charts on pages 56 and 57 are designed specifically to produce color slides or color negatives for color prints, they also give you a great deal of versatility. You can have color slides made from your color negatives and color prints made from you color slides. You can also have color prints made directly from finished color prints. See your photo dealer.

In addition you can have black-and-white prints made from your color negatives. Or you can make them yourself. Kodak manufactures KODAK PANALURE II RC Paper specially for this purpose. When color negatives are printed on KODAK PANALURE Paper, the tones of gray in the print accurately represent the tonal relationships in the original scene. When color negatives are printed on regular black-and-white printing paper, you don't get this accurate tonal relationship.

EXPOSURE

Accurate exposure is important in producing a high-quality photograph, and it is critical when you use a slide film. Exposure is the amount of light reaching the film. Each film requires a specific amount of light to produce a picture of the proper brightness. How much light a film requires depends on its speed. The versatility of your camera enables you to shoot pictures at sunrise, during a blizzard or rainstorm, in your family room, or at a night baseball game.

For such unusual lighting situations, a light meter is a must. Most 35 mm cameras have built-in meters. The built-in meters of SLR cameras indicate the shutter speed and aperture required for correct exposure. Those cameras that set the aperture and shutter speed are automatic-exposure cameras. Those that leave it up to you to set the shutter speed and aperture are manual-exposure cameras. Many cameras offer both automatic and manual exposure.

## EXPOSURE WITH AUTOMATIC CAMERAS

Most new cameras set the exposure and film speed automatically. Not all automatic cameras, however, have the same features. Many compact 35 mm cameras have very simple exposure systems and allow little (if any) control of exposure. Some sophisticated SLR models offer several exposure modes. Between the two are cameras that have only partial auto-exposure systems. These may require you to make part of the exposure decision—setting the shutter speed or aperture, for example. If your camera has several exposure modes, knowing the advantages of each mode is of great importance in making the most of auto-exposure capability.

Automatic cameras that offer a choice of modes do so to suit different needs, such as extending depth of field or stopping action. Other modes optimize results with a particular piece of equipment, such as a telephoto lens. Below is a look at each of the different auto-exposure modes. Read your instruction manual for specifics about your camera.

Linda Tomaszewski

The aperture-priority mode allows you to set the aperture for creative effects—either great depth of field or little depth of field. Here the photographer set a large aperture, f/2.8, so the background would be out of focus and not distract from the subject. The camera will automatically set the shutter speed.

Laurie McAtee

The shutter-priority mode enables you to set the shutter speed required by the subject. Here the photographer used a fast shutter speed to freeze the action. The camera will automatically set the aperture.

## APERTURE PRIORITY

In this mode you select the aperture and the camera automatically picks a shutter speed for correct exposure. Aperture priority is ideal if you want to control depth of field. By choosing a small aperture for extensive depth of field or a large one for selective focus, you get the benefits of auto-exposure while being able to manipulate scene sharpness.

## SHUTTER PRIORITY

In this mode you set the shutter and the camera sets the aperture required for correct exposure. You can choose a fast shutter speed to halt action subjects or a longer shutter speed to accentuate motion (to blur water going over a waterfall, for instance).

If the shutter speed you have selected requires an aperture beyond the range of your lens, you may have to adjust the shutter speed or use a faster or slower film. If you wanted to make a 1-second exposure in daylight with medium-speed film, for example, even a very small ap-

erture, such as $f/22$, wouldn't be small enough to give proper exposure. The solution in this example would be to switch to a slower film or to use a neutral density filter.

## PROGRAM MODE

Cameras that offer a full program mode choose both the aperture and the shutter speed for you. In the normal program mode, the camera provides a moderate shutter speed (one that is safe for handheld shooting and a relatively stationary subject) and a moderate aperture for an average amount of depth of field. Unless you have specific creative or technical demands that require other settings, this is the best mode for general photography.

Some cameras have a feature called **program shift** that allows you to choose any equivalent combination of shutter speed and aperture by simply turning a dial or pressing a button (usually near the shutter release). With this feature you can let the camera figure

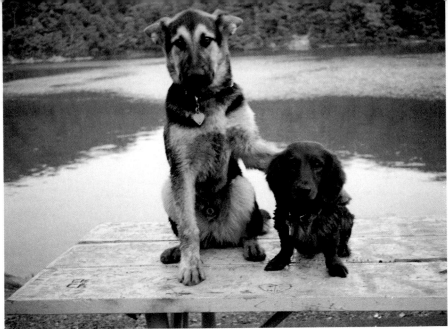

Christine Blair Hutchins

In a program mode, the camera sets both the shutter speed and aperture. If the subject does not require a particular shutter speed or aperture, use the normal program mode. It sets a moderate shutter speed and aperture.

the exact exposure, but then quickly tailor the exposure combination to your subject's needs. If the camera meter chooses a combination of 1/125 sec at $f/8$, for example, you could shift to an equivalent exposure: 1/250 sec at $f/5.6$, 1/60 sec at $f/11$, etc.

Two special program modes that some cameras feature are a **depth-of-field program** and an **action program**. Both are full program modes (aperture and shutter speed are chosen for you), but they allow you to tailor the exposure system to a particular type of subject. When set to the depth mode, for example, the camera will automatically choose the smallest possible aperture that still allows a safe handheld shutter speed. This is a good mode to use in scenic photography when you want great depth of field. Similarly, in the action-program mode, the camera will pick a fast shutter speed with a large aperture to stop fast-moving subjects.

Some cameras that use interchangeable lenses often switch automatically to these special program modes as you switch lenses to choose a mode that best complements the specific focal length of the lens. For example, if you're using a telephoto lens (typically the cutoff point is 135 mm or longer), the camera will automatically go into the action mode and set a fast shutter speed to prevent blurred pictures caused by camera shake. If you attach a wide-angle lens, the camera will switch to the depth program and select an aperture that will give the maximum available depth of field—since gaining maximum depth of field is a prime reason for using a wide-angle lens.

What about zoom lenses? Cameras with a choice of programmed exposure modes often have sensors in the lens mount that monitor focal length and set the program mode accordingly.

Finally, you can use most automatic cameras in a full **manual** exposure mode by selecting the manual mode on the mode selection switch. In the manual mode you are free to select both aperture and shutter speed, to handle a particularly difficult subject or to create an imaginative effect.

## SELECTIVE METER READINGS (AUTOMATIC CAMERAS)

Automatic cameras are programmed to give you good exposures with subjects of average brightness under average lighting conditions, and generally they do this job very well. But as mentioned in the previous section, you won't always be working under average lighting conditions or with average subjects. The meter in your automatic camera can be fooled—although some exposure systems are more foolproof than others.

A few automatic cameras, for example, are able to evaluate even the most complex light situations and provide accurate exposure information. They do this with a system called **matrix** or **zone** metering. In this type of metering system, the camera's computer divides the picture area into a grid. It compares various data such as contrast, bright-

John Fis

It's easy to determine the exposure for a normal scene. Just make the meter reading from the camera position by aiming your exposure meter or camera with built-in meter toward the subjects.

Keith Boas

When the scene lighting is uneven, as it often is for stage shows and sporting events, a spot meter will allow you make a reading of only the subject. Some cameras have built-in spot meters.

ness, and subject size, and then uses this information to make "educated" exposure decisions. In some cameras these decisions are based on comparisons with hundreds of thousands of exposure patterns that have been programmed into the camera's memory. This type of camera can make a correct exposure even if, for example, the main subject is backlighted.

**The exposure corrections we suggest for unusual lighting conditions may not always be needed for cameras with matrix or zone metering.** If your camera has such a system, study your pictures to see how accurate the meter is in handling tricky lighting. If it sometimes falls short, you may be able to switch to an averaging meter mode (or manual) and follow our recommendations.

No matter how sophisticated the metering system, all automatic cameras occasionally need your guidance. And most provide one or more controls that can alter the exposure. Common controls are the spot meter, exposure lock, backlight button, and exposure-compensation control. With any exposure-compensation feature, be sure to set it back to its neutral or zero position when you change subjects or settings.

A spot meter enables you to take a reading from a small area (usually marked by a circle in the center of the viewfinder) that you deem important, such as a brightly colored flower against a black background. To activate this feature, you would typically depress the spot-metering button and then activate the meter by pressing the shutter release partway. As long as you keep the shutter release depressed (or until you take the picture), the meter will lock in this spot reading. With some cameras, just pressing the spot button locks the exposure until you take a picture.

For handy reference, keep the exposure chart with your camera.

A **memory-lock** button lets you take a reading from the entire metering area and hold that reading until you take the picture. By moving in close (physically or with a zoom lens) to fill the frame with the main subject and locking the reading, you can get accurate exposure for the important part of the scene—a face, for instance. As long as the exposure remains locked, you can recompose the scene in any way you want and still get the right exposure.

Memory-lock is particularly useful in very contrasty situations. For example, if you needed to make a close-up meter reading of a dark subject in front of a light background (or vice versa), you could move in close to make the reading, push the memory-lock button to hold the exposure, and then move back to your original shooting position to take the picture. If you were using a zoom lens, you could zoom to the longest focal length, take a reading and lock it, and then recompose the scene by adjusting the zoom setting.

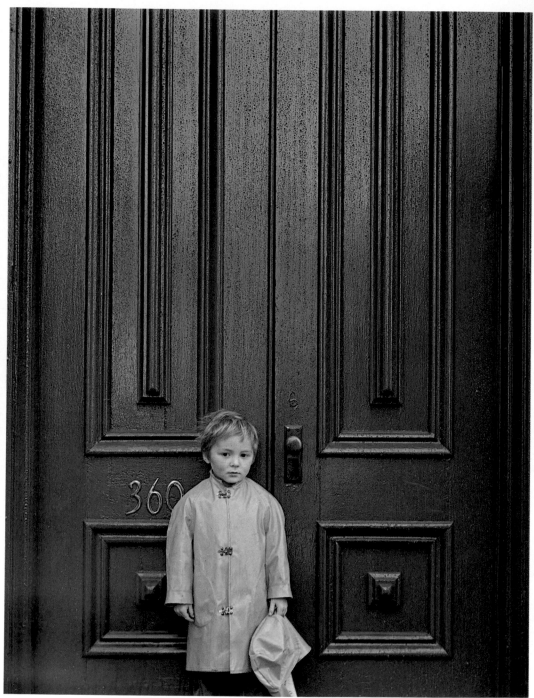

Dick Faust

The reverse of the bright background situation is a background darker than the subject which can mislead your exposure meter. Surroundings darker than your subject can cause a meter reading that's too low resulting in overexposure. To obtain the right exposure, make a close-up meter reading of the subject.

An **exposure compensation** control lets you alter the exposure automatically by up to plus or minus 2 or 3 stops, usually in $^1/_2$- or $^1/_3$-stop increments. Exposure compensation is useful for backlighted scenes and for very bright or dark subjects that would normally mislead the meter.

Some simpler cameras have a similar but less sophisticated exposure-compensation feature called a **backlight** button. This is actually an exposure-compensation button that gives a fixed amount—usually $1^1/_2$ or 2 stops—of extra exposure to compensate for dark foreground subjects (like faces) in strongly backlighted situations.

If your automatic camera doesn't have a compensation control or a backlight button, it may be possible to change the exposure by changing the setting on the film-speed dial. All you have to remember is that each time you **double** the film speed, you decrease exposure by one stop; each time you **halve** the speed, you increase exposure by one stop.

To correct the exposure by altering the film-speed setting or using any type of compensation feature, you first have to know the amount of correction that's needed. Estimating the correction is fairly simple for overall light or dark scenes, especially when they don't include people. Also the amount of correction isn't as critical when you are using color negative film, which has a fairly wide exposure latitude.

For example, a sunlit, snow-covered hill would cause a meter to underexpose the scene so that the snow would appear gray rather than bright white.

The exposure compensation control might be a button, **above,** that you press and see the amount of compensation on an LCD panel. Or it might be a dial that you set to alter the exposure.

Since this kind of scene usually requires 1 stop more exposure than that indicated by the meter, simply divide the film speed by 2 (effectively adding 1 stop of exposure) and set this lower film speed on the film-speed dial—or set +1 stop on the compensation control. With a 200-speed film, for instance, you would set the dial to 100. Conversely, if you were photographing a very dark scene that the camera would normally overexpose, multiply the film speed by 2 (ISO 400 instead of 200, for example) —or set −1 stop on the compensation control.

With cameras that set the ISO speed automatically for DX-encoded films, you may or may not be able to alter the ISO speed. If you do change ISO speeds in mid-roll, be sure to set the correct speed back when you're done, or you will alter the exposure for the rest of the roll.

## MANUAL EXPOSURE WITH BUILT-IN METERS

Most manually adjustable SLR cameras have a built-in reflected-light exposure meter that takes light readings through the camera lens (called TTL metering). Some built-in meters measure the light as it enters the lens and hits sensors on or near the reflex mirror; others measure the intensity of the light at the film plane (called OTF or "off-the-film" metering).

One important way that meters differ is in the area where they measure the light. Most TTL meters measure the average of all the light reflecting from a scene. Others take a weighted reading. In meters that weigh the reading, a small area has the greatest influence on exposure determination, but the remaining picture area also exerts some influence. Some cameras have TTL meters that work on the same principle as a spot meter; they read only a small segment of the scene.

Using a built-in meter is easy. Once you've set the film speed on your camera dial (not necessary with a camera that senses DX-encoded film), all you have to do is aim your camera at the scene, and the meter will measure the light reflecting from the scene. You then adjust the aperture or shutter speed (or both) until a viewfinder display indicates you have set the exposure correctly. The correct exposure may be indicated by matching a needle to a specific mark or area in the viewfinder, or by a lighted display.

When you set the shutter speed and aperture, consider subject demands. With moving subjects, for example, you may want to select a shutter speed fast enough to stop action, and then find an aperture to give the correct exposure. With breathtaking vistas, you may want to select an aperture small enough to make a picture sharp from foreground to background, and then find an appropriate shutter speed.

Louise Lapalice

When the scene contains large shadows and highlights, move in close to take a meter reading. Set the indicated exposure on your camera and return to your original position to take the photo.

### SELECTIVE METER READINGS (MANUAL CAMERAS)

The exposure indicated by the camera's meter works well for most subjects. But you will encounter difficult situations where you'll have to use the built-in meter to make more interpretive, or selective, readings.

Very contrasty scenes that have large dark and bright areas, for example, may require selective meter readings. An overall meter reading from the camera position is affected by the large areas in the scene, such as light or dark foregrounds or backgrounds. If the main subject (a person, for example) is surrounded by a large area that is much lighter or darker than the subject, the meter will indicate an exposure that's correct for the background, but wrong for the main subject.

Neil Montanus

A conventional meter reading from the camera position would lead to overexposure because of the dark surroundings. With a spot meter you could make a meter reading of the subjects' faces without moving from where you want to take the picture.

In situations such as this, you should make a selective meter reading. For example, move in and make a close-up reading of the subject (a person's face or body) that excludes the unimportant light or dark area. You may sacrifice detail in the larger background or foreground area, but the main subject will be correctly exposed. When you make a close-up reading, be careful not to measure your own shadow or the shadow of your camera. If you have a spot-metering camera, making a selective reading is just a matter of centering the important subject area in the spot-metering zone.

Scenes that include a large proportion of sky often require selective meter readings. Since the sky is usually brighter than other parts of the scene, your exposure meter may indicate too

little exposure. As a result, a subject that's darker than the sky will probably be underexposed. This effect is even greater with overcast skies than with blue skies. One trick to avoid this problem is to aim your camera down slightly when taking a light reading so that the meter isn't fooled by the bright sky.

In backlighted scenes, the background is often sunlit and therefore brighter than the subject. Also, light coming from behind the subject may shine directly into the lens or metering cell. Both situations often result in underexposure of your subject. The solution is to take a close-up reading, being careful to shade the lens from extraneous light.

If you're using a zoom lens, taking close-up readings is easy, since you can often do it without changing your shoot-

Neil Montanus

The brightness of white beaches, **above,** and snow, **below,** can also trick the camera into making pictures too dark (underexposed). To adjust for this situation, either base exposure on a close-up meter reading of the subject or increase exposure one stop by adjusting the compensation control on automatic cameras or opening up the lens aperture one stop on manual cameras.

Dick Boden

ing position. Simply zoom the lens to its longest focal length, take a reading from the important areas of the scene, and then return to the focal length that you want to use for shooting the picture. Be sure to use the exposure you determined from the close-up reading, even if the meter is warning you of under- or overexposure when you change the zoom setting to take the picture.

Sometimes a large very light area or a large very dark area is an important part of the picture, and you'll want to be sure that it is exposed correctly. Vistas filled with snow or white sand fall into this category. If you used an overall or average meter reading, the scene would be underexposed—too dark. White subjects, such as snow scenes, would come out a drab gray instead of white because the meter is trying to make everything in the scene an "average" tone. This type of scene usually requires about 1 to 1½ stops **more** exposure than indicated by the meter. It's a good idea to compare the camera settings you have determined with your TTL meter with those recommended in the film instructions. If your meter reading is much less, you'll probably get better results by following the film instructions.

Conversely, when you encounter an important dark scene—a black horse against a dark forest, for example— you'll want to use 1 to 1½ stops **less** exposure than the meter indicates. Otherwise your meter, in its effort to average all subjects, will cause your horse and background to record too light. You'll get a gray horse instead of a black one. For difficult scenes like these, it's often a good idea to bracket your exposures to get a properly exposed picture.

John J. Bright, KINSA

In backlighted scenes, the background is often brighter than the subject, so here again take a close-up meter reading of the subject. Also, the sun can shine into the meter cell or camera lens on a camera with through-the-lens metering causing a meter reading that's way too high and thus underexposure. To avoid this, hold your hand or some other object so it blocks the sun from shining on your meter or camera lens. Be careful not to include your hand or other object in the meter or camera field of view.

Finally, if a scene has both very bright and very dark areas, make a meter reading of the brightest and darkest areas that are important to your picture and then use a setting midway between the two. This won't guarantee you perfect exposure of all parts of the scene, but it will keep the meter from being swayed too far in either direction.

**NOTE:** With KODACOLOR GOLD Films and T-MAX Professional Films, you will get good results even if your exposure is off ±2 stops. They'll give even better results if your exposure is correct. With other films, strive for accurate exposure.

Scott Nicholas

One advantage of an incident-light meter is that it isn't misled by surroundings darker or lighter than the subject. Here an incident-light reading made a short distance away from the subjects in the same lighting would not be influenced by the dark foreground and background.

## INCIDENT-LIGHT EXPOSURE METERS

Incident-light meters measure the illumination falling on the scene. You hold this type of meter in the same light that's illuminating the subject, usually near the subject, and point the meter at the camera (unless the instruction manual for your meter recommends a different technique).

Exposure determined by an incident-light meter assumes that the subject has average reflectance. Fortunately, most scenes have average reflectance, so the exposure indicated by an incident-light meter is good for most picture-taking situations. However, if a very bright or very dark area is an important part of the picture and detail

recorded in that area in the picture is wanted, you should modify the exposure indicated by the meter:

- Use a lens opening ½ to 1 stop smaller than the meter indicates if a bright subject is the most important part of the picture.

- Use a lens opening ½ to 1 stop larger than the meter indicates if a dark subject is the most important part.

If the scene is unevenly lighted and you want the best overall exposure, make incident-light readings in the lightest and darkest areas of illumination that are important to the picture. Then use the f-number that's midway between those that the meter indicates.

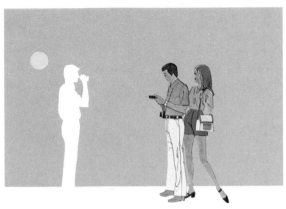

With an incident-light meter, you point the meter toward the camera position to make the reading. The meter measures the incident light illuminating the subject. An incident-light meter is not influenced by the brightness of the subject. If the lighting at the camera position is the same as the lighting on the subject, you can make the meter reading at the camera position with the meter facing the camera. If the lighting is different at the subject, then you have to make an incident-light reading at the subject location.

## BATTERY POWER

To obtain accurate readings from a meter, be sure the batteries that power it are in good condition. Cameras that have other automatic features, such as auto-focus, auto-wind and rewind, and built-in flash depend even more on battery power. Many cameras have a battery-check indicator to tell you when batteries are okay; it's a good practice to check this indicator frequently, especially before an important shooting event such as a party or vacation.

If your camera doesn't have a battery-checking device and the exposure meter behaves erratically or the camera doesn't operate normally, it's probably time to replace the batteries. Clean contacts are important too; if batteries seem weak, clean the contacts in your camera and on the batteries with a rough cloth or pencil eraser. Most batteries will last about a year in normal use, although lithium batteries usually last longer. Actual battery life will depend on the number of battery-dependent features your camera has and how many rolls of film you shoot. When AA batteries are required, use **alkaline** batteries, such as KODAK PHOTOLIFE™ Batteries.

Remember, too, that batteries weaken quickly in cold weather. It's a good idea to carry a set of spare batteries. In the winter, put them in an inside pocket to keep them warm, and then switch them when the batteries in your camera become weak. Battery strength returns when cold batteries warm up.

## BRACKETING EXPOSURES

There may be times when very unusual lighting or subject brightness will exhaust the versatility of you and your meter. To be sure of getting the best exposure when this happens, it's wise to bracket your exposures. Take a picture at the exposure setting indicated by your meter, another with 1 stop less exposure, and a third with 1 stop more. If it's a case of now or never, also shoot pictures with 2 stops more and 2 stops less exposure than the meter indicates.

A few automatic cameras have autobracketing features. You choose the amount of bracketing (usually up to plus or minus 2 stops in half- or third-stop increments) and the camera motor drive will automatically fire off a series of pictures in rapid succession when you press the shutter button. Most cameras with this feature make 3 bracketed exposures, but at least one has the capability to make up to 19 bracketed exposures.

1/60 sec f/8, 1 stop overexposed

1/60 sec f/11, film speed ISO 64, normal exposure

Bracketing your estimated exposure is good insurance for getting a picture with proper exposure when you're not sure what the exposure should be. These pictures show exposure bracketing of 1 stop on either side of the estimated exposure. Strasenburgh Planetarium, Rochester, New York

1/60 sec f/16, 1 stop underexposed          Caroline Grimes

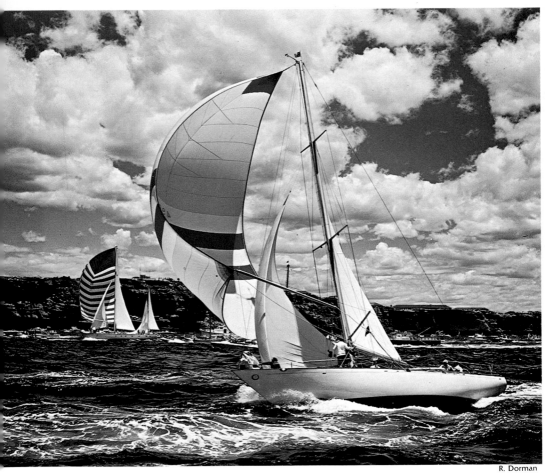

R. Dorman

Bright sunlight is very popular for outdoor photography. Colors are at their brightest when the sun is shining. The bright colors and the sparkling highlights and interesting shadows created by a radiant sun produce brilliant pictures.

# DAYLIGHT PHOTOGRAPHY

The lighting outdoors in the daytime is quite variable. Sometimes it's brilliant sunlight that might be shining on the front, side, or back of your subject. At other times it may be the shadowless light of an overcast day or the dim light of a deep forest. Knowing how to make the most of the various daylight lighting situations will mean better pictures for you. Understanding outdoor lighting will make you aware of more interesting picture possibilities and increase your creative abilities.

75

Midday

Late afternoon

Sunset

Herb Jones

Since the appearance of a scene varies with the time of day and the outdoor lighting conditions, you'll get better pictures by observing these differences and taking the picture when the conditions are optimum for the effect you want to create. Half Dome, Yosemite National Park, California

# DESCRIPTIONS OF BASIC DAYLIGHT LIGHTING CONDITIONS

To become familiar with the nature of outdoor lighting, you should have a clear impression of the basic daylight lighting conditions and the exposures they require. Even though most 35 mm cameras have built-in exposure meters, you can use the exposure guidelines to verify that you're using your exposure meter correctly or to determine the correct exposure to use if your meter is not working properly.

## BRIGHT OR HAZY SUN, AVERAGE SUBJECTS

The sun is shining with a blue sky or the sun is covered with a thin haze. The sun is unobstructed and clearly defined, though scattered clouds may be present. Shadows are sharp and distinct.

You can determine the basic exposure for frontlighted, average subjects in bright or hazy sun by a simple formula:

$$\frac{1}{\text{Film Speed}}\text{ second at } f/16$$

For example, if you're using a film with a speed of ISO (ASA) 64, the exposure would be 1/64 second at $f/16$. Use 1/60 second, the speed nearest to 1/64 on your camera. You can use this formula to find the exposure if you don't have an exposure meter or if your meter is in need of repair. We will refer to this basic exposure in our discussion of other lighting conditions.

## BRIGHT OR HAZY SUN, ON LIGHT SAND OR SNOW

The sun and sky condition is the same as for the first lighting condition given above, but the subjects are on very light sand or snow. Since these bright surfaces reflect a lot of light, the

Larry Gong

It's easy to photograph subjects lit by bright sunlight. The exposure is easy to determine and the bright colors will be pleasing.

Peter Gales

When photographing snowy scenes in bright sunlight, increase the exposure 1½ stops from the meter reading so the snow appears white (instead of gray) in your pictures.

recommended exposure is 1 stop less than the basic exposure for average subjects.

Note that the exposure corrections given in this section are for use with the basic daylight exposure defined on page 76, not with exposure meter readings. Refer to the chapter on exposure beginning on page 60 for how to use in-camera and handheld exposure meters.

Because reflected-light exposure meters can be fooled by such light backgrounds, to determine the proper exposure make a close-up reading of the subject. If this is not practical, be suspicious of a meter reading that calls for an exposure much less than 1 stop less than the basic exposure for aver-

age, frontlighted subjects in bright or hazy sunlight. If the meter reading is too high because of the bright background, you'll probably get better results using the exposure recommendations given here.

## WEAK, HAZY SUN

The light from the sun is weakened by a heavy haze and the sun's disk is visible but diffusely outlined. Shadows are weak and soft but readily apparent. Since there are no harsh shadows, these conditions are wonderful for photographing people.

With weak, hazy sun, you use 1 stop more exposure for average subjects than the basic exposure for bright sunlight.

Kim Coffey

Weak, hazy sun is flattering lighting for informal portraits. Shadows are softer and it's easier for people to have natural expressions when the sunlight is not so bright for their eyes.

Marty Czamanske

Under cloudy bright sky conditions there are no shadows so you don't have to be concerned with the direction of the lighting.

## CLOUDY BRIGHT

The sun is hidden by light clouds. The sky may be completely overcast or there may be scattered clouds. You can't see the sun's disk, but you can tell where it is by a bright area in the sky. There are no shadows.

Cloudy bright requires an exposure 2 stops greater than for bright sunlight.

## HEAVY OVERCAST

The sky is filled with heavy clouds and there's no bright area to show the location of the sun. There are no extremely dark areas to indicate an approaching storm and there are no shadows.

Use 3 stops more exposure for heavy overcast lighting than for bright sunlight.

Walter Lee

The soft, even lighting of an overcast autumn sky produced this appealing double portrait in delicately muted colors.

79

## OPEN SHADE

This is the kind of lighting you have when your subject is in the shadow of a nearby large object such as a house or a building. But you can still see a large area of open sky overhead, in front of the subject.

Open shade usually requires an exposure increase of 3 stops over that for bright sunlight.

Shot In The Dark Studios

Open shade describes the lighting conditions when your subject is in the shade of a nearby object that is not overhanging the subject and there is open sky overhead. Since there is no sunlight to cause squinting, chances are your subjects will have more pleasing expressions.

Don Maggio

When your subject is in the shade of objects blocking the sky overhead, you'll have to rely on exposure meter readings for proper exposure. The amount of light varies considerably and typically requires 1 or 2 stops more exposure than open shade.

Richard W. Brown

Sometimes the best time of day to take pictures is early or late in the day when artistic highlights and shadows are created by low sun angles when the sun is near the horizon. So don't restrict yourself to just taking pictures in the middle of the day. You'll need to increase exposure one or more stops.

Marty Czamanske

## BRIGHT SUNLIGHT

Most outdoor pictures are made in bright sunlight. This type of lighting offers the advantage of making colors look their brightest and snappiest. Exposure calculation is also simpler in bright sunlight because you can use the same exposure settings for most subjects. As long as you take pictures of average frontlighted subjects, you can shoot during most of the day at the same exposure settings.

A basic way to take pictures is in bright sunlight with frontlighting. The sun is behind the photographer's back or slightly off to the side. When the sun is at a slight angle to the camera axis, modeling from the highlights and the shadows on your subject's face gives it a three-dimensional quality.

81

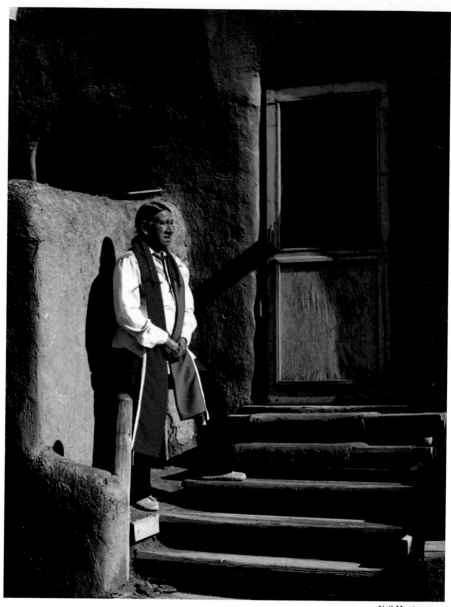

Neil Montanus

The shadows created by sidelighting make subjects appear more three-dimensional by revealing texture and form. Photo made on KODAK EKTAR 25 Film.

# SIDELIGHTING AND BACKLIGHTING

If you photograph all your subjects by frontlighting, you'll miss some excellent picture possibilities. Sidelighting and backlighting can help create interesting and pictorial photographs. You can use sidelighting and backlighting to produce strong separation between a subject and the background because the lighting creates a rim of light around the subject. You can use this type of lighting to emphasize the shape of the subject since sidelighting and backlighting create highlights and shadows called modeling. You can also use strong sidelighting to bring out surface textures and backlighting to capture the translucent quality of flowers and foliage. These advantages are lost when the sunlight comes over your shoulder and falls directly on the front of your subject.

When you take pictures of backlighted and sidelighted subjects, shielding your camera lens from the direct rays of the sun will help to avoid lens flare. You can use a lens hood or the shadow from your hand or a nearby object. Also be sure the sun's rays don't strike the light-sensitive cell of an automatic camera or exposure meter.

You'll usually need to use larger lens openings or slower shutter speeds for this type of lighting than for frontlighted subjects. In close-up pictures, especially of people, the shadows will probably be large and contain important details. To capture this detail, increase exposure for sidelighted subjects 1 stop over the normal exposure you'd use for frontlighted subjects, and give backlighted subjects 2 stops more exposure than normal. When you're photographing subjects at a medium distance and shadows are part of the

Herb Jones

When you're taking backlighted pictures, you should use a lens hood or shield the camera lens with your hand or another object to keep the sun from shining into the lens. It's also very important to keep your lens sparkling clean. Sunlight shining into the lens can cause reflections and flare inside the lens and camera which can spoil your pictures.

Gary Whelpley

The sunlight has produced shimmering highlights on the water in this picture which shows effective use of backlighting.

scene but not too prominent, increase
exposure by only 1/2 stop from nor-
mal for sidelighted subjects and 1 stop
for backlighted subjects. If you're pho-
tographing a distant scenic view in
which shadows are relatively small and
don't contain important detail, usually
no exposure increase is necessary.

Backlighted close-up pictures may contain
important shadow areas. To capture the de-
tail in the shadows, give a backlighted sub-
ject 2 stops more exposure than you'd use
for a frontlighted subject.

Marty Czamanske

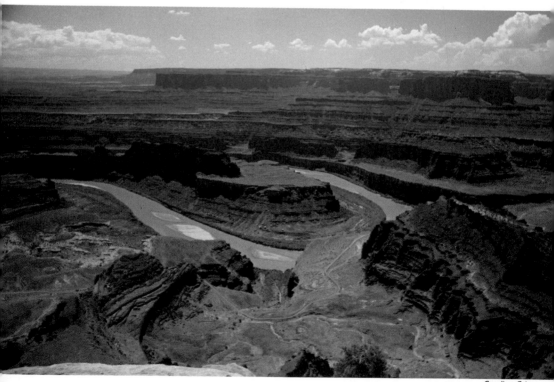

Caroline Grimes

No exposure increase is usually required for sidelighting or
backlighting in scenic views where the shadows are small without
important detail. Dead Horse Point near Moab, Utah

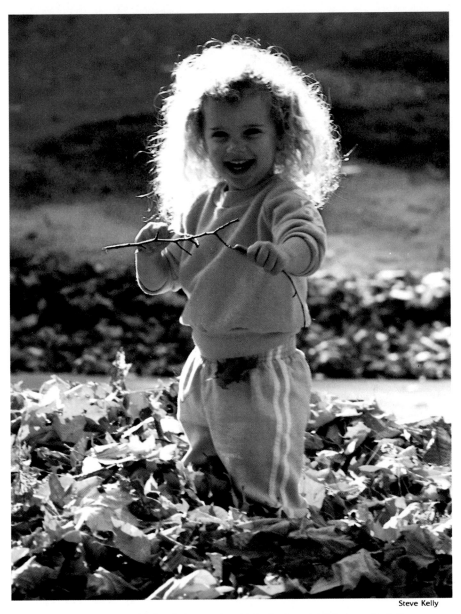

Steve Kelly

When taking backlighted pictures in which shadow detail is important, increase exposure 1 to 2 stops above that indicated by the meter.

Sunrise

Over the course of a day, the appearance and mood of a scene changes as the lighting shifts from back-lighting to sidelighting to frontlighting. Color changes in the light also affect mood.

Midday

Sunset

Derek Doeffinger

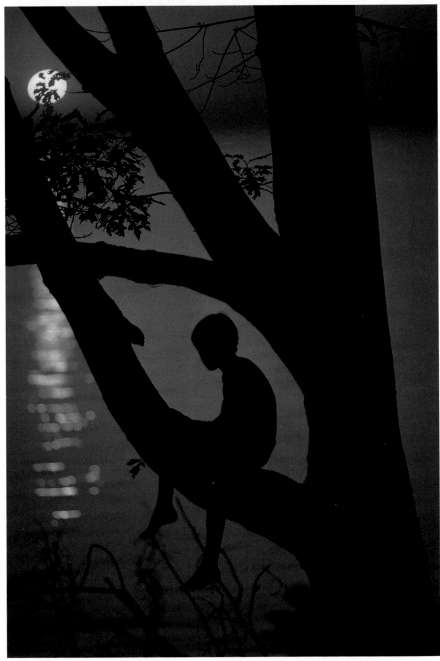

Phillip Lisik

To silhouette a backlighted subject, base the exposure on the brightest part of the scene but exclude the sun from the metering area. Set the indicated exposure on your camera and take the picture.

Norm Kerr

The soft, warm lighting produced at sunset is especially flattering in portraits.

© 1988, Jeff Wignall

# REDUCING LIGHTING CONTRAST

The contrast between shadow and highlight in brightly sunlighted conditions is frequently greater than film can reproduce. The answer is to reduce the contrast by brightening the shadows of important scene elements to preserve valuable detail.

## *FILL-IN FLASH*

Fill-in flash is especially useful for brightening the shadows in scenes with nearby people or objects with detail you want revealed. With people, you'll probably get more relaxed expressions because your subjects will be looking away from the sun. Now they won't have to squint.

SLR cameras with built-in or dedicated accessory flash units make fill-in flash easy. Often you have only to turn on the flash or camera. The camera will then fire the flash with the correct amount of light to lighten the shadows. Low- and medium-speed films, such as KODACOLOR GOLD 100 Film, work best

Many SLR cameras with built-in or dedicated flash units can provide fill-in flash illumination automatically. The bottom picture, without flash, is unattractive because you can't clearly see the woman's face. The top photo, with fill flash, is much more appealing. See the flash section for more on fill-flash techniques.

with fill-in flash. On bright days, these slower films allow you to use the correct synch speed required for flash. For detailed procedures on fill-in flash, see the section on flash photography.

Marcia Carter

For relaxed, wide-eyed (unsquinting) expressions, place your subjects in the shade and use a reflector to illuminate the face.

## REFLECTORS

Another good way of reducing the contrast of a nearby subject on a sunny day is to use a reflector to bounce light into the shadow areas. The reflector can be almost anything that will reflect light—a large piece of white paper, crumpled aluminum foil, or even a white sheet. Don't use a colored reflector with color films because it will reflect light of its own color onto your subject.

Try to have the reflector close enough to your subject, but not *in* the picture, to bring the light level in the shadows within 1 stop of normal sunlight exposure. Expose as you would for a normal frontlighted subject.

Sometimes you'll be able to take advantage of natural reflectors in a scene to fill in the shadows. If you can photograph your subject in surroundings including bright reflective surfaces like light sand, white buildings, or snow, the light reflected from them will often fill in the shadows to produce a pleasant lighting effect.

Without reflector

With reflector    Herb Jones

The photographer used a white cardboard as a reflector to lighten this woman's hair and face. He also used a diffusion filter to further soften the harsh lighting.

John Menihan, Jr.

You can use a piece of white cardboard to reflect the sunlight into the shadows.

## NO DIRECT SUNLIGHT

On overcast days or for subjects in the shade, lighting contrast is very low. In these situations you simply use an exposure meter to determine exposure or follow the exposure table in the film instructions. With this very soft and shadowless type of lighting, you won't need to use fill-in flash or reflectors.

When you take color slides on overcast days or in the shade, it's a good idea to use a No. 1A, or skylight, filter over the camera lens. This filter re-duces the bluishness of color slides made with this type of lighting. No exposure compensation is necessary with the skylight filter.

You're bound to encounter some unusual outdoor lighting situations, such as those found on foggy days or on the back porch during a rainstorm. In such situations, your best friend is an exposure meter or an automatic camera.

Tom McCarthy

Don't let rainy days discourage you from taking pictures.
Polished by the rain, colors seem to glow.

Norm Kerr

Overcast days are ideal for taking pictures of people because the soft lighting flatters skin tones. The photographer used KODACOLOR GOLD 200 Film.

Karen Stanley

On rainy days, keep your camera dry by shooting from under shelter, using an umbrella, or placing your camera inside a plastic bag with only the front of the lens poking out.

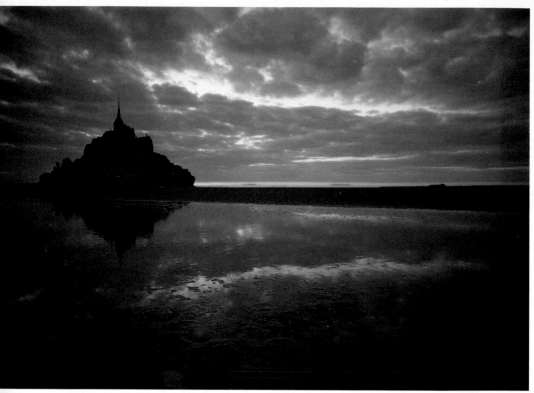

© Ric Ergenbright

Sunsets don't always have to brashly show the sun. Here, although obscured, the sun nonetheless attractively lights the clouds over Mont St. Michel. The reflection of the clouds seems to show the castle floating in the air.

## SUNSETS

Beautiful sunsets are superb subjects with rich, dramatic color and sunset pictures are easy to take. For proper exposure, just go by the meter reading of the colorful sky and clouds but do not include the sun in the metered area. Usually the exposure for KODACOLOR GOLD 100, EKTAR 125, and EKTACHROME 100 HC Film (Daylight) when the sun is partly or wholly obscured by a cloud is 1/125 second $f$/8. To have more assurance of obtaining saturated colors, it's best to bracket the estimated exposure by plus and minus 1 stop. When the sun is below the horizon, the sunset is dimmer, so try an exposure series of 1/60 second $f$/5.6, 1/60 second $f$/4, and 1/60 second $f$/2.8 with the films mentioned above. With KODACOLOR GOLD 200 Film use 1 stop *less* exposure than given above; with KODACHROME 64 Film (Daylight), use 1 stop *more* exposure.

Your sunset pictures will be even better when you include a foreground object that will photograph as a silhouette with the sunset in the background.

Keep your lens sparkling clean because dust particles, fingerprints, or other foreign matter can cause considerable lens flare when you photograph sunsets.

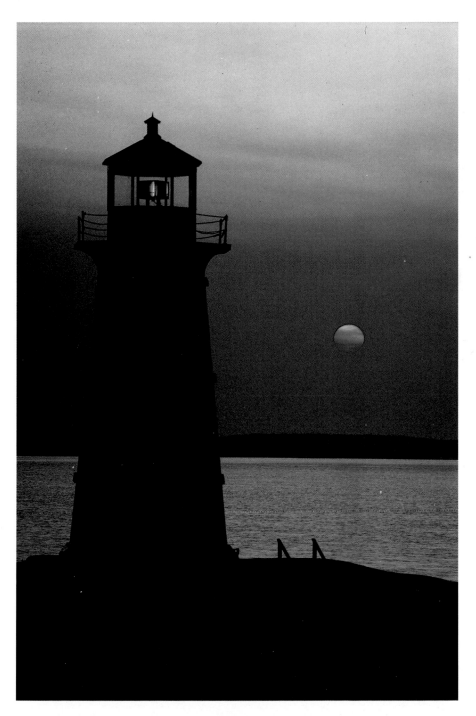

Sunsets often cause built-in meters, whether in an automatic or manual camera, to recommend the wrong exposure. Set the exposure based on a meter reading of the sky next to but excluding the sun. This exposure will record the sky at the brightness you see and cause foreground subjects to become silhouettes.

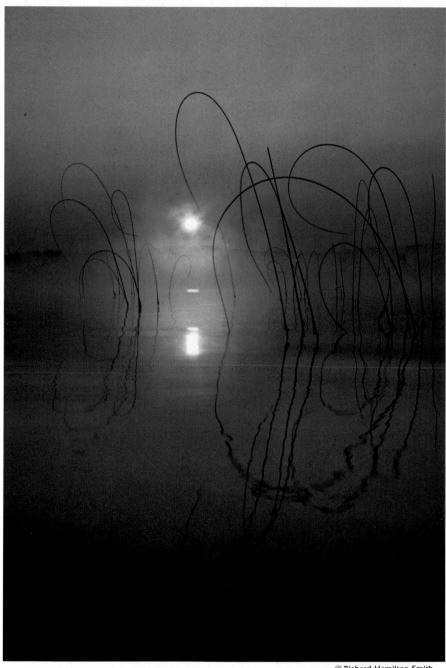

© Richard Hamilton Smith

At sunrise the sky tends to be clearer than at sunset because atmospheric moisture hasn't had all day to accumulate. Take several pictures of the rising or setting sun, because the sky colors and lighting change rapidly, greatly affecting mood. Look for water to add a mirror-like reflection that makes the sky seem encompassing.

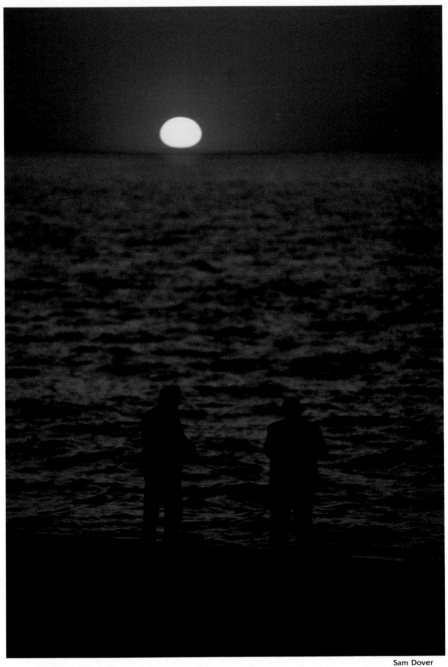

Sam Dover

Just as including the sun when metering a sunset can cause underexposure, so including a dark foreground when metering can cause overexposure.

Bob Clemens

Since flash is a convenient, portable light source, it's excellent for important away-from-home events.

# FLASH PHOTOGRAPHY

With your 35 mm camera and an accessory (or built-in) electronic flash unit, you can take flash pictures indoors just about as easily as you take pictures in daylight. And as you'll see, you can also use your flash to improve the quality of your outdoor pictures, as well as to create special effects both indoors and out.

# ELECTRONIC FLASH

An electronic flash unit is convenient to use because it allows you to take a little slice of daylight with you wherever you go. A single set of batteries will provide hundreds of exposures. Also, because the light from electronic flash is similar to daylight, you don't have to worry about color balance as long as you're using daylight films. As an added bonus, the burst of light from electronic flash is brief enough to halt almost any subject or camera motion.

There are three basic types of electronic flash units: manual, automatic, and dedicated. These three types of flash units differ from one another mainly in the way that they (or you) determine exposure. With **manual** flash units, you determine the proper lens opening for your camera based on the guide number for your flash unit (see page 107) and the film you're using, or from a calculator dial on the flash. Manual units are slower to use because each time you change flash-to-subject distance, you must also change your lens aperture.

**Automatic** flash units have a light sensor that measures the light reflected by the subject from the flash and automatically controls the duration of the flash to produce the correct exposure.

Although built-in flash units are now common on SLR cameras, the extra power of an accessory flash gives you more options in setting f/stops and using different flash techniques.

You determine the aperture by using a calculator dial on the flash unit. Within a given distance range, the flash unit will provide accurate exposure even if you change your flash-to-subject distance.

**Dedicated** flash units, the most complex technologically, are the easiest to use. They also offer the most flexibility. Dedicated units automatically set your camera to the correct sync shutter speed and lens aperture, and then control exposure by regulating the amount of light the flash emits. These flash units measure the light with sensor on the unit or through the lens (TTL) by using the camera metering system. Many TTL units read the amount of light reflected off the film plane (called OTF flash) and automatically control the flash duration. For more about dedicated flash, see page 105.

# FLASH SYNCHRONIZATION

The camera shutter speed that you use with a manual or automatic flash unit is very important. While the duration of the flash is extremely brief (usually measured in thousandths of a second), the burst of light must occur when the shutter is fully open; otherwise the shutter curtain may obscure part of the image (see illustration). This timing between electronic flash and shutter is called **flash synchronization** or X sync.

Cameras with leaf shutters sync at all shutter speeds. Cameras with focal-plane shutters (nearly all SLR cameras) sync only at certain speeds. Although your main concern with shutter speed is synchronization, different shutter speeds can affect the appearance and exposure of your flash pictures in other ways; for more on this, see "Shutter Speed for Flash Pictures," page 112.

## CAMERAS WITH FOCAL-PLANE SHUTTERS

Almost all modern 35 mm SLR cameras have focal-plane shutters. The typical synchronized shutter speed is 1/60, 1/125, or 1/250 second. If your camera has a shutter-speed dial, this speed is usually marked in red on the dial. If you have an older camera that has a switch with a choice of X sync or M sync (M Sync is used for flashbulbs) or a choice of X- or M-sync-cord sockets, use the X-sync setting or socket with electronic flash.

The focal-plane shutter will be fully open to expose the film only at the specified shutter speed or slower shutter speeds. At faster speeds, the shutter curtain forms a moving slit. If you set a faster shutter speed, light from the flash will expose only the band of film uncovered by the slit at the moment the flash fires, and most of the scene will be cut off. One camera manufacturer has gotten around the sync problem with focal-plane shutters by modifying the flash unit to emit light during the full time the shutter (at any speed) is moving.

Barbara Jean

If you set the shutter for a speed that's too high with a focal-plane shutter and electronic flash, the camera will not synchronize properly and you'll get only a partial picture. Most cameras with focal-plane shutters are designed to synchronize at 1/60 second, or 1/90 or 1/125 second, or slower depending on the camera. See your camera manual.

Most single-lens reflex cameras have *focal-plane shutters*. This kind of shutter consists of fabric curtains or metal blades placed behind the lens and as close as possible to the focal, or film, plane. When the shutter is closed you can see it covering the picture area directly in front of where the film will be exposed. With the shutter closed, you cannot see the camera lens from the back of the camera. Since the focal-plane curtain is a delicate mechanism, do not touch it with your fingers.

Putting your focal-plane camera and flash in sync is simple: If your camera is equipped with a hot shoe,* all you have to do is attach the flash and set the shutter speed dial to the proper sync speed. If your camera doesn't have a hot shoe or if you're using the flash off-camera, you can use a sync cord to plug the flash into the X-sync socket.

## CAMERAS WITH BETWEEN-THE-LENS (LEAF) SHUTTERS

Some older cameras and many newer compact 35 mm cameras have shutters located between the elements of the lens. Cameras with this type of shutter will synchronize with electronic flash at virtually any shutter speed. The ability to synchronize flash at any shutter speed is particularly useful for controlling very bright or very dim ambient light or for balancing flash and available light—for example, when you use fill flash.

*A bracket on top of the camera to hold the flash. It's "hot" (nearly all are) if it has an electrical contact to complete a circuit with the flash unit.

Most rangefinder cameras have *between-the-lens shutters*. This kind of shutter has leaves (blades) located between the lens elements close to the aperture. Usually, you can see the camera lens from the back of the camera when the back is open.

## DEDICATED FLASH SYNC

With dedicated flash units and compatible cameras, the camera will automatically set the sync shutter speed when you attach the flash unit. Although the camera may be able to sync at several shutter speeds, most dedicated flash/camera combinations will automatically choose the fastest possible shutter speed so that light from the flash, and not the ambient light, exposes the film. When you want to record some ambient light, you can usually manually set any shutter speed in the sync range.

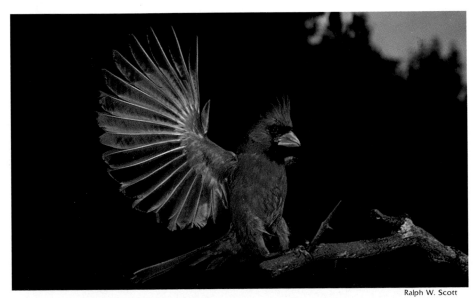

Ralph W. Scott

The very brief flash duration of an electronic flash unit is ideal for stopping action or catching a fleeting expression.

# FLASH EXPOSURE

## EXPOSURE WITH AN AUTOMATIC FLASH UNIT

An automatic unit uses a calculator dial to indicate the aperture that will give the correct exposure for the speed of the film and the flash-to-subject distance. Once you have set the aperture, a light sensor in the flash unit will automatically adjust the duration of the flash to provide correct exposure within a specified distance range—for example 3 to 15 feet. As long as you stay within that range, your pictures should be correctly exposed.

Some automatic units have a mode switch that enables you to choose from several apertures over different distances ranges. For example, the yellow mode may allow you to use $f/5.6$ over a distance range of 3 to 20 feet. A blue mode may allow you to use $f/8$ (for greater depth of field) over a distance range of 3 to 15 feet. Automatic units usually have a manual setting that lets you choose the best aperture for correct exposure in situations that might fool the automatic exposure system. Scenes that have large bright or dark areas, such as a white or dark brown wall, can trick the flash sensor. With large white areas, the automatic flash would underexpose (make the scene too dark), and with large dark areas, it would overexpose (make the scene too light). By setting the flash on manual, you disengage the sensor. But now you have to refer to the calculator dial and use the specific $f$-stop indicated for the flash-to-subject distance. As long as you are in the manual mode, you have to change the $f$-stop anytime you change the flash-to-subject distance.

The convenience of a built-in flash makes it very desirable.

With light and dark scenes, you could also remain in the automatic mode if you simply used an $f$-stop one stop larger for light scenes ($f/5.6$ if $f/8$ indicated) and one stop smaller for dark scenes ($f/11$ if $f/8$ indicated). The exposure should be correct as long as you remain within the recommended range for the mode you're using.

## EXPOSURE WITH A BUILT-IN FLASH

Many compact and some advanced SLR cameras have small electronic flash units built into them. In some cameras, the flash is hidden (in the prism housing, for instance) and pops up when activated; in others the flash is built into the face of the camera. Although quite convenient, these low-power flash units produce good results only within a rather short range (usually about 3 to 12 feet). You can use them as a main flash indoors or as a fill light outdoors.

Some cameras automatically turn on the flash in dim light. Other cameras flash an indicator or beep to tell you to switch on the flash. Typically, the flash begins charging as soon as its activated, and on most models, an indicator light in or near the viewfinder will tell you when the flash is fully charged. With all built-in-flash cameras, exposure is fully

automatic—measured either by an external sensor or inside the camera by a TTL or OTF metering system.

What do you do in dimly lit situations where you **don't** want the flash to fire automatically? One way to keep some pop-up flash units from firing is to hold your finger on top of it to prevent it from popping up. **Read your manual** first to make sure that this won't damage your camera. With face-mounted built-in flash units, you may be able to block the flash by holding your fingers (or a small piece of black cardboard) in front of the flash.

Cameras with built-in flash are particularly suited to outdoor fill flash work, and many are programmed to create an accurate exposure balance between flash and ambient light automatically. Some of these cameras will turn on the flash and automatically activate the fill flash whenever the foreground subject is significantly darker than the background.

In addition to supplying a ready source of light, built-in flashes on some cameras provide other helpful services. On auto-focus cameras, the built-in flash may have an auto-focus illuminator to help your lenses focus in low light. With SLR cameras that have both built-in flash and the capability of accepting an accessory flash unit, you may be able to use the built-in flash as part of a multi-flash setup. To take a group portrait, for example, you might use an accessory flash bounced off the ceiling as your main light, and use the built-in flash as a frontal fill light to open up shadows in faces.

Green mode: f/2, 6.6 to 60 ft

Yellow mode: f/4, 3.3 to 30 ft

Red mode: f/8, 1.6 to 15 ft

When set to automatic, this flash unit lets you choose from three modes. Each mode gives a different aperture you can use over a different distance range. In the green mode, you can use f/2 over a range of 6.6 to 60 feet. In the yellow mode, you can use f/4 over a range of 3.3 to 30 feet. In the red mode, you can use f/8 over a range of 1.6 to 15 feet.

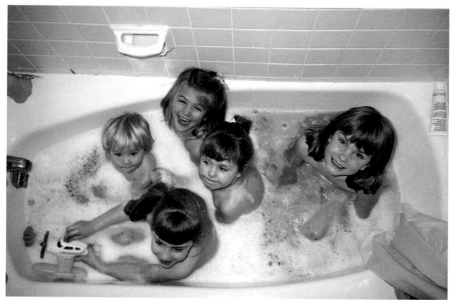

Pat Nelson

When the background is very light and at about the same distance as the subject, the automatic sensor may be fooled into underexposing the picture. For proper exposure, either use the flash on manual or increase the aperture by 1 stop or for dedicated units set the exposure compensation control to +1.

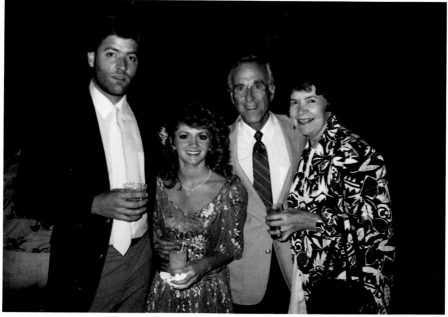

Neil Montanus

When you take a flash picture against a dark background, the flash sensor may put out too much light for the subject, thereby overexposing it. For this type of scene, you should override the automation by using the flash on manual, by compensating with a 1-stop smaller aperture, or by setting the exposure compensation control to −1 for a dedicated flash.

## EXPOSURE WITH A DEDICATED ELECTRONIC FLASH

Dedicated electronic flash units provide the most versatile flash available. The term **dedicated** comes from the fact that these units are brand-specific; that is, they are designed to be used with— or are dedicated to—a certain brand (and often a specific model) of camera. As mentioned earlier, many sophisticated dedicated models measure the intensity of the flash inside the camera as it reflects off the film (OTF) itself; a few simpler models measure light from a flash-mounted sensor.

While most dedicated flash units can be used as automatic (if they have a flash-mounted sensor) or as manual units with any other camera brand or model, they are truly dedicated only with a specific model of camera. Most dedicated equipment is made by camera manufacturers for their own cameras. Some universal dedicated flash units can be adapted to a variety of cameras with accessory modules, but most offer fewer features than a same-brand flash. Read your camera manual and talk to your photo dealer before attaching any dedicated flash other than one designated to be used with your camera.

Though they can handle complex tasks, dedicated flash units are extremely simple to use, because they'll make all the exposure decisions for you. Once you attach a dedicated flash to your camera, you are ready to start taking flash pictures. No calculations or complex tables are required. Through a series of electronic contacts and circuits, the flash and camera are able to relay information to one another almost instantaneously.

After you mount the flash on the camera and turn them both on, the camera tells the flash the speed of the film in the camera, and automatically

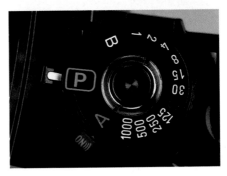

A dedicated flash unit works only with specific cameras. Contacts in the flash foot complete circuits with identical contacts in the camera hot shoe. To use a camera in the dedicated flash mode, you may have to set the camera to "P" (program) or "A" (automatic). Other cameras set the dedicated mode automatically when you attach the flash to the camera.

sets the proper shutter speed for flash sync. If you're using a camera with a programmed exposure mode, the camera also sets the lens aperture automatically. After you press the shutter button, the flash fires and the camera measures illumination at the film plane; when the film has received enough light for proper exposure, the camera turns the flash off. All of this happens in microseconds after you press the shutter button.

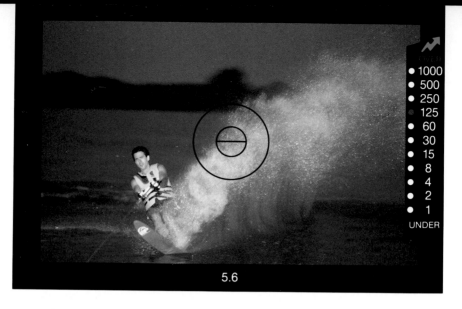

1000
500
250
125
60
30
15
8
4
2
1
UNDER

5.6

The camera viewfinder provides flash exposure information, including the need for a flash unit and whether the flash has correctly exposed the subject.

With most dedicated flash/camera combinations, the settings chosen by the camera are displayed in the viewfinder, and sometimes on an LCD panel on the back of the flash. If you want a different aperture (to control depth of field, for example) or a slower shutter speed (to record a dimly lit background), you can usually switch to an aperture- or shutter-priority flash mode. If proper flash exposure with the aperture/shutter speed combination you have chosen is not possible, the flash and/or viewfinder will display a warning—usually by flashing the aperture or shutter speed or both. Some cameras with matrix-light metering will know if the background is unusually dim (at twilight, for instance) or bright (a white-sand beach) and set the exposure accordingly    using camera controls to expose for the background and flash duration to light the main subject.

Other helpful displays in the viewfinder of a dedicated camera are a flash "ready" light to tell you that the flash is fully charged, and a sufficient-light indicator to tell you that the flash has provided adequate lighting. Units with an LCD panel may also provide you with a maximum distance (or the near/far range) for the aperture you select. This is a particularly useful feature, since it tells you **beforehand** if the aperture you're using will provide sufficient light at your working distance.

Another benefit of using an OTF dedicated flash is that the amount of light is being measured **behind** the lens; this means that you don't have to make any special calculations when you use extension tubes or bellows for close-up work, or place colored filters over the flash or camera lens. And since dedicated cameras measure light at or near the film plane, you can use the flash in a bounce or off-camera mode and still get good exposure automatically.

Dedicated flash units for some auto-focus cameras have auto-focus "illuminators" that enable the camera to focus in very dim—or even totally dark—situations. By projecting a visible near-infrared grid of red light on the subject (usually when the shutter button is partially depressed), the flash provides the camera with sufficient contrast for accurate focusing. In any flash situation, the camera may adjust flash power or aperture based on distance information provided by an auto-focus lens.

The options and possibilities offered by dedicated flash are many and useful; take the time to study your manual fully to get the best results from your flash.

## EXPOSURE WITH A MANUAL FLASH UNIT

Even though only a few manual flash units are being sold today, the ability to figure exposure with a manual flash unit (or an auto or dedicated unit in the manual mode) can be very useful. In extreme close-up photography and outdoor flash-fill photography, for example, you may be faced with situations in which manual flash exposure would provide more accurate and predictable results. The same is true of subjects that might fool an auto-flash sensor—such as a particularly dark or light subject.

To determine the correct lens opening for proper exposure with a manual flash unit, you need to know the light output of the electronic flash unit you're using, the speed of the film you're using, and your distance from your subject—and how to calculate these factors.

Most manual (and some auto) flash units, have a dial that will perform calculations for you—simply set the speed of the film you're using and read the correct aperture opposite the flash-to-subject distance. If your flash unit doesn't have a calculator dial, you need to use a guide number for your calculations. A guide number lumps all these variables into one easy-to-use number for each combination of flash power and film speed. Guide numbers are easy to use and are usually provided in the flash manual.

To figure the correct exposure with a manual flash unit, simply divide the guide number for your film/flash combination) by the flash-to-subject distance in feet. (If your flash is camera mounted, you can simply read the subject distance from the focusing scale on the lens barrel.) The result is the lens opening to use. Here's how the formula looks:

$$\frac{\text{Guide Number}}{\text{Distance in Feet}} = \text{Lens Opening}$$

For example, if the guide number is 110 and the subject is 10 feet away, the correct lens opening is $f/11$. When the calculated lens opening is one that's not marked on the $f$/number scale of your camera lens, just use the nearest one that is marked or a point halfway between the two nearest ones. Of course, if you have a metric guide number, you would divide by the distance in metres to obtain the $f$/number.

If you know the guide number for only one film speed, you can calculate it for others by using this formula.

$$GN_2 = GN_1 \left( \sqrt{(ISO_2/ISO_1)} \right)$$

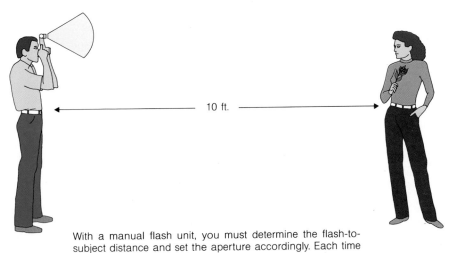

10 ft.

With a manual flash unit, you must determine the flash-to-subject distance and set the aperture accordingly. Each time that distance changes, you must set a new aperture.

# TESTING YOUR FLASH UNIT

Although most modern flash units give reasonably accurate results, you can easily test your unit and adjust exposure if it's off the mark. Here's how:

1. Use a slide film, such as EKTACHROME 100 HC Film, to make it easier to evaluate the results.
2. Mount the flash on the camera and place your subject 10 feet from the camera.

## Manual and Automatic Flash Units

3. Set the film speed on the flash calculator dial.

Auto flash units only: Choose the mode setting (not offered on all flash units) on the flash. Choose a setting in which 10 feet falls roughly halfway between the minimum and maximum distances of the flash range.

4. On a medium-tone (not white) card, write the following information:
   a. Film speed
   b. Lens aperture
   c. Flash-to-subject distance
   d. Mode (sensor) setting—auto flash units only
5. Set the flash aperture recommended by the calculator dial. If the flash lacks a calculator dial, divide the guide number by 10 to obtain the aperture. On the card, write a big "R" for recommended.
6. Turn on the flash and set the flash sync speed. Wait several seconds after the ready light glows before taking the first picture.
7. Take the first test shot.
8. Take additional test shots with the lens aperture set to give $1/2$ stop, 1 stop, and $1 1/2$ stops more exposure. For each test shot, write the aperture you used on the card in the scene. Be sure to wait several seconds after the ready light glows before taking each test picture.
9. Repeat step 9, but take test pictures with the aperture set to give $1/2$ stop, 1 stop, and $1 1/2$ stops less exposure.

## Dedicated Flash Units*

3. On a medium-tone (not white) card, write the following information:
   a. Film speed
   b. Lens aperture
   c. Flash-to-subject distance
   d. Exposure-compensation setting $(0, +1/2, -1/2, etc)$
4. Set the film speed on the flash calculator dial if the flash has one.
5. Turn on the flash and the camera. The camera should automatically set the shutter speed and may even set the film speed, depending on the model. Wait several seconds after the ready light glows before taking the first test picture.
6. On the card for the first test shot, write a big "R" for recommended because the camera will automatically set the aperture. Also write "exposure comp. = 0" to indicate you did not alter the exposure compensation control.
7. Take the first test shot.
8. Without changing anything else, take additional test shots with the exposure-compensation control set to give $1/2$ stop, 1 stop, and $1 1/2$ stops more exposure. For each test shot, write the exposure compensation on the card placed in the scene. Be sure to wait several seconds after the ready light glows before taking each test picture.
9. Repeat step 8, but take test pictures with the exposure-compensation control set to give $1/2$ stop, 1 stop, and $1 1/2$ stops less exposure.

*If the light sensor of your dedicated flash is mounted on the unit, follow the procedure for automatic and manual units.

Have the film processed and evaluate the results. Does the slide with the recommended exposure give the best results? If not, adjust the exposure according to the slide that gives the best results. For example, if the slide with an extra stop of exposure (*f*/5.6 instead of *f*/8) looks best, in the future use 1 stop more exposure than recommended by the calculator dial or guide number. Or for a dedicated flash, set the exposure-compensation control to give 1 stop more exposure; be sure to reset it to normal when you take non-flash pictures.

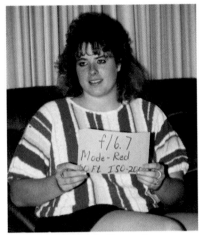

Correctly Exposed

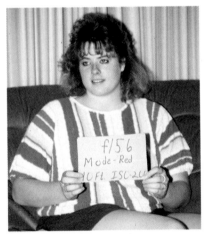

Overexposed

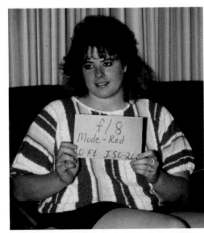

Underexposed

Underexposed

Jean Leavy-Ells

Marty Czamanske

With most manual and automatic flash units, you can easily determine the correct lens opening by referring to a calculator on the flash unit.

## TAKING THE PICTURE WITH A MANUAL FLASH

1. Mount the flash on the camera's hot shoe. Or if you are using off-camera flash, connect the flash to the camera with a sync cord.
2. Set the speed of your film on the flash calculator dial. If the flash has no dial, look in your instruction booklet for the proper guide number for the film you're using.
3. If you are using an automatic or dedicated flash in the manual mode, set the flash to "manual."
4. Set the shutter speed at the fastest available sync speed, usually 1/60 or 1/125 second. If you are using an automatic programmed camera, also be sure to set the camera on manual and then set the shutter speed.

5. Focus on your main subject and read the distance opposite the index mark on the lens barrel.
6. Find this distance on the flash calculator dial and set your camera lens to the aperture indicated on the dial. Again, if there is no dial, you can figure the correct aperture by dividing the distance of your subject into the flash guide number.
7. Turn the flash on and wait for the ready light to glow.
8. Take the picture. Manual flash uses a lot of power, so recharging will take longer than with an automatic flash. However, if the flash takes an unusually long time to charge between shots (more than 12 to 15 seconds), install fresh batteries.

## TAKING THE PICTURE WITH AN AUTOMATIC FLASH

1. Mount the flash on the camera's hot shoe, or connect it to the camera with a sync cord if you're holding the flash off-camera.
2. Set the film speed on the flash calculator dial.
3. Set the fastest available sync speed on the shutter-speed dial, usually 1/60 or 1/125 second. The fastest sync speed is usually marked in red on the dial. If you are using an auto-exposure camera, **don't** set the camera to automatic because the camera and flash may be out of sync—set it to the sync shutter speed.
4. Focus on your main subject and read the distance opposite the index mark on the lens barrel.
5. Find this distance on the flash calculator dial and set the lens to the aperture indicated on the dial. Many auto-flash units offer a choice of several aperture/mode combinations; at any given distance, you may have a choice of four or more shooting apertures. To find out which apertures you can use at a given distance, see your flash manual. Each different aperture/mode pairing is usually color-coded to a mode-selector dial.
6. Turn the flash on and wait for the ready light to glow.
7. Take the picture. If your flash has a sufficient-light indicator, check to see that it has lit. If it hasn't, be sure that you are working within the distance range that applies to that aperture.

   When you are using the flash in a bounce mode and you don't get a sufficient-light indication, you may have to use the next larger aperture/mode combination—even if you're within the correct working distance. This is because the bounce surface absorbs and scatters much of the light from the flash. Or you can move closer to your subject.

## TAKING THE PICTURE WITH A DEDICATED FLASH

1. Mount the flash on the camera's hot shoe.
2. Set the film speed on the camera and on the flash if it has a film-speed dial. Some cameras will read the DX code and set the film speed for both the camera and the flash.
3. If you are working in the full program mode, set the flash to the TTL (through-the-lens) or OTF (off-the-film) mode.
4. Set the camera mode selector to "P" (program) mode or the equivalent mode on your camera (see your manual). The camera will automatically set the proper sync speed and aperture. As you move around a subject and the ambient light changes, the camera may also change the aperture. On some cameras, you may have to set the aperture ring to the "A" position or the smallest aperture for programmed operation.
5. If your camera has an LCD panel or printed scale that tells you the working distance range for the aperture it has chosen, be sure that you remain within that distance, or check your instruction booklet for flash-to-subject limits. If your dedicated flash unit has the light sensor on the unit (non-TTL), you may have to set the aperture yourself. To do this, follow the instructions for choosing an aperture for automatic flash.
6. Turn the flash on and wait for the ready light to glow.
7. Take the picture.
8. Most dedicated cameras have a sufficient-light indicator in the viewfinder that will light if the subject has received adequate light. If it doesn't light, check to see that the flash and camera are in the proper modes and that you are within the required distance range.

Sam Dover

One of the most important steps when using a manual or automatic flash, is to set the correct shutter speed so that the entire picture area is included. By using a slow shutter speed and a flash with a fast-moving subject, you can create unusual effects. Here the camera was panned with a shutter speed of ⅛ second.

## SHUTTER SPEED FOR FLASH PICTURES

Because the duration of electronic flash is so brief, the camera shutter stays open for a period longer than the flash duration—even leaf-type shutters at high shutter speeds. As a result, the shutter lets all of the light from the electronic flash pass through the lens regardless of shutter speed. Consequently, changing the shutter speed with electronic flash does not affect the exposure for a main subject illuminated mainly by flash. Different shutter speeds can, however, alter the appearance of the scene. In some situations you may want background light to register; in others, you will want to use shutter speed to subdue it.

When you want to minimize the background light, use the fastest sync speed possible (such as 1/125 or 1/250 second). You might want to control background light in this way, for example, if you're using daylight film and the background lights are tungsten (giving an orange cast to the background). A fast shutter speed is also useful with fill-flash. Use a fast shutter speed to get proper exposure for a bright background when you want to use a relatively large lens aperture—to use selective focus in an outdoor portrait, for instance. Also, if there is strong light present when you are photographing action with electronic flash, use a shutter speed fast enough to stop the action or you will get a "ghosting" effect from the moving subject.

If stopping action is not a problem and if dimly lit background detail is important, use a slower shutter speed, such as 1/30 second. For example, if you are photographing a person on a beach at twilight, and want to use flash to illuminate your subject and still record the colors of the sky, a slow shutter speed would be the answer. As mentioned earlier, some auto and dedicated units will provide this background/subject balance automatically. If you use speeds slower than 1/30 second, remember to use a tripod.

112

# VARIETY IN FLASH LIGHTING

The simplest and fastest way to take flash pictures is with the flash mounted on the camera. However, if you want to take flash pictures that appear more professional, you may want to try the special flash techniques that follow.

## BOUNCE FLASH

With this technique you aim the flash at a ceiling or wall and bounce the light back onto your subject. This produces gentle, even lighting similar to that found outdoors on an overcast day. Bounce flash is especially useful for large interiors or group portraits, because you can light a large area more subtly than with direct flash. With color film, be sure to aim the flash at a white or near-white ceiling or wall. Otherwise your subject may pick up a color cast from the reflecting surface. White is also an efficient reflector of light.

Flash units designed for bounce flash can usually be tilted or swiveled to let you bounce flash off a ceiling for both vertical and horizontal pictures. Units with lateral swivel can also be aimed at a wall. If your flash has no built-in bounce capability, you can probably purchase a special bracket that will allow you to position the flash in any direction.

When you use any camera-mounted automatic flash unit (or a dedicated flash with a flash-mounted sensor) for bounce lighting, the light sensor of the flash must always be aimed at your subject to determine exposure correctly. Exposure for bounce flash with a dedicated camera and flash combination that uses a TTL or OTF metering system is completely automatic and accurate in almost all situations, since the light is being measured inside the camera.

Remember that even though your flash will figure bounce exposure automatically, just as it would for on-camera-flash picture, the maximum flash-to-subject distance recommended by the flash manufacturer is intended for **direct** flash only. With bounce flash, you lose about 50-percent efficiency. To avoid underexposure with bounce flash, be sure that the **flash-to-ceiling-to-subject** distance is less than half the maximum recommended flash distance for the aperture you're using. Check the maximum distance on your flash calculator dial.

If your automatic flash unit (or dedicated camera/flash) has a sufficient-light indicator, it will help you determine if your exposure for bounce flash is okay. With some units, you can test for sufficient light without actually taking a picture. To use this feature, you fire the flash without taking a picture and watch the indicator light to see if there is enough light from the flash. Most flash

To take bounce-flash pictures, aim your flash upward. The light will bounce off the ceiling and onto your subject. For color pictures, the ceiling should be white or near-white to avoid an overall color cast.

units have a button for firing the flash independently of the camera. If there's not enough light, you will have to use a larger lens opening, move closer to your subject, or use a faster film.

If you are using an automatic flash unit that has no tilt or swivel capability, the only way to use it for bounce is to take it off the camera and aim the whole unit at your bounce surface. However, because the exposure sensor will be aimed in the same direction as the flash (at the bounce surface and not the subject), it will read the light reflecting from that surface and not the subject—producing the wrong exposure. The only solution is to switch the flash unit to manual.

To determine exposure for bounce flash manually, first find the **total** distance from the flash to the bounce surface and from the bounce surface to your subject. Find the aperture that corresponds to this distance on the flash calculator dial; then set an aperture 1½ to 2 stops larger than the aperture on the dial. For example, if the dial recommends $f/8$, use $f/4$.

If the flash doesn't have a calculator dial, divide the guide number by the total distance. Then use a lens opening 1½ to 2 stops larger than the $f$-number calculated from the guide number. Exposure also is affected by the size and color of the room.

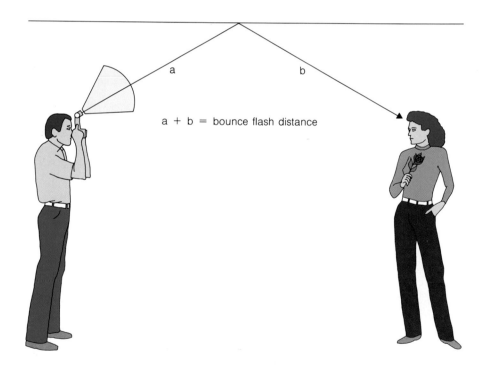

a + b = bounce flash distance

To calculate exposure for bounce flash with a manual or automatic unit, determine the total distance the light travels: from flash to ceiling to subject.

Direct flash

Bounce flash

The soft light of bounce flash eliminates harsh shadows and glaring high-lights. Use a fast film, such as KODACOLOR GOLD 400 Film, so you can make up for light absorbed by the bounce surface.

## OFF-CAMERA FLASH

Although on-camera flash produces well-exposed pictures, its flat frontlighting makes subjects seem one-dimensional. Off-camera flash makes subjects look three-dimensional. It also creates interesting highlights and shadows on your subject. People will appear more realistic when facial texture and forms are revealed. By placing off-camera flash at a high angle, you can separate subjects from their surroundings and subdue distracting background shadows that head-on flash often causes.

To use your flash off the camera, you'll need a long flash synchronization cord (also called a "PC" cord). Now you can hold the flash in one hand and the camera in the other. Don't worry if you're slightly wobbly in holding the camera. The flash will freeze camera motion. You can also mount the flash on a light stand or have a helper hold it. Make sure to set the aperture for the flash-to-subject distance and to aim the flash sensor at the subject. A special sync cord with a remote auto-sensor that fits in the camera's hot shoe is available for some flash units. Once aimed at the subject, the flash sensor will provide correct exposure no matter where you hold or aim the flash.

With a dedicated flash unit, you will need to use an extension cord specifically dedicated to your camera/flash combination that attaches to the camera's hot shoe. This cord carries information between camera and flash so that both units can carry on their elec-

You can take off-camera flash pictures by holding the flash above and to one side of the camera with one hand while holding the camera and snapping the picture with the other hand.

tronic conversation. Dedicated flash/camera combinations with TTL/OTF metering are especially accurate for off-camera use because the light is always being measured at the film plane.

Of course, you can also use a manual flash off camera (or an automatic or dedicated flash set to manual), but you will have to calculate your exposure differently. Instead of dividing the guide number by the distance from the camera to the subject (as you would with a camera-mounted flash) to get your working aperture, you must divide the guide number by the distance from the **flash to the subject**. You may have to adjust the aperture slightly for very dark or light subjects.

With the flash off the camera, you can easily create sidelighting to bring out your subject's features.

**Herb Jones**

Flash at Angle

Flash Head-on

Shooting flash head-on in a scene that includes a mirror, paneling, metal cabinets, or other shiny material, will cause a glare reflection of the flash. To minimize this reflection, use a flash extension cord and hold the flash off to one side as you aim it at the subject.

## FILL-IN FLASH

When subjects are in bright sunlight, deep shadows often obscure important details. You can lighten these shadows to reveal detail by using your flash. This is called fill flash.

Fill flash is particularly useful for lightening shadows on faces. As a bonus, when you're using fill flash with people, you can turn your subjects away from the sun so that they don't have to squint. The rim lighting created by the sun in backlit portraits also gives a pretty glow to hair and helps separate your subjects from distracting surroundings.

For best results, use a low- or medium-speed film so that the camera can provide a good balance between sunlight and flash exposure. KODAK EKTAR 25 and 125 Films and KODACOLOR GOLD 100 and 200 Films are all good choices.

The ideal fill-flash exposure gives your subject about one stop **less** exposure than the background receives. This opens the shadows sufficiently to reveal detail as it maintains a natural appearance. If you give the main subject the same exposure as the background, the picture tends to look artificially lit.

You can create fill flash with dedicated, automatic, or manual flash units. An automatic flash unit will be much easier to use, however, if you have a choice of several flash modes to choose from.

By far the simplest method of creating flash fill is with a dedicated flash/camera combination that has automatic fill-flash capability. The advent of dedicated flash/camera combinations with TTL or OTF metering, particularly those cameras with matrix OTF metering systems, has all but eliminated the need to calculate exposure for fill-flash pictures.

These systems are programmed to provide proper exposure for the background and automatically fill the main subject with about one stop less light. A few sophisticated dedicated SLR camera/flash combinations even allow you to manipulate this subject-to-background lighting ratio with a switch.

In any case, using a programmed camera with OTF metering and automatic fill may require no more than attaching the flash to the camera. The camera will measure the ambient light and supply the correct amount of flash to fill your main subject. If the camera also has auto-focus, it may even use the distance information from the lens to help calculate the amount of fill required. As you move closer or farther from the subject, the camera will adjust the aperture and/or the amount of fill accordingly. Also, if you want to maintain a constant aperture (e.g., for depth-of-field), some cameras let you use an aperture-priority mode and still get correct fill flash.

Review your equipment manuals to learn how to use fill-flash with your camera and flash.

One caution: If you are using a compact or SLR camera with a built-in flash, be aware that cameras that offer "automatic flash" may not offer "automatic fill flash." The difference is that the former will provide adequate flash exposure for the subject, but it will provide equal exposure for subject and background. Cameras that offer automatic fill will automatically create a more natural-looking brightness relationship between subject and background. Still, using a camera with automatic flash in contrasty situations is better than using no flash at all.

Calculating correct exposure with an automatic or a manual flash unit (or an automatic used in the manual mode) is a little more time-consuming, but can be reduced to a series of easy-to-follow steps. With either type of flash, the basic principle is to set the lens aperture for the ambient light and then use the flash to create light that is one-half to one-fourth as bright as the ambient light.

First take a meter reading of the bright ambient light. To do this, set the camera shutter-speed dial to the fastest sync speed available, and then set the lens aperture as the meter indicates. In the manual mode, after making your initial reading of the ambient light, you can control the amount of fill light by altering the flash-to-subject distance; see the step-by-step procedure on the next page. With an automatic flash unit, you manipulate the amount of fill flash by choosing a mode that matches the amount of fill you want to use.

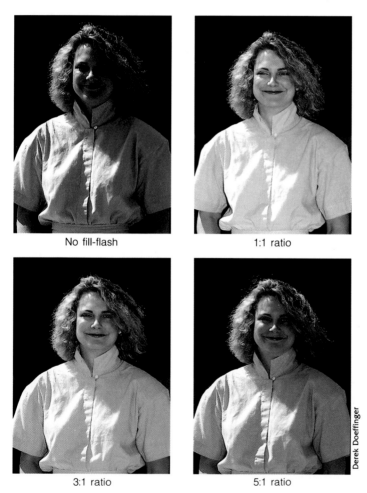

No fill-flash

1:1 ratio

3:1 ratio

5:1 ratio

Derek Doeffinger

Shot outdoors in front of a shadowed wall, this series shows how the ratio of sunlight to fill-light affects appearance. When the fill-flash equals the brightness of the sunlight (1:1), the result is unnatural. But when the amount of fill-flash is less than the sunlight (3:1 and 5:1 ratios), the effect is more attractive.

### Fill-Flash With a Manual Unit

1. Mount the flash on the camera's hot shoe, and if you are using an automatic flash, set the unit on manual.
2. Set the film speed on the flash calculator dial.
3. Set the fastest sync shutter speed.
4. Take a meter reading of the sunlit area and set the lens at the indicated aperture.
5. On the flash dial find the aperture that is **1 stop larger** *than the meter reading indicated in step 4* (for example, if you set the lens at $f/11$, find $f/8$ on the calculator dial). Read the distance indicated opposite this aperture. This is the correct flash-to-subject distance for fill flash that is 1 stop **less** bright than the sunlit area (3:1 lighting ratio). Move to this distance to shoot your picture (or take the flash off camera and move **it** to that distance). If you want a stronger fill (equal to the ambient light), you can simply shoot from the distance opposite the $f$-stop that you set on your lens. For a weaker fill, move the flash farther away from the subject. Use a zoom lens to adjust image size once you are at the proper distance.
6. Turn on the flash unit, and shoot the picture when the ready light glows.

### Fill-Flash With an Automatic Unit

1. Mount the flash on the camera's hot shoe and set the film speed on the flash calculator dial.
2. Set the fastest sync shutter speed.
3. Take a meter reading of the sunlit area and set the lens to the indicated aperture.
4. Set the flash mode switch. Look at the flash calculator dial and find the mode corresponding to the aperture 1 stop larger than that set on the lens (for example, if $f/11$ is set on the lens, set the mode that corresponds to $f/8$). This will give you a pleasing 3:1 lighting ratio. You could also make the fill 2 stops dimmer (5:1 lighting ratio) than the ambient light by using a mode that requires **2 more** stops than the aperture set on the lens ($f/5.6$ if lens is set to $f/11$). If there is no flash mode to match the aperture your meter has chosen, switch your shutter speed/aperture combination to one that uses a shutter speed that's 1 speed slower; then look to see if there is a mode that matches the corresponding new aperture. This will give you the same ambient-light exposure, but will allow you to work within the allowable aperture range for the flash.
5. Turn on the flash unit and shoot the picture when the ready light glows.

**NOTE:** The light sensor on most automatic flashes will be affected only by the flash reflecting from your subject not by the ambient light. However, in situations where there is very bright light spilling around the edges of your subject and falling directly onto the flash, it may give the flash false readings. One answer is move your subject so that the excess light is not hitting the flash directly. With automatic-flash it's important to experiment with your flash in different situations and see how it performs; see your flash manual for specific instructions.

Neil Montanus

Fill flash lightens the dark shadows created by bright sidelighting to produce a pleasing portrait. This photo was made on KODAK EKTAR 25 Film, the world's sharpest 35 mm color negative film.

Norm Kerr

Check your flash equipment in advance to see if the batteries need to be replaced or recharged so that you're not disappointed when you're ready to take flash pictures.

If there are deposits on the equipment or battery contacts, even brand-new batteries won't fire the flash. To prevent this type of flash failure, clean the battery ends and equipment contacts with a rough cloth. If the battery compartment in the flash unit is small, wrap the cloth over the end of a pencil eraser to clean the contacts. Clean the contacts even if they look clean, because some deposits are invisible.

To prevent flash failure, keep all electrical contacts clean. Take a rough cloth and rub the ends of your batteries and the contacts within the flash unit battery compartment.

## PREVENTING FLASH FAILURE

The most frequent causes of flash failure are weak batteries and battery or equipment contacts that need cleaning. With electronic flash units, when the time required for the ready light to come on becomes excessive—about 30 seconds or longer—or it doesn't come on at all, it usually means the batteries are weak and need to be replaced or recharged, depending on the kind of batteries. See your flash equipment manual.

Be sure to use the type and size of battery recommended for your flash equipment. Alkaline batteries such as KODAK PHOTOLIFE™ Batteries have a long life and a short recuperation time. They are generally recommended for electronic flash units. Nickel-cadmium batteries are rechargeable and are recommended for use in many electronic flash units. See your flash instruction manual for the kind of battery recommended for your flash unit.

When you're not going to use your flash unit for a period of time, remove the batteries to prevent possible corrosion of the contacts in the unit.

Check the fittings between the flash and the camera to see that they remain tight. If your flash connects to your camera with a flash cord, make sure any press-on adapters are tight. Also, a break in the cord will prevent the flash from firing. You can often detect an internal break in the cord by wiggling the cord. When momentary contact is made, the flash will fire. When you detect such a break, replace the cord.

# CAUSES OF LIGHT LOSS WITH ELECTRONIC FLASH

## RECYCLING TIME

After you have fired an electronic flash unit, it takes several seconds for the condensers in the unit to recharge. Most electronic flash units have a ready light that comes on after about 10 seconds, depending on the unit, to indicate that the unit is ready to flash. But at this point you may get only about 65 percent of the total light output because the ready light does not necessarily indicate when the condensers in the unit are *fully* charged. Recycling time for full light output varies in practice and depends on the electronic components in the unit, type and condition of batteries, and other factors. An automatic flash unit with an energy-saving circuit, called a thyristor circuit, will recharge more quickly on automatic than a unit without this circuit. An ac-powered unit may recharge faster than a battery-powered unit.

You will get more consistent photographic results if you wait until your flash unit has recycled completely before taking the next picture. After the ready light comes on, wait a few seconds before firing the flash. Or to be on the safe side, allow at least 30 seconds between flashes, because it may take that long for the condensers in some units to recharge fully. If necessary, you can take pictures more rapidly than this, but you may not get full light output from your flash unit. This can cause underexposed pictures, depending on the exposure latitude of the film you are using.

## WEAK BATTERIES

As the batteries in your flash unit lose power with use and age, the recycling time increases. When the battery power drops below the required level, the unit will lose light output even though it may still flash. Replace or recharge the batteries whenever the recycling time becomes excessive. Also, remember that it's important to keep the battery and flash contacts clean by wiping them with a rough cloth.

## DE-FORMING OF CONDENSERS

Another factor which can weaken batteries and cause a loss of light output is the tendency of the condensers in an electronic flash unit to de-form after a month or so of inactivity. When this happens it will take an extra-long time to re-form the condensers and bring them back up to a full charge. This re-forming puts a considerable drain on the batteries. If you can use regular house current (ac) to power your unit, re-form the condensers by letting them recharge from the power line for an hour or so—and fire the flash a half dozen times—whenever the unit has been out of use for a few weeks. This helps your flash unit produce full light output.

Bob Clemens

This photo shows the "zoom" effect you get when you rapidly change focal lengths of a zoom lens during the exposure. To obtain such an effect, use a shutter speed of 1/8 second or slower. Focus at the longest focal length and as you press the shutter release, quickly pull on the zoom collar to change the focal lengths. Take several pictures at different shutter speeds and at different rates of changing the focal lengths to see which results you like best. Mount the camera on a tripod and use a slow film so you can obtain a slow shutter speed.

# LENSES

The ability of many 35 mm cameras to accept interchangeable lenses is one of the features that makes these cameras so versatile. Since the lens plays a vital role in determining what the camera can do for you, knowing how to take full advantage of the various lenses for your camera pays dividends in terms of better, more exciting pictures.

## ZOOM LENSES

Certainly the most popular lenses in use today are zoom lenses. Though early zooms suffered from the reputation of being heavy, awkward to use, and less sharp than fixed-focal-length lenses, today's zoom lenses are compact, easy to use, and sharp. Zoom lenses are available for both manual-focus and auto-focus cameras.

Zoom lenses offer you the flexibility of many different focal lengths along with the convenience of having to carry only one lens. For example, instead of carrying a wide-angle, a normal, and a telephoto lens, you could take along a single zoom lens with a range of 35 to 135 mm. Such a zoom not only replaces several fixed-focal-length lenses, but also offers you **all the focal lengths** that fall within that particular zoom range. Instead of having to decide between a normal and a telephoto lens, for instance, you could use a focal length anywhere between the two.

Equally enticing is that a zoom lens lets you fine-tune your compositions without having to change your shooting position. Instead of walking closer to or farther from your subject, you can remain in place and adjust the focal length to fit the composition you have in mind. With a wide-angle-to-telephoto zoom, for instance, you could take a group shot around the picnic table at a wide-angle setting and then zoom in close to take a full-frame portrait without taking a step.

Zoom lenses are available in a variety of focal-length ranges. Among the most common are those that cover a wide-angle-to-normal range (28 to 50 mm or 21 to 50 mm), a wide-angle-to-medium-telephoto range (35 to 105 mm or 35 to 135 mm), and a medium-telephoto-to-full-telephoto range (80 to 200 mm). The zoom lenses with the greatest ranges—28 to 210 mm and 50 to 300 mm, for example—tend to be heavier and less sharp than those with more moderate ranges. They're also more expensive. Their close-focusing distances may be as far as 10 feet.

If you are thinking of buying your first zoom, those in the wide-angle-to-medium-telephoto group (35 to 135 mm, for example) make a good choice; they offer a great range of focal lengths in a lightweight package and have relatively

The convenience and versatility of zoom lenses has made them popular with photographers. This 28 to 200 mm zoom lens could replace all the single-focal length lenses behind it.

fast maximum apertures. Also very useful are the medium-to-long-telephoto zooms (around 70 to 210 mm). They provide you with substantial telephoto capability, but still allow you to broaden the composition when necessary. Many zooms in this range also have macro capability, which lets you take close-ups of small objects.

Most zooms in use today are called "one touch" lenses. You focus the lens and change focal lengths by pushing or pulling on the focusing collar. A few zoom lenses are "two touch;" they have separate controls for focusing and zooming. Auto-focus zooms are available too, and they're even easier to use; they do the focusing and leave you to concentrate on adjusting the focal length to get the composition you want.

What are the disadvantages of zooms? Weight is one disadvantage (especially among longer telephoto zooms); zooms are heavier and bigger lenses. Flare is another; especially in backlit situations, zoom lenses may flare

noticeably, scattering light throughout the picture. But when you compare carrying one zoom lens to carrying several fixed-focal-length lenses, the zoom ends up being the lighter choice. Zooms also cost a bit more than fixed-focal-length lenes of similar focal lengths, but again, one zoom is cheaper than several fixed-focus lenses and considerably more flexible.

A more serious drawback of zoom lenses is that they are generally slower, i.e., they have smaller maximum apertures, than equivalent fixed-focal-length lenses. Also, most zooms have a variable maximum aperture that gets smaller (letting in less light) as you move toward the longer focal lengths of the lens. A 70 to 210 mm $f/4.5$-5.6 lens has a maximum aperture of $f/4.5$ at 70 mm, for example, but a maximum aperture of only $f/5.6$ at its longer focal lengths. The smaller aperture means slower shutter speeds, which can increase the likelihood of blur from camera shake or from moving subjects. Because it lets in less light, a smaller aperture makes focusing more difficult, too, particularly in low light levels.

Finally, remember that all of the information we're about to discuss for wide-angle and telephoto lenses also applies to zoom lenses that have wide-angle or telephoto focal lengths.

28 mm

100 mm

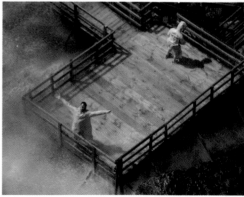

200 mm

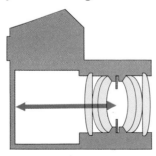

The focal length of a lens indicates its magnification rate. With a 50 mm lens rated at 1X, a 100 mm lens would magnify 2X and a 200 mm lens 4X. Except for zoom and telephoto lenses, the focal length is measured from the physical center of the lens to the film plane.

If you're on the brink of Niagara Falls, you won't be ab to move closer to get a larger image. Whenever chang ing viewpoint isn't practical, a zoom lens will prove vita A 28 to 200 mm zoom lens was used for this series.

Joy MacIntyre

A normal lens is also a good choice for informal photos of people. It provides sharp pictures, sufficient depth of field, and little distortion. For more formal portraits, use a moderate telephoto lens.

## NORMAL LENS

The normal lens is the one that comes with most 35 mm SLR cameras. Because it gives such natural-looking pictures, you'll probably use it more than any other lens. The normal lens receives its name because it provides a natural perspective and an angle of view similar to the central vision of the eye.

The focal length of the normal lens for most 35 mm cameras falls between 45 to 55 mm.

The focal length of a camera lens is the distance from the film plane of the camera to the center of the lens when the lens is focused on infinity.

The normal lenses on 35 mm cameras are usually fast, having maximum apertures of $f/2.8$, $f/2$, or as large as $f/1.2$. With today's fast films, a normal lens with a maximum aperture of about $f/1.8$ will usually suffice. You will pay much more to get a lens with a maximum aperture of $f/1.4$ or $f/1.2$. A lens with a large maximum aperture lets you handhold the camera to take pictures in dim light. Using a large aperture, such as $f/1.8$, also enables you to use high shutter speeds to stop action. However, the depth of field is quite shallow at such maximum apertures. Focus carefully. Otherwise you risk out-of-focus blur with all but distant subjects.

Bob Harris

The photographer used a 16 mm fisheye lens to make the ground and skyline bow in counterpoint to the curve of the St. Louis Arch.

## WIDE-ANGLE LENS

A wide-angle lens has a shorter focal length than the normal lens for the camera. A wide-angle lens takes in a greater angle of view than the normal lens. From any given spot a picture made with a wide-angle lens includes more than a picture made with the normal lens.

When do you use a wide-angle lens? Some of its uses are rather obvious. A wide-angle lens is helpful for taking pictures in places where space is limited. Without enough space, you just can't move back far enough to include everything you want with the normal lens. When you're photographing such subjects as all the in-laws around the Christmas tree at home or a brand-new

sports car on display at a crowded auto show, a wide-angle lens is a very handy item to have.

A wide-angle lens is often a good friend to have outdoors, too. When you take pictures in narrow city streets or crowded public markets or photograph sweeping scenic vistas, a wide-angle lens will let you get it all in when this isn't possible with the normal lens.

Another situation where a wide-angle lens may help you is in public places when people or other objects are between you and your subject. You may be able to eliminate them from the picture by using a wide-angle lens which allows you to move closer to your subject and frame the picture the way you want it.

© 1988, Kenneth E. Nelson

With a wide-angle lens, you can more easily include foreground subjects and emphasize the distance to the background. Here the photographer used a 28 mm lens set at f/11 to make both the foreground and background sharp. Notice how the rope unites the foreground and background by leading your eye directly to the ice climber.

Herb Jones

Here the photographer created a humorous picture by using a wide-angle lens to diminish the size of the person in relation to the boots.

A. Chastel/A. Courtois

When you are indoors, you can use a wide-angle lens to include nearly the entire room.

130

Enrique Miranda

The photographer creatively framed Toronto's CN Tower in a life preserver and kept both elements sharp by using a wide-angle lens at a small aperture.

## PERSPECTIVE CONTROL

Perspective is determined by camera-to-subject distance. Whether you have a normal, wide-angle, or telephoto lens, perspective is the same for all of them if the camera-to-subject distance remains the same. When you get close to a subject, as you might with a wide-angle lens, nearby objects look unusually large, and distant objects in the same picture look small and far away. This is because the distance between the near and far subjects is great compared to the distance from the camera to the near subject. The wide-angle lens exaggerates space relationships by expanding the apparent distance between nearby and distant objects. You'll increase the feeling of vastness in scenic pictures by using a wide-angle lens and including a nearby foreground object, such as a person, tree, or automobile, for size comparison.

For the same reason—exaggerated perspective—a close-up picture of a person's face made with a wide-angle lens gives the features a distorted appearance. The nose, since it is closer to the camera, looks bulbous, while the more distant ears look exceptionally small. If you use a wide-angle lens to take a picture of an automobile from a front angle, it will look especially long and sleek. A welcoming hand stretched toward a wide-angle lens looks as large as or larger than the head of the person offering the greeting.

When you use a wide-angle lens to photograph entire buildings or similar subjects with prominent parallel vertical lines, try not to tilt the camera up or down. If you do, the vertical lines will converge, or keystone, in your picture. While keystoning is usually undesirable, there may be times when you want to create this effect—to make a building look taller, for example, or to exaggerate perspective for creative composition.

131

Herb Jones

A wide-angle lens lets you include a large expanse of background to instill a photo with a sense of freedom.

## DEPTH OF FIELD

Photography with a wide-angle lens offers the bonus of increased depth of field. For example, with a 28 mm wide-angle lens on a 35 mm camera, if the lens is set at $f/11$ and is focused on a subject 10 feet away, *everything* from about 4½ feet to infinity will be in focus. In the same situation with a 50 mm lens, the depth of field would extend from about 7 feet to 17 feet.

Depth of field is actually the same for all lenses, no matter what their focal length, *if you adjust the subject distance to give the same image size.* For a particular camera and particular subject distance, however, we can say that depth of field increases as focal length decreases.

132

# TELEPHOTO LENS

A telephoto lens has a longer focal length than the normal camera lens. Technically, the term telephoto refers to a particular kind of optical arrangement that has a positive front element and a negative rear element. This allows the physical length of some telephoto lenses to be shorter than the focal length. However, it has become common practice to call any lens with a focal length that is longer than normal a telephoto lens, so that's what we do in this book.

Telephoto lenses do just the opposite of what wide-angle lenses do. They include a narrower angle of view than the normal lens, so they take in a smaller area of the scene. Consequently, distant subjects photographed through a telephoto lens appear closer than they do when photographed through a normal lens. A telephoto lens magnifies the image similarly to the view you see through binoculars or a telescope.

When do you use a telephoto lens? As a rule, you use a telephoto lens when you can't get as close to your subject as you'd like—for example, when you're photographing a baseball game, an alligator in Okefenokee Swamp, or a chalet perched on a distant hillside. You can't climb into a cage at the zoo to get a close-up of a lion or stand in the middle of the Hudson River to get a close-up of a luxury yacht, but a telephoto lens can produce a big image of such subjects by bringing them closer to you optically.

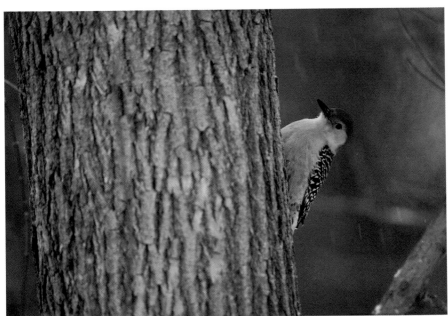

Richard Hamilton Smith

A telephoto lens is a required item for wildlife photography. By using a large aperture (f/4) with a 600 mm telephoto lens on a car window mount, the photographer was able to blur the background to emphasize the woodpecker.

## PERSPECTIVE AND COMPOSITION CONTROL

Like wide-angle lenses, telephoto lenses offer advantages that aren't so obvious, as well. For example, lenses in the 75 mm to 105 mm focal-length range are great for making head-and-shoulder portraits of people. You can be 6 or more feet from your subject and still get a nice-size head-and-shoulder image on the film with a moderate telephoto lens. This means that the nose-to-ears distance is very small in relation to the total subject distance, so the exaggerated perspective we mentioned in the section on wide-angle lenses doesn't exist. Being 6 or more feet from your subject also makes it easier to take pictures of people. You can move around your camera when it's on a tripod and your subject without stumbling over them.

We mentioned that wide-angle lenses expand distances. As you might suppose, telephoto lenses have the opposite effect—they compress distances. Distant objects look closer to each other than they actually are. You've probably seen extreme telephoto pictures of a large city or rows of buildings on a distant hillside. In such pictures, the distant subjects appear squashed together. This effect is caused by the very narrow angle of view, which eliminates from the picture all the nearby objects that help us judge distances.

Because a telephoto lens has a narrow angle of view, it can help eliminate distracting elements in the composition of a picture. If there is a water tower next to a picturesque country church, you can crop the tower out of the picture by using a telephoto lens with its narrower angle of view. The lens sees the church, but not the tower. In the same way, you can photograph between the heads of spectators at a sports event or parade.

Jim Franklin

A telephoto lens is ideal for panning because it allows you to choose a small, pleasing portion of the background that complements the subject. This shot was made with a 200 mm lens. Exposure was 1/125 second, f/8 on KODACHROME 64 Film.

Norm Kerr

With both manual and auto-focusing telephoto lenses, accurate focusing is important because of shallow depth of field. If possible, avoid a large aperture, such as f/3.5, and use a medium aperture such as f/8 to be sure of getting a sharp picture.

## DEPTH OF FIELD

Telephoto lenses have shallow depth of field. The longer the focal length of the lens, the more shallow the depth of field. This means that accurate focusing is much more important with telephoto lenses than with normal and wide-angle lenses.

As mentioned earlier, you can use shallow depth of field as a creative tool for throwing a distracting background out of focus or for de-emphasizing foreground objects, both of which help concentrate interest on the main subject.

Michele Hallen

In making portraits, a telephoto lens lets you isolate your subject from its surroundings. If you use a large or medium aperture, such as f/5.6, it also throws the background out of focus so it doesn't compete with the subject.

## CAMERA STEADINESS AND SUBJECT MOVEMENT

While a wide-angle lens is forgiving, the telephoto lens is demanding. In addition to focusing very carefully, you must hold your camera extremely steady to get pictures that are free of blur. This is because a telephoto lens magnifies camera movement as well as image size. Consequently, it's a good idea to use a tripod and a cable release with a telephoto lens. As a general rule, don't try to handhold the camera when you're taking pictures with a lens that has a focal length longer than about 400 mm.

To minimize the effects of camera motion, it's essential to use a high shutter speed. A good rule to follow is to use a shutter speed approximately equal to: 1/Focal Length in Millimetres second. For example, with a 200 mm lens, you should use 1/200 second or higher. Since 1/200 second is not available on your camera, use the next higher shutter speed setting of 1/250 second. If you still have difficulty getting sharp pictures, use a shutter speed twice as fast—in this case 1/500 second. Be especially watchful with automatic cameras that determine the shutter speed. If the shutter speed indicated by the camera drops to a speed that's too slow for sharp pictures, use a larger lens opening so the camera will adjust for a sufficiently high shutter speed.

A telephoto lens increases the effect of subject movement, too. Since the subject appears to be nearby and relatively large in the picture, any movement of the subject will be quite noticeable. This means that when you photograph action with a telephoto lens, you should use higher shutter speeds than you would to photograph the same action with a normal lens.

Martin Brock

Since telephoto lenses magnify the image to make it larger, they will also magnify any unsharpness caused by camera motion. Many such pictures taken with telephoto lenses are spoiled this way. When handholding your camera, you should use a high shutter speed to minimize the effects of camera motion. The photographer held his camera steady to obtain excellent sharpness as well as an extraordinary expression in this zoo picture.

So, you may want to use a telephoto lens—

- to produce a large image of a distant subject by bringing it closer to the camera optically.
- to make portraits.
- to compress distances.
- to eliminate distracting elements from a picture.
- to get shallow depth of field.

Roger Smith

A tripod is an important aid to help you get sharp, crisp pictures by providing a firm support for your camera when you use a telephoto lens.

Keith Boas

A beanbag is a handy item to have along in your camera bag. The beanbag provides a flexible cushion which conforms to your telephoto lens while supporting it on a firm object for steadiness.

## TELECONVERTERS

A teleconverter, sometimes called a teleextender, is an inexpensive way to increase the focal length of a telephoto lens. A teleconverter will also work with a normal-focal-length lens to produce the effects of a telephoto lens. These converters fit between the camera body and the lens. They extend or multiply the focal length of the lens by 2 or 3 times depending on the power of the converter. A 2X teleconverter converts a 100 mm-focal-length lens to 200 mm focal length, and a 3X teleconverter will convert the same lens to 300 mm focal length.

Another advantage of a converter is that it will give you a larger image for close-up photography. You get a larger image because of the increased focal length of the lens with the converter and because you can focus at the same close focusing distance as the original lens when it's used without the converter.

However, there are some disadvantages in using a teleconverter. A converter makes the effective lens opening smaller—a 2X teleconverter reduces the effective lens opening by 2 stops; a 3X teleconverter by 3 stops. For example, if your lens is set at $f/5.6$, the effective lens opening with a 2X converter is $f/11$; with a 3X converter it is $f/16$. Through-the-lens exposure meters in cameras will automatically compensate for the reduced effective lens opening. With a separate exposure meter or for flash pictures you will have to determine the exposure based on the smaller effective lens openings.

The reduced lens openings make the viewfinder dimmer for viewing. Also you may have difficulty using a high enough shutter speed or getting enough exposure under dimmer lighting conditions. In addition, with a converter it's generally better to use a

By using a teleconverter with a telephoto lens, you can double or triple the effective focal length. The picture on the top was taken through a 200 mm lens; the one on the bottom was taken with the same lens plus a 2X teleconverter lens to extend the focal length to 400 mm.

Herb Jones

Jerry Antos

Typical teleconverters—The left one extends the focal length by 3 times; the right one by 2 times.

smaller lens opening to increase the image quality.

You may notice some darkness and a loss of the image around the corners and top edge of your viewfinder when you use a teleconverter. This happens because the mirror in a single-lens reflex camera is not designed to reflect all the light from lenses when teleconverters are used with them. However, this affects only the viewfinder. The film should receive a complete image with no darkness around the edges when you take the picture.

In selecting a teleconverter, make sure that the mechanical linkage between the camera body and the lens will still work properly.

## AUTO-FOCUS LENSES

Perhaps the most exciting technological development in 35 mm cameras in recent years has been the advent of fast, accurate, and affordable auto-focus cameras. Although auto-focus technology made its debut in relatively simple compact cameras, today the most sophisticated auto-focus lenses are being made for 35 mm SLR cameras.

Auto-focus lenses for SLR cameras are available in a variety of fixed-focal lengths and zoom ranges. Some things to consider when buying an auto-focus lens are its weight, size, and focus response. To some degree each of these is related partly to the focal length of the lens and partly to the design of the camera and lens system. As with manual-focusing lenses, a wide-angle auto-focus lens will be much lighter and focus faster than a telephoto auto-focus lens.

The focusing mechanisms of auto-focus lenses fall into two categories: those that use a focusing motor in the lens and those that use a focusing motor in the camera body. Lenses with a built-in motor may focus slightly faster than those that use a motor in the camera body, but they are generally more expensive because you're buying a focusing motor each time you buy a lens. Lenses used on auto-focus cameras that have the focusing motors built into the camera body, on the other hand, are lighter and usually less expensive—though the initial investment in the camera body may be a bit higher. There is debate among manufacturers (and users) about which design truly focuses faster, but to the average photographer the difference in speed is negligible.

Auto-focus lenses with built-in motors will not auto-focus on a non-auto-focus camera. This is because the focusing sensors that activate the focusing motor

Auto-focus lenses are available in many of the same focal lengths as manual-focus lenses.

are in the camera body—regardless of where the focusing motor is located. You can, however, use an auto-focus lens as a **manual-focusing lens** on any camera body that it's designed to fit. Similarly, a non-auto-focus lens used on an auto-focus body won't focus automatically, although you may be able to use it as a manual-focus lens. (Be sure to check your camera instruction booklet to see what lenses are safe to use on your body before attaching any lenses to it.) Also, a few camera manufacturers make auto-focus adapters so that older non-auto-focus lenses of the same brand can be used on a newer AF body.

The only exceptions to this discussion are a few "universal" auto-focus lenses that have both built-in focusing motors and auto-focus sensors; these lenses are **specifically designed for use as auto-focus lenses on non-auto-focus cameras.** With these lenses, you choose the lens you want and then buy an adapter to fit it to your specific camera body.

M. Spencer Rigney

Off-center subjects can cause focusing errors for many auto-focusing cameras. If the subject is outside the focusing target in the viewfinder, either manually focus on the subject or use the focus lock to obtain correct focus and then recompose the picture.

### INTERNAL FOCUSING

One major difference between auto-focus lenses and most manual-focus lenses is that most auto-focus lenses focus internally. In other words, as the lens focuses, the elements shift position internally, but the outer barrel neither rotates nor extends in length. With manual-focus lenses, the lens barrel turns, and the lens becomes longer as you focus on closer objects. On some auto-focus lenses, the very front ring of the lens (particularly on zooms) **does** turn during focusing, which can be a problem if you're using a polarizing filter (or cross-screen filter) which has to be oriented in a certain direction for best effect. The only solution is to focus first, then mount the filter and rotate it to the correct position. (You may have to switch your lens to manual to mount the filter to keep from damaging the focusing motor; see your manual.)

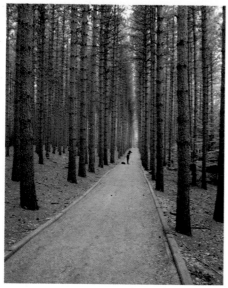
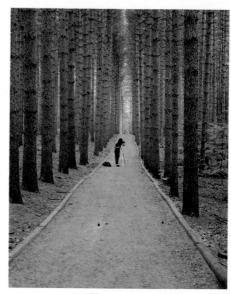

24 mm lens

50 mm lens

This series of pictures was taken from the same subject distance to show the effect of using different focal-length lenses. Note how the subject appears larger and closer as the focal length increases.

24 mm lens

50 mm lens

These pictures show how lens perspective changes with the focal length when the subject distance is adjusted to maintain the same image size.

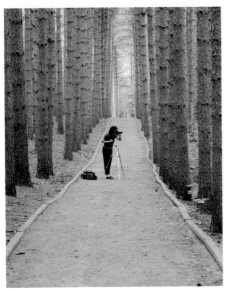

100 mm lens

200 mm lens

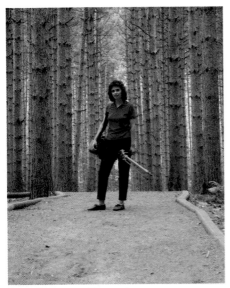

100 mm lens

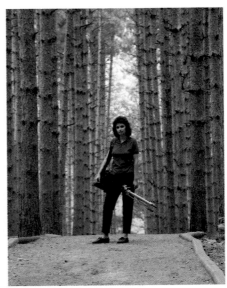

200 mm lens

143

# COMPOSITION

Most good pictures are not the result of a fortunate accident! The photographs you admire in exhibits may look like chance shots. But most often they have been created by the photographer. How do you create a picture? First you learn the rules of good composition given here. After you learn these rules, you'll realize that most pictures with good composition are the result of careful planning, patient waiting, or a quick sensing of the best moment to take the picture. But it's easier than it sounds. You'll find that the rules of composition will become part of your thinking when you are looking for pictures, and soon they will become second nature to you.

Photographic composition is simply the selection and arrangement of subjects within the picture area. Some arrangements are made by placing figures or objects in certain positions. Others are made by choosing a point of view. Just moving your camera to a different position can drastically alter the composition. For moving subjects you select the best camera position and wait for the opportune moment to snap the picture when the subject is in the best location for composition.

While the rules for good pictures are not fixed and unalterable, certain principles of composition will help you prevent making serious mistakes in subject arrangement and presentation.

Peter Gales

Sometimes you can include a secondary subject in the picture to complement the main subject and to create a pleasing, balanced composition. When secondary subjects are included, position them in the viewfinder so that they do not detract from the main subject. If each of these two balloons appeared as the same size, the composition would be static and uninteresting.

Robert Glidden

**Opposite,** several elements come together to make this photo work. An interesting foreground highlighted by sunlight and spots of bright color contrasts with a background subdued by fog. A seagull animates an otherwise still scene. And the placement of lobster traps, shed, and seagull balance the composition. Photo shot on KODACOLOR GOLD 100 Film.

Don Maggio

A bright-colored subject naturally attracts the eye, adding strength to the center of interest.

Herb Jones

Consider the power that color has when choosing and composing your pictures. To draw your viewer's attention to your subject, it helps to have that subject be the brightest element in the scene. Warm colors, such as reds, oranges, and yellows, usually work best for attracting interest.

## HAVE A STRONG CENTER OF INTEREST

It is usually best to have one main point of interest because a picture can tell only one story successfully. The principal subject may be one object or several. For instance, you may want to include a secondary subject, but make sure that it doesn't detract from your main subject. Whatever the main subject is, always give it sufficient prominence in the photo to make all other elements subordinate to it.

Avoid putting your center of interest in the center of your picture. Usually, if the main subject is in the middle of the picture, it looks static and uninteresting. You can often make excellent picture arrangements that have pleasing composition by placing your center of interest in certain positions according to the rule of thirds. When you divide a scene into thirds both vertically and horizontally, the dividing lines intersect in four places. Any of these four intersections provides a pleasing position for your center of interest.

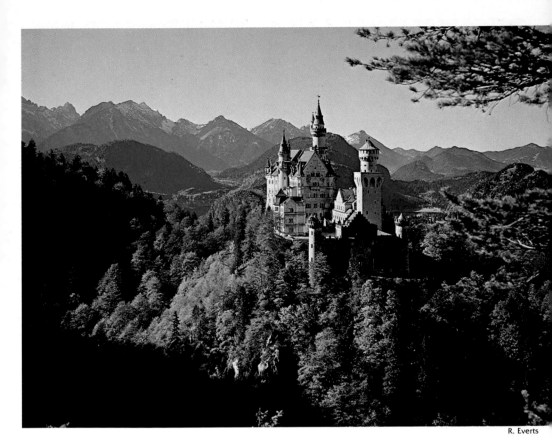

R. Everts

To understand the rule of thirds, imagine two horizontal lines cutting the picture into thirds. Then imagine two vertical lines cutting the same picture into thirds vertically. The intersections of these imaginary lines suggest four possible options for placing the center of interest for a pleasing composition. Neuschwanstein Castle, West Germany

**Derek Doeffinger**

When you find an interesting subject, try composing it several different ways. In this series, the lighthouse is positioned in different parts of the frame and the water is excluded from one of the shots. An orange filter was added on most of the shots, but was omitted from one. Our favorite is the shot that excludes the water.

In photographing this hang glider—dwarfed by the sheer face of a mountain in Yosemite National Park—the photographer used the rule of thirds to make an effective composition.

Gary Whelpley

The window mullions frame the inquisitive expression of the cat, whose face falls nicely into the upper left third of the picture. For a pleasing composition, think in terms of thirds as you compose in the viewfinder.

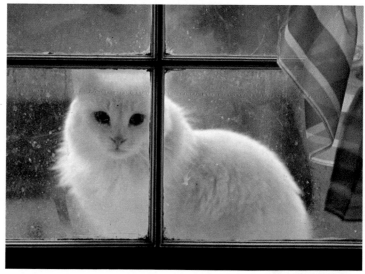

Michael Powell Taylor

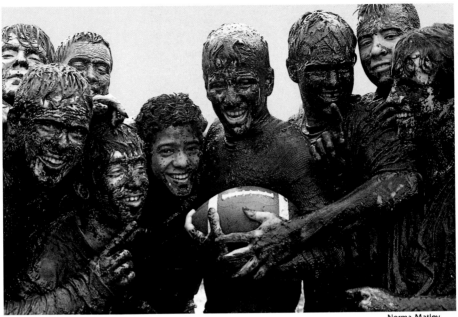

Norma Matley

To make a group of people look unified, have them all look at the camera (or at least in the same direction). If you can also get them to take a mud bath, then you can produce a picture as humorous as this one.

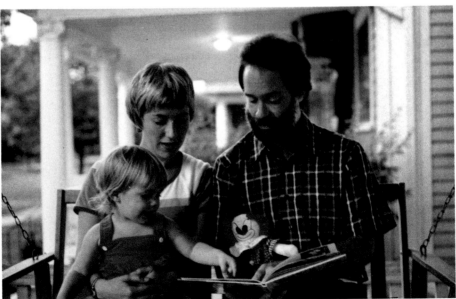

Norm Kerr

Here the entire family was asked to look at the child's book—a simple technique for producing candid harmony in this late afternoon scene.

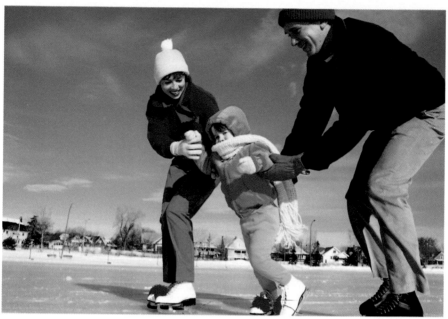

Neil Montanus

Using a low angle to photograph active people further animates them to reinforce the sense of movement.

## USE THE BEST CAMERA ANGLE

Good pictures usually depend on selecting the proper point of view. You may need to move your camera only a few inches or a few feet to change the composition decidedly. When you want to photograph a subject, don't just walk up to it and snap the shutter. Walk around and look at it from all angles; then select the best camera angle for the picture.

Outdoors, shooting from a low camera angle provides an uncluttered sky background. However, when the sky is overcast with cloud cover you'll want to shoot from a high angle and keep most or all of the sky out of the picture. Overcast skies look bleak and unappealing in pictures.

Always consider the horizon line. Avoid cutting your picture in half by having the horizon in the middle of the picture. When you want to accent spaciousness, keep the horizon low in the picture. This is especially appropriate when you have some white, fluffy clouds against a blue sky. When you want to suggest closeness, position the horizon high in your picture. Another important point, easily overlooked, is to see that the horizon is level in the viewfinder before you press the shutter release.

Raunikar

By choosing an unusual viewpoint, the photographer made a striking image of a mundane subject.

James R. Howard

The high camera angle selected for this picture helped to isolate the children and raft and better display the pattern of ripples in the water.

Neil Montanus

The photographer pointed the camera down from a high vantage point in a nearby building to capture this unusual design of cars and pavement.

R. Terry Walker

A water-level camera angle in this case helps suggest the feeling that you're right in the water with the swimmer, sensing the power of his competitive stroke.

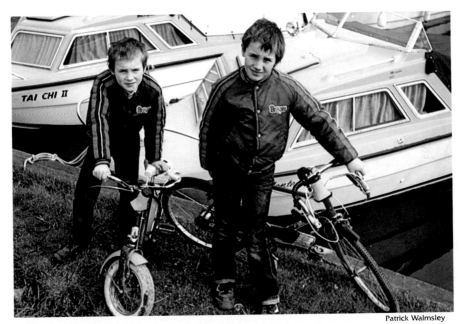

Patrick Walmsley

On overcast days, you can avoid a cloudy, gray, uninteresting sky in your pictures by choosing a high camera angle.

Steve Drexler

Where you position the horizon can dramatically alter the mood of a photo. A high horizon seems confining, while a low horizon frees the eye.

Marissa R. Ellis

Move close to your subjects for dynamic photos with impact.

## MOVE IN CLOSE

One rule of composition you should always keep in mind is whether the picture you're about to take would be better if you move in closer to your subject. Close-ups convey a feeling of intimacy to the viewer while long shots provide a sense of distance and depth. A close-up picture focuses your attention on the main subject and shows details that you could otherwise overlook or defines details that are too small in more distant views.

Some amateur photographers look through the viewfinder when they're taking pictures and start backing away from the subject. This is not only bad from a safety standpoint, but it can also be bad for composition. This can have the effect of making the subject too small in the photograph and encompassing too many elements that are not part of the picture. Including too much in the picture can be confusing and distracting to the viewer.

When you look through your viewfinder, move toward your subject until you have eliminated everything that does not add to the picture. Even though you can crop your picture later if you plan to enlarge it, it's usually better to crop carefully when you take the picture. Carefully composing the picture in the viewfinder is essential for taking color slides because cropping techniques are not generally used with slides. In addition, because the frame size of a 35 mm camera is not large, you'll obtain the highest quality when you utilize all of the picture area. The larger the image size on the film and the less enlarging that's necessary, the higher the image quality. A good rule to remember is to fill the frame.

157

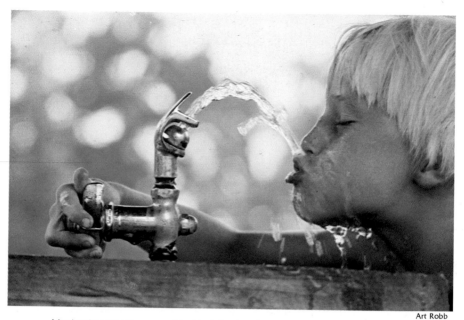

Art Robb

Moving in close to your subject to take the picture gives the viewer the sense of being there.

Derek Doeffinger

Show interesting details by moving in close so the subject fills the frame. The shadows created by sidelighting give this photo a strong sense of three-dimensionality.

Neil Montanus

Crop carefully when you take the picture. To emphasize the subject, show it
big, **top,** and eliminate extraneous elements.

# USE LINES FOR INTEREST AND UNITY

Use leading lines to direct attention into your pictures. Select a camera angle where the natural or predominant lines of the scene will lead your eyes into the picture and toward your main center of interest. You can find a line such as a road or a shadow in almost anything. The road will always be there, so it's just a matter of choosing the right camera angle to make it run into the picture. A shadow, however, is an ever-changing element in the scene. There may be only one time in the day when it's just right. So you should patiently wait for the best composition.

Tom Tracy

A leading line is usually the most obvious way to direct attention to the center of interest. In this case, the road leads the viewer's attention to the distant house—the center of interest.

B. B. Caron

Here the bright mooring lines in the foreground and the diagonal line formed by the reflections in the background direct the viewer's eye to the two small boats.

In this case, the two long necks and outstretched chin lead your eye to the head of the dominant giraffe on the right. Look for leading lines in whatever you choose to photograph.

B. Greiser

The modified S curve formed by the road combines well with the rule-of-thirds placement of the pedestrians. The resulting arrangement is a pleasing blend of scenic elements.

Barbara Jean

Thomas Ervin

The V formations of multiple tree trunks perform the dual functions of framing the subject and leading your eyes to the child.

Margaret Fava

The dominating S curve formed by train and track leads you into and through the picture.

The radial arrangement of this family group draws attention to the pet in the center. Having family members look at each other and at the dog (but definitely not at the camera), develops a fine feeling of natural spontaneity.

Bob Clemens

In this composition, the triangular arrangement of the mission bells calls attention to the cross by directing the viewer's eye upward.

Herb Jones

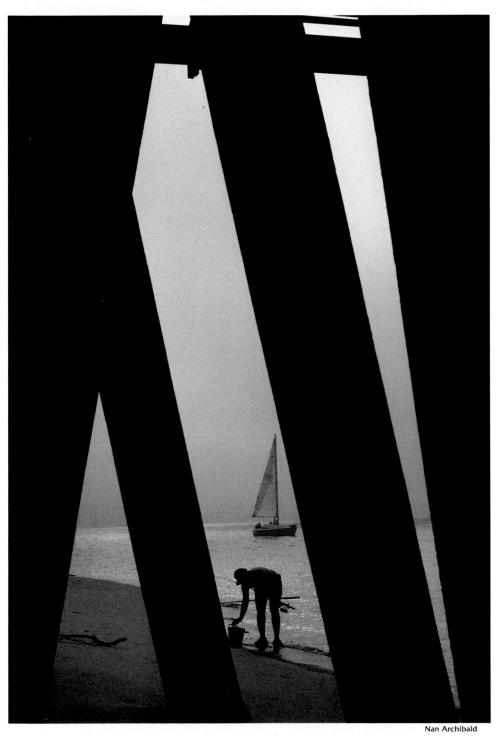

Nan Archibald

The slanting, bold, silhouetted pier supports invigorate this photo. The fisher-
man and sailboat add scale and balance to the scene.

Philip Voss

Always keep an eye open for elements that will unify a scene. Here the
leading line of a fence ties the foreground to the background.

# WATCH THE BACKGROUND

The background can make or break a picture. It can add to the composition and help set the mood of a picture, or it can detract from the subject if it is cluttered. Watch out for backgrounds that are more compelling than the subject. Cluttered, distracting backgrounds often spoil otherwise good pictures. Before you snap the shutter, stop for a minute and look at the background. Is there some obtrusive object or action in the background that does not relate directly to your subject which would divert the viewer's attention? For example, is there a telephone pole growing out of your subject's head? Beware of an uncovered trellis or the side of a shingled house when you take informal portraits or group shots, because prominent horizontal or vertical lines detract from your subject. Foliage makes a better background. A blue sky is an excellent background, particularly in color pictures. Remember to look beyond your subject because your camera will!

Patrick Walmsley

A cluttered background with trees or other unwanted elements sprouting out of your subject's head usually makes a confusing and distracting picture. Also, people may not appear at their best when photographed head-on with their bodies perpendicular to the axis of the camera.

Moving the offending tree to the right in this comparison shot improved the overall arrangement, and having the subject take a relaxed position at a slight angle to the camera helped create a more pleasing informal atmosphere.

David Sacco

When the subject is interesting by itself, such as these Burmese boys, use a plain background that will not compete with the subject.

Patty Van-Dolson

Add a natural frame to your scenics by including foreground objects such as trees. A foreground frame can help add the feeling of depth to a picture.

# TAKE PICTURES THROUGH FRAMES

For an added creative dimension, compose your pictures with an interesting foreground frame, such as a tree, a leafy branch, or a window. Try to choose a frame that links thematically with the subject—such as a sailboat's rigging framing a harbor scene. Foreground frames create a sensation of depth and direct the viewer's attention to the center of interest. Watch the depth of field of your lens so that both the foreground and the other details in the scene will be in focus. In scenic photos, avoid a very out-of-focus foreground that can distract from the subject. But in other kinds of shots, such as informal portraits, an unsharp foreground frame emphasizes the main subject.

If you're using an auto-exposure camera, and you want both the foreground frame and the main subject sharp, remember to use the aperture-priority mode or depth program so that you can use a small aperture. Or you can use this mode to set a large aperture to put the frame out of focus. If you are using an auto-focus camera and you want only the main subject in focus, be sure to lock in the focus for the most important subject area first, and then include the out-of-focus foreground—otherwise the lens will focus on the foreground.

Neil Montanus

Arranging the subject so that it is surrounded by an appropriate frame, such as this doorway, is another way to focus attention on the subject. Notice the extremely fine grain and excellent sharpness of this photo. It was taken on KODAK EKTAR 25 Film.

After you've followed the rules of composition for a while, you'll no longer need to spend much time trying to determine the best arrangement of the picture you're taking. As we all have some artistic ability, soon the recognition of pleasing composition will become almost automatic. You'll be aware that it is important to place figures or objects in certain positions. Figures should look into not out of the picture. Fast-moving objects should have plenty of space in front of them to give the appearance of having

somewhere to go. And remember that since bright tones or colors attract attention of the eye, the most important elements of the picture should be the lightest or brightest or most colorful.

To remind you again: composition is simply the effective selection and arrangement of your subject matter within the picture area. If you follow the suggestions given here, experience will teach you a great deal about this subject. When you look through the viewfinder, concentrate on how you want the final picture to appear.

For this interpretation, the photographer walked around to picture the mission with a different foreground frame. A wide-angle lens was used to include the entire height of the archway and to make it more prominent relative to the church.

Herb Jones

Caroline Grimes

Overhanging branches are usually available and, consequently, popular as elements for foreground framing. Here in this scene, they provide added dimension to Thomas Jefferson's Monticello, near Charlottesville, Virginia.

Doris Barker

Framing can give a picture the depth it needs to make it more than just another snapshot. In this picture, the photographer used tree branches both as a frame and as a device to add interest to a rather bland sky.

Robert Kretzer

You can usually improve a sunset scenic by using silhouetted objects in the foreground as a compositional frame.

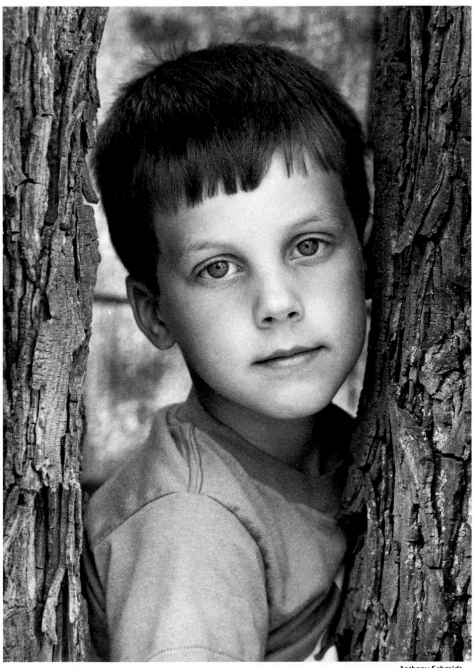

Anthony Schmidt

Tree branches and forks in trunks often form attractive frames. The rough bark contrasts nicely against the boy's smooth skin.

Patty Van-Dolson

Don't limit your selection of foreground frames to trees and architecture. Keep an eye out for fresh approaches to make more of your pictures have lasting appeal.

Sometimes you can use a colorful foreground like pretty flowers to frame your subject.

Paul Kuzniar

Herb Jones

A foreground subject can do more than make the picture prettier. It can also add story-telling details. What better to signify a Maine harbor than a foreground that includes lobster trap buoys.

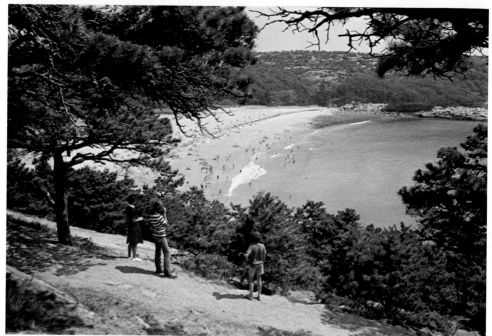

John Fish

Include people in the fore-
ground of scenic pictures to
provide color and scale. The
picture above is more effective
than the one below because
the people have provided
foreground interest. By includ-
ing your companions in your
scenic views, you'll also be
personalizing your pictures
—an added bonus that says
*you were there.* Sand Beach,
Mt. Desert Island, Maine

Paul Kuzniar

Adding the person in the picture has introduced a colorful center of
interest to attract the eye.

Herb Jones

You can use people effectively in pictures to give scale to the rest of the subject matter. The presence of a person in this photo helps us appreciate the great size of the redwood tree.

Herb Jones

Yosemite Falls in Yosemite National Park, California, takes on added height with the inclusion of people for scale in the lower left corner.

Marcella Martin

The size of a mountain, valley, or cliff often escapes the viewer unless an object of known size is included in the scene. This rock climber keys the viewer to the enormity of the cliff.

Kerry Drager

Since people often express themselves humorously through decor, signs, mailboxes, and even scarecrows, making humorous pictures often requires only a diligent search.

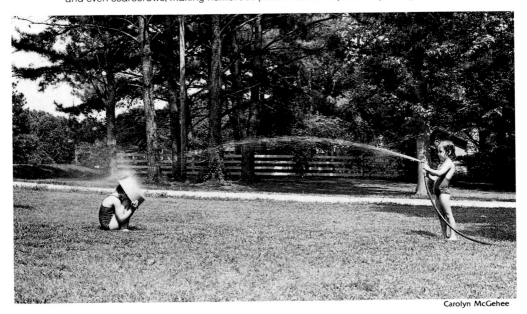

Carolyn McGehee

If you can keep up with them and react fast, you'll find kids an endless source of humor. With no central subject, this is the type of subject that could cause an autofocus camera to focus on the background instead of the kids at the sides of the picture. Use the focus lock or manual focus to obtain sharp results.

179

Norm Kerr

The blurred background created by panning conveys a strong sense of movement through the city streets of Seoul, Korea.

## ACTION PICTURES

Pictures of subjects in action usually convey a feeling of excitement, so the technique you use to photograph the action will have a great deal to do with the quality and mood of your pictures.

## STOPPING THE ACTION

The most common technique for stopping action in a photograph is to use a high shutter speed. For most action pictures, you'll probably want to use as high a shutter speed as lighting conditions and depth-of-field requirements allow. Auto-exposure cameras that have an "action" program mode are especially good for stopping action; they automatically choose a fast shutter speed for the prevailing lighting conditions. Some auto-exposure cameras automatically switch to an action mode when you mount a telephoto lens (or telephoto zoom) on the camera. But even if you can use action modes, it's useful to know when you must use the highest shutter speed and when you can stop the action with slower speeds.

Action moving at right angles to the camera is more difficult to stop than action moving diagonally, and action moving directly toward or away from the camera is the easiest to stop. Also, distant action is easier to stop than action close to the camera.

For example, suppose you were photographing the Grand Prix. You would have to use your highest shutter speed to stop the action if you were photographing the cars from the side as they raced across the finish line. If you were near a bend in the track and could photograph the cars coming toward you, you could get away with a slower shutter speed. Also, you could stop the action with a slower speed if you were in the last row of the bleachers rather than in the pits.

Certain types of action have a peak— a split second when the action almost stops. If you anticipate the peak of the action and begin pressing the shutter release so that the shutter clicks right at the peak, the action is easier to stop. A pole-vaulter at the top of his jump, a

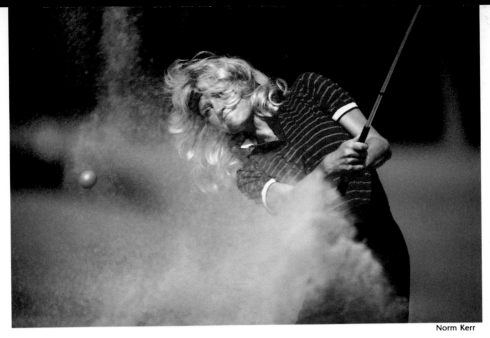

Norm Kerr

A photo sharp all over conveys less sense of motion, but it clearly reveals an instant from an ongoing action. In this example, it also shows the intense concentration required by any successful athlete. To stop action, use the fastest shutter speed allowed by the conditions.

golfer at the end of his follow-through and a tennis player at the peak of her backswing are all examples of peaks of action.

Another good way to arrest action is to pan with a moving subject. If you move the camera to keep the subject centered in the viewfinder as you squeeze the shutter release, the subject will be sharp and the background blurred. The slower the shutter speed, the more blurred the background will be. This technique is useful for creating a feeling of speed in a photograph. A picture of a trotter made at 1/500 second may show the action frozen in a rather static-looking photograph. But if you reduce the shutter speed to 1/125 second and pan the camera with the action, the result will be an exciting photograph filled with the feeling of motion.

It's not difficult to track a moving subject with a manual-focus lens, but an auto-focus camera that has a servo or continuous-focus mode makes panning easier because the camera will do the focusing while you follow the action in the viewfinder. The camera will continue to adjust focus almost until the instant of exposure. The disadvantage of this mode is that, unlike the single-shot focusing mode, the continuous-focus mode will allow you to take a picture whether sharp focus has been achieved or not.

Why wouldn't the focus always be sharp? One reason is that a moving subject may escape the focus target at the moment you press the shutter release. Another reason is that although auto-focus lenses respond in fractions of a second, the subject may be moving faster than the focusing motor can adjust focus. Finally, there is a lag between the time you press the shutter and the time it takes for the camera to move the mirror out of the way and expose the film. At least one camera is programmed to take this time lag into consideration—along with the speed and direction of the subject—and adjust focus so that it is correct at the very instant of exposure.

The thrill and fun of a water slide are effectively shown here as this girl heads down the slide enveloped by water. Use a high-speed film, such as KODACOLOR GOLD 400 Film, and the telephoto setting of a zoom lens to stay out of the way.

Magaret Weinand

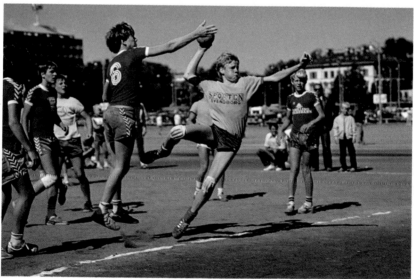

Marty Czamanske

Sports are a natural for action photography. The main concern is to watch for the most opportune moment to snap the shutter as the action takes place. This is where an autowinder or motor drive comes in handy because you can take pictures rapidly.

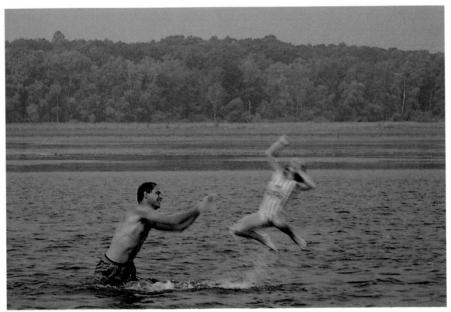

1/30 second

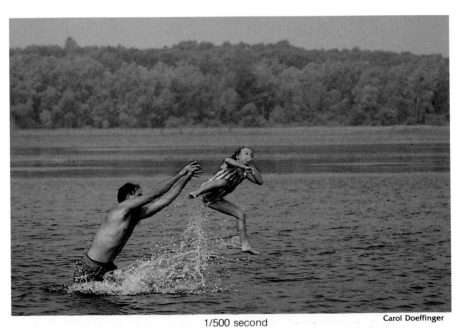

1/500 second

Carol Doeffinger

This comparison shows that a slow shutter speed blurs moving subjects and that a fast shutter speed renders them razor sharp. A fast shutter speed also counteracts the camera motion (magnified by a telephoto lens) to give sharp pictures.

Kevin Anderson

The frozen wingbeat of this gull seems almost unnatural, but the composition and the gull's unusual posture make the photo appealing. When a moving subject fills a large part of the picture, you have to use a very fast shutter speed to freeze the subject.

William Mays

To photograph the extremely fast movement of the Blue Angels, the photographer used a shutter speed of 1/2000 second.

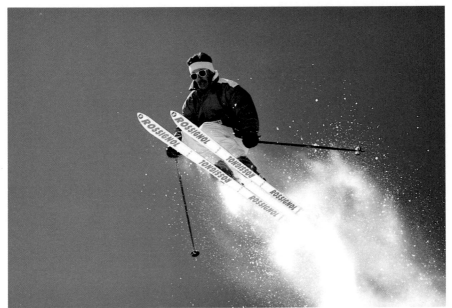

Christopher Clemens

Action cutting diagonally across the scene is the most dynamic. For a fast moving subject like this skier, you should use a shutter speed of 1/1000 second or faster.

Neil Montanus

Stop-action photos take on a strong sense of action when their subjects are in postures that reflect vigorous movement. EKTAR 1000 Film will let you use fast, action-stopping shutter speeds.

A. Chastel/ A. Courtois

Subjects moving directly across the scene require a very fast shutter speed, usually 1/500 second or faster, to freeze their motion.

Vernon Fisher

You can stop action coming directly at you with a fairly slow shutter speed, such as 1/125 or 1/250 second.

Frank Haggerty

Auto-focus systems can track and focus on fast-moving subjects fairly well. But when you know the action will take place at a particular spot, such as at this sprinkler, you can be sure of getting a sharp picture by prefocusing on the spot. Take the picture just as the subject arrives at the spot.

Here the photographer snapped the picture at the precise moment when the motorcycle was at the peak of its jump. It's easier to stop motion this way.

Lawrence Grella

You can pan with the action to keep a moving subject centered in the viewfinder as you squeeze the shutter release. When you do this, the subject will be sharp, but the background will be blurred.

Don Maggio

In this picture, panning wasn't used so the background is sharp. But a higher shutter speed is necessary when you don't pan your camera with the moving subject. Compare this photo with the one above.

Murry Koblin

Panning is a big help to get sharp pictures of fast-moving subjects when you're photographing them close to your camera or with a telephoto lens.

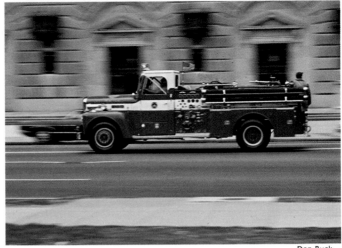

Don Buck

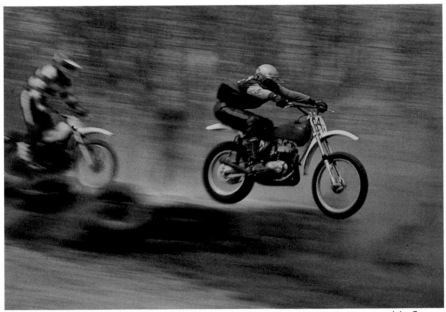

John Green

The composition of action photos often looks better when you leave some room for the subject to move into. Of course, don't take all your action photos using this tip. Occasionally, you may increase the tension by pushing the subject up against the side of the photo.

Bob Clemens

People walking at a distance from the camera can be easily stopped in your pictures using 1/125 second. This is a good shutter speed to use for general handheld picture-taking with normal or wide-angle lenses. The speed is fast enough to produce sharp pictures with a handheld camera and fast enough to stop moderate action. Note how the woman's moving hands and feet are sharp, as are the breaking waves in the background.

The children have momentarily halted their rapid action to be ready to hit the ball, so 1/250 second is fast enough to stop the action. If they were swinging their rackets, 1/500 second would be needed at the distance this picture was taken.

Howard E. Marlin

Since a telephoto lens magnifies the image and brings the action closer optically, you need to use higher shutter speeds than with normal or wide-angle lenses.

F. P. Foltz

## ACTION SHOTS WITH TELEPHOTO LENS

Sometimes you'll want to photograph action that you can't get as close to as you'd like, so you may use a telephoto lens to bring the action closer to you. Remember that a telephoto lens not only increases image size but also increases the effect of subject movement. When the subject distance remains the same, the effect of subject movement increases in direct proportion to the focal length of the lens. For example, if you need a shutter speed of 1/250 second to stop the action with a 50 mm lens, you'll have to use a shutter speed that's twice as fast or 1/500 second with a 100 mm lens. The longer the focal length, the faster the shutter speed needs to be.

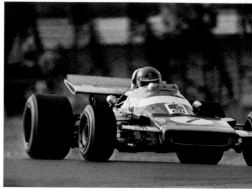

Lee Howicl

A close-up action photo of auto racing is usually possible only when you use a telephoto lens. The car moving diagonally by the camera helped the photographer get a sharp picture. It would be best to use 1/1000 second for this kind of picture.

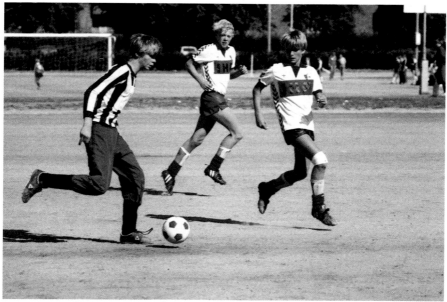

Marty Czamanske

It's often easier to take good telephoto pictures with a high- or very high-speed film such as KODAK EKTACHROME 400, EKTACHROME P800/1600 Professional, KODACOLOR GOLD 400, or KODAK TRI-X Pan Film. These films will let you use a smaller lens opening for improved depth of field with the very high shutter speeds required to stop actions when you're using a telephoto lens.

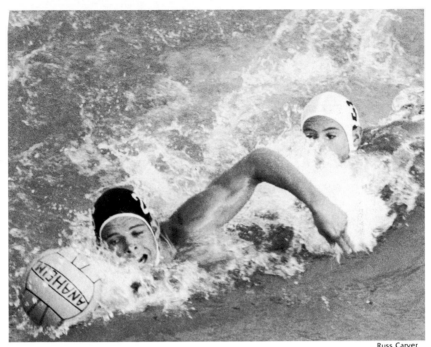

Russ Carver

Because it's difficult to get close enough to subjects in the water, a telephoto lens is a great asset in getting a good image size to show the action. Shutter speeds of 1/500 or 1/1000 second are necessary to stop the motion.

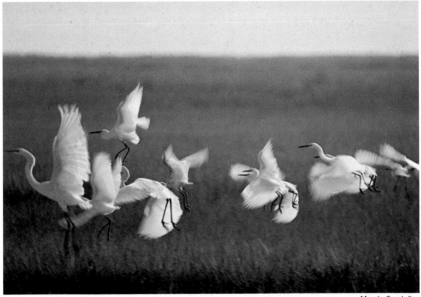

Morris Guariglia

Not all action pictures should show completely stopped action. The blurred wings of these beautiful snowy egrets photographed at the best possible moment have created a breathtaking nature photograph. A shutter speed of 1/125 second recorded just the right amount of blur in the wings. The photographer used a 300 mm telephoto lens and panned his camera with the birds' flight path.

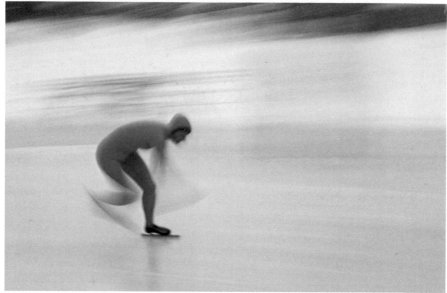

Don Maggio

The blurred action effectively shows the great speed of the skater. The camera was panned to follow the skater while the exposure was made at 1/8 second. Good shutter speeds to try for blurred action are 1/30 to 1/4 second depending on the speed of your subject and the amount of blur you want in the picture. A low-speed film—less than ISO 50—will allow the slow shutter speed necessary to get an attractive blur.

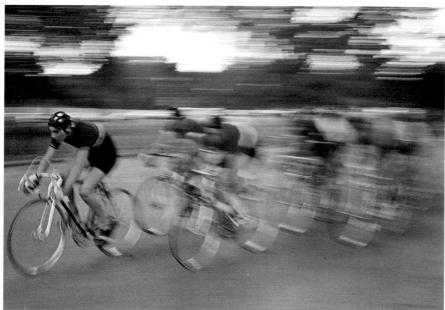

Don Hanover III

A slow shutter speed of 1/8 second, used while panning the camera, reproduced the fast-moving pace of a bicycle race as a blur of motion.

194

# EXISTING-LIGHT PHOTOGRAPHY

Steve Kelly

With a very high speed of ISO 1600, KODACOLOR GOLD 1600 Film can handle most existing-light scenes. It's especially well suited for photographers using zoom lenses. Because zoom lenses have small maximum apertures that don't let in as much light, they need a very fast film if you want shutter speeds fast enough for handholding the camera in dim light.

Existing light, sometimes called available light, includes artificial light which naturally exists in the scene, daylight indoors, and twilight outdoors. It's the light that happens to be on the scene. Technically, sunlight and other daylight conditions outdoors are existing light. But in defining existing light for photography, we are referring to lighting conditions that are characterized by lower light levels than you would encounter in daylight outdoors.

Existing-light pictures have a natural appearance because they're made by the natural lighting on the subject. Existing-light photography is also sometimes more convenient than picturetaking with flash or photolamps because you don't have to use extra lighting equipment or concern yourself about the light source-to-subject distance.

An added bonus of taking pictures by existing light is that it's less expensive than using flashbulbs.

Existing-light photography really isn't as new as we sometimes think. Photographers have been taking existing-light pictures for over 50 years. But their exposures often lasted several minutes. The big advantage of today's fast lenses and fast films is that they make it possible to take existing-light pictures with much shorter exposure times. Often the exposure times are short enough to allow you to handhold your camera.

Since most existing lighting is comparatively dim, you need an $f/2.8$ or faster lens and a high- or very high-speed film for handheld picture-taking. An $f/2.8$ lens is sufficient for many existing-light scenes. But if you have

Ann Marchese, SKPA

Taking the picture by the existing lighting lets you capture the realism of beautiful interiors you see in your travels.

an even faster lens such as $f/2$ or faster and use a high- or very high-speed film—ISO 400 to ISO 1600—you'll have more versatility. The combination of an $f/2$ or faster lens and a 400-speed or faster film lets you take pictures in dimmer lighting conditions while hand-holding your camera. A fast lens and a high- or very high-speed film also let you use higher shutter speeds for stopping action when the existing lighting is somewhat brighter. Another advantage is that you can use a smaller lens opening for greater depth of field under brighter existing-light conditions.

Handholding your camera is suitable for shutter speeds as slow as 1/30 second with a normal-focal-length lens. To obtain sharp pictures consistently when using a slow shutter speed, you must be able to hold the camera steady. Practice holding the camera as shown on page 22. Eventually you may find that you can get satisfactory results with even slower shutter speeds. However, at slower shutter speeds you should normally place your camera on a tripod; use a cable release so that you don't jiggle the camera when you trip the shutter.

If you don't have a tripod and you want to use a slow shutter speed, try bracing the bottom of your camera against a wall or post while you take the picture. If your camera has a self-timer, you can use it instead of risking camera shake by tripping the shutter with the shutter button. For example, set the self-timer, press the camera against its support, press the shutter button, and wait a few seconds until the shutter trips.

You will take most of your existing-light pictures with a large lens opening, which means the depth of field will be shallow. Focus accurately so the subject is sharp.

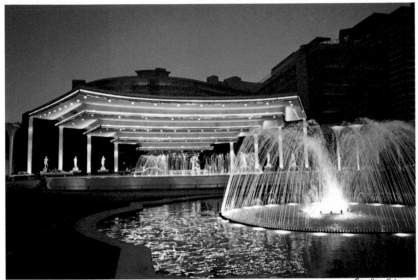

Caroline Grimes

Night scenes are natural subjects for your existing-light photography. The colorful and dramatic lighting patterns let you create pictures with a totally different appearance from that of conventional pictures taken in the daytime. Las Vegas, Nevada, KODAK EKTACHROME 160 Film (Tungsten), 1/30 second f/4

Marty Taylor

The lighting in museums is arranged to produce the most effective illumination for the objects on display. You can take advantage of this lighting when you take your pictures by existing light. The Imperial Calcasieu Museum, Inc., Lake Charles, Louisiana

Compare this picture taken with flash with the one on the left. When you use flash, your camera does not record the pleasing appearance of the museum lighting on the display.

Peter Fareri

The colorful light shows at rock concerts are easy to photograph using a high-speed film. However, before taking your camera, you may want to call the promoter to see if you are allowed to take pictures during the show. At some concerts, security guards confiscate cameras until after the show.

Focus carefully when you take existing-light pictures because depth of field is shallow due to the large lens openings that are required for the relatively dim lighting. Made on EKTACHROME P800/1600 Professional Film (Daylight) exposed at EI 1600, 1/30 second, f/2.8.

Shot In The Dark Studios

Sam Campanaro

High-speed negative films, such as KODAK EKTAR 1000 Film, enable you to get good pictures with good color even under the most trying conditions.

## FILMS

When you want color prints, KODACOLOR GOLD 400, KODACOLOR GOLD 1600, and KODAK EKTAR 1000 Films are excellent for existing-light photography. They are especially suited for this kind of picture-taking because of their speed and their versatility. You can take pictures in various kinds of existing light—daylight indoors, tungsten, and fluorescent illumination—without using filters. These films produce more natural color rendition under a wide range of lighting conditions because they have special sensitizing characteristics that minimize the differences between various light sources. Also, color rendition can be partially controlled during the printing process.

KODAK EKTACHROME P800/1600 Professional film (Daylight), EI 800 or 1600 (depending on exposure index and processing); EKTACHROME 400 Film (Daylight), ISO 400; EKTACHROME 200 and KODACHROME 200 Film (Daylight), ISO 200; and EKTACHROME 160 Film (Tungsten), ISO 160, are great for making color slides by existing light. KODAK EKTACHROME P800/1600 and KODAK EKTACHROME 400 Films are real boons for the existing-light photographer who wants color slides because they offer the advantages of high film speeds. If you don't need that much speed, you may want to use EKTACHROME 200 Film or 160 Tungsten Film which offer the advantage of finer grain. When you need more film speed, you can double the speed of most 35 mm EKTACHROME Films.

Whether you choose daylight-type color-slide film or color-slide film designed for use with tungsten light—regular light bulbs—for your existing-

You need a high-speed film for action pictures in existing light because a high shutter speed is necessary to stop the action and a large lens opening is required for proper exposure. Existing light is not very bright compared with bright outdoor lighting conditions in the daytime. KODAK EKTACHROME 400 Film (Daylight).

Don Maggio

KODAK EKTACHROME 200 Film (Daylight) is a good choice when you plan to take both existing-light pictures and daylight pictures outdoors on the same roll of film. Its speed of ISO 200 is adequate for many existing-light scenes if your camera has an f/2.8 or faster lens.

Gary Whelpley

For scenes with tungsten existing light—regular light bulbs—KODAK EKTACHROME 160 Film (Tungsten) produces pleasing slides with good color balance.

Gary Whelpley

Bob Clemens

By using a high-speed film for existing light pictures, you can handhold the camera and sometimes use a small aperture for greater depth of field.

light pictures is often a matter of personal taste. With existing tungsten light, you'll get the truest color rendition when you use film balanced for tungsten light. With daylight film the colors will appear warmer, or more orange. However, many people like this added warmth in their existing-light pictures. With fluorescent lamps, daylight film is the better choice, but the colors are still likely to have a cold greenish or bluish cast. When daylight from windows or a skylight illuminates your subject, use daylight film.

For taking existing-light pictures in black-and-white, both KODAK T-MAX 400 Professional Film, ISO 400, and KODAK T-MAX P3200 Professional Film, EI 3200, are excellent choices. You can get excellent results push processing either film in T-MAX Developer. You can push T-MAX P3200 Professional Film all the way to EI 25,000 and still get acceptable results. When you photograph your subjects with black-and-white film, you don't have to be concerned with the color quality of the light or the type of lamps illuminating the scene.

The combination of a very high film speed and superb quality makes EKTACHROME P800/1600 Professional Film (Daylight) a really great film to use for taking color slides by existing light. Exposed at EI 800, 1/30 second, f/4.5.

Shot In The Dark Studios

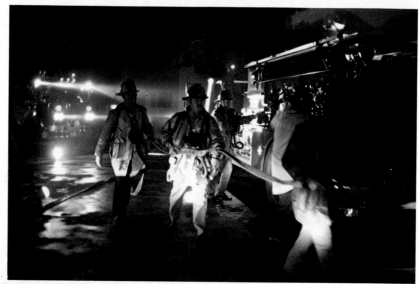

Tom McCarthy

For activities outdoors at night, you need a lot of film speed.

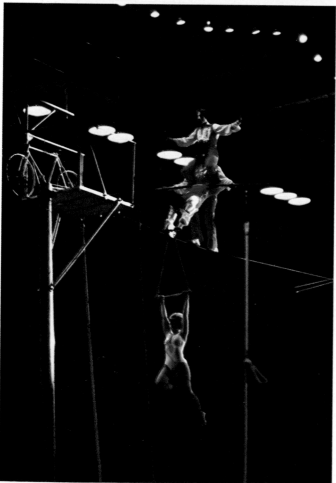

A high or very high film speed is a tremendous help when you want color slides of action in existing light. The speed of KODAK EKTACHROME 400 Film (Daylight) was increased to ISO 800 by push processing. Damascus Temple Shrine Circus. 1/250 second f/2.8.

Caroline Grimes

KODAK EKTACHROME 160 Film (Tungsten), 1-stop push processing

Jim Dennis

KODAK EKTACHROME 200 Film (Daylight), 1-stop push processing

For taking color slides in tungsten lighting, tungsten film gives color rendition that appears natural as shown by the photo on the top. The one on the bottom, which has an orange-red color cast, was made on daylight film. Although the bottom photo has a warm color balance, many people like the color in slides made this way. Damascus Temple Shrine Circus

You can use either tungsten or daylight film for color slides of night scenes. Slides made on tungsten film have a bluer, perhaps more realistic appearance than slides made on daylight film which have an orange-red color balance. Both kinds of film produce good results. The one you select is a matter of personal preference. Made in England on KODAK EKTACHROME 160 Film (Tungsten).

Patrick Walmsley

Fluorescent lights give off greenish light, not readily noticed by the eye, that is clearly visible in photos. To improve color under fluorescent lights, use an FLD filter.

With FLD filter

Without filter

Film for color prints, such as KODACOLOR GOLD 400 Film usually produces acceptable pictures in fluorescent lighting because color rendition can usually be improved when the prints are made. However, the pictures may still have a greenish cast depending on the kind of fluorescent lamps.

Bob Clemens

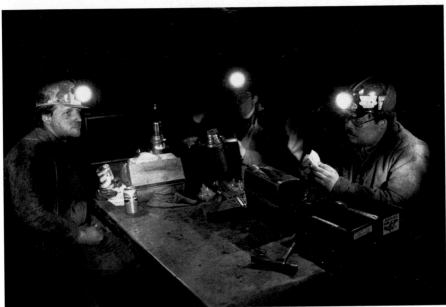

Bob Clemens

What better way to test a film's existing-light ability than to photograph a lunch break in a coal mine. KODAK T-MAX P3200 Film easily met the test. You can rate this film at a variety of speeds up to an astonishing EI 25,000.

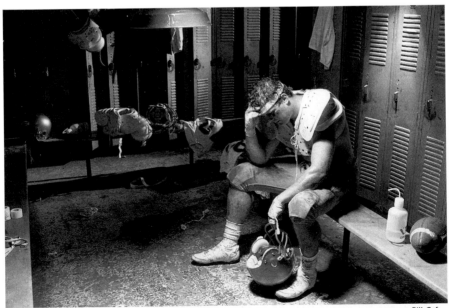

Bill Cafer

The high speed and extremely fine grain of T-MAX 400 Professional Film makes it very versatile. You can use it outdoors to catch the excitement of the game and then go into the dim locker room to catch the moods that show who won and who lost.

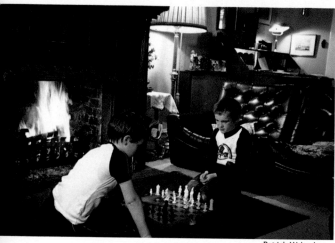

Patrick Walmsley

Home lighting is dim at best, so it's best to use a film in the 320- to 1600-speed range and a fast lens of f/2.8 or faster for handholding your camera. Made on EKTACHROME 160 Film (Tungsten) exposed at ISO 320.

Bob Clemens

In the existing lighting at home, position your subject or select a camera angle where the light source is illuminating the front or side of the face so it's not in heavy shadow.

## EXISTING-LIGHT PICTURES INDOORS

You'll find lots of possibilities for existing-light pictures indoors. Around home you can take unposed pictures of your family just being themselves or you can record holidays and special occasions. Away from home you can take pictures of such subjects as ice shows, stage plays, museum displays, auto shows, and graduation ceremonies.

When your subject includes both very bright and very dark areas, such as spotlighted performers, and you can't take a close-up reading, a built-in meter isn't much help unless it has a spot-metering feature. An averaging meter sees the large dark areas surrounding the small bright area and indicates more exposure than is needed. In reality, there is plenty of light on the spotlighted subject. If you shoot at the exposure indicated, however, the meter will average the dark and light areas, causing the bright subject to be overexposed.

Auto-exposure cameras that have a matrix metering system will do better in such situations because they are pro-grammed to recognize the signals of the contrast differences and bias their exposure for the important subject area. No matter how sophisticated the metering system, you must be careful not to aim the lens directly into a bright light, such as a stray spotlight or even a reading lamp. If you do, the meter will underexpose the subject.

In many existing-light situations, you may find that using the existing-light exposure table on page 218 gives more reliable results. Or you can simply bracket your exposures.

Auto-focus systems may also be adversely affected by low light levels. As mentioned earlier, auto-focus lenses have difficulty focusing in extremely dim or low-contrast lighting. Some cameras focus better than others in low light, but there are a few tricks you can use to help any auto-focus system. If you are photographing a spotlighted act, for instance, keep the brightly lit subject centered in the focusing area of the viewfinder. If you don't want the subject in the center, you can use the focus lock to hold focus while you recompose.

If the lamp is behind your subjects, their faces will be too dark because of dark shadows.

Don Maggio

At night it helps to turn on all the lamps in the room to lighten the shadows on the subject. More lamps also help provide enough light so you can handhold your camera when you use a high-speed film.

John Menihan

The soft, diffuse light from existing daylight is excellent for photographing subjects indoors. Compare the lighting in this photo with the tungsten household lighting used for the photo above. Notice how reflected light from the sheet music brightens the shadowed face?

Patrick Walmsley

Cynthia Heckelsberg

Normally pictures taken by window light work best when direct sunlight isn't streaming through the window. This photographer, however, was able to use the sunlight to partially light the subject and make an attractive photo.

Museums have fascinating displays which offer superb opportunities for existing-light photographs. When the scene and displayed objects are lighted evenly, expose according to an overall meter reading. Otherwise get as close as possible to the subject to make your reading.

Bob Clemens

Life-sized dioramas yield pictures that are almost like those taken of a real-life scene. If there is a framework surrounding the diorama, it's frequently darker than the objects on display so move close enough so your exposure meter measures only the diorama in order to obtain the proper exposure.

John Fish

When windows are part of the picture, either make a close-up meter reading of the subject if you can or aim your meter or camera with built-in meter to the side away from the window toward a similarly lighted subject to take the meter reading. Set the exposure on your camera, recompose the picture in the viewfinder, and take the picture. KODAK EKTACHROME 200 Film (Daylight)

Barbara Jean

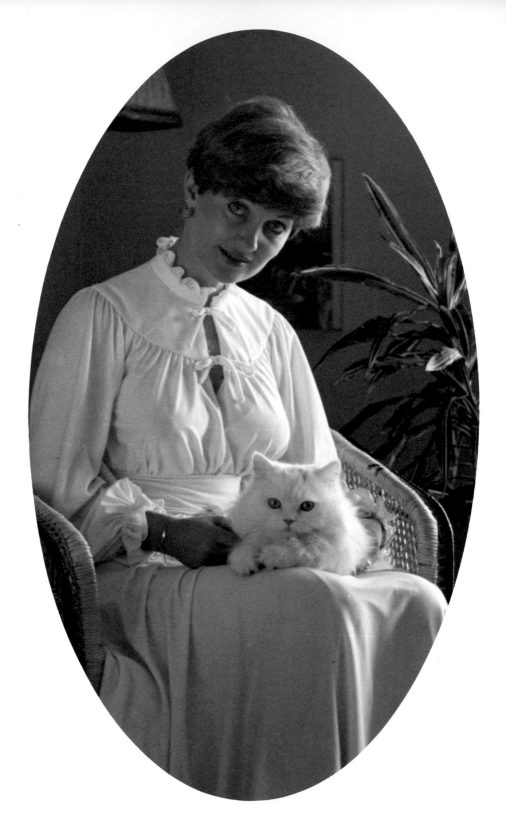

You can often improve existing daylight pictures by using a reflector to fill in the shadow side of the face similarly to using a reflector outdoors. This rewarding informal portrait shows how sidelighting from the window highlights the right side of the subjects with the shadows lightened by the reflector. KODAK EKTACHROME 400 Film (Daylight)

Gary Whelpley

If no reflector is used, the shadow on the face is quite dark. The reflector was turned to show its surface. It's not reflecting light on the subjects in this picture.

This shows the position of the reflector and window for the picture on the left. The reflector should be close enough to the subjects to fill in the shadows. Keep the reflector outside the picture area.

For the reflector you can use crumpled or textured aluminum foil or a large white card. Here aluminum foil was wrapped over a piece of plywood. The plywood was mounted on a light stand with a ball-joint adapter, both of which are sold by photo dealers. You can also mount the reflector on the tilting head of your tripod or you can have a helper hold the reflector in the proper position.

You can use either gold or silver aluminum foil for the reflector surface. Gold foil was used for this setup to add a little yellow or warmth to the bluish light from a winter day. Silver and gold foils are available from art or display supplies stores. You can also use silver aluminum foil sold in food stores.

A ¼ x 20 threaded T-nut for pounding into wood was used on the back of the plywood to attach to the threaded bolt of the ball-joint adapter. This kind of nut for use in wood is sold by hardware stores.

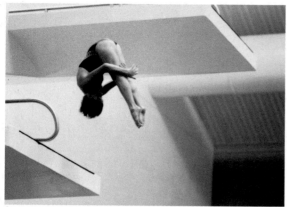

Neil Montanus

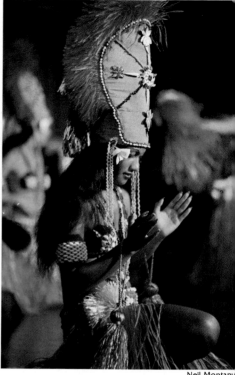

Indoor sporting events are usually evenly lighted so exposure meter readings of the action area will indicate correct exposure. If your seat is far away, try to make an exposure meter reading up close before the contest begins.

The background and surroundings for performers in stage shows are often dark. Since an exposure meter would measure the dark surroundings, the pictures would be overexposed. Make a close-up meter reading if you can or try the exposure given in the existing-light exposure table in this book.

Neil Montanus

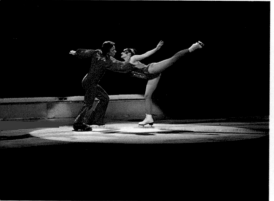

John Menihan, Jr.

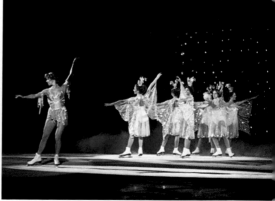

John Menihan, Jr.

KODAK EKTACHROME 200 Film (Daylight), 1-stop push processing, 1/250 second f/2.8

Since the lighting changes rapidly at ice shows and often includes larg' areas of darkness, it's not practical to make exposure readings of some acts. Suggested exposures for ice shows are given on page 218. Because conditions vary, you should bracket your exposures.

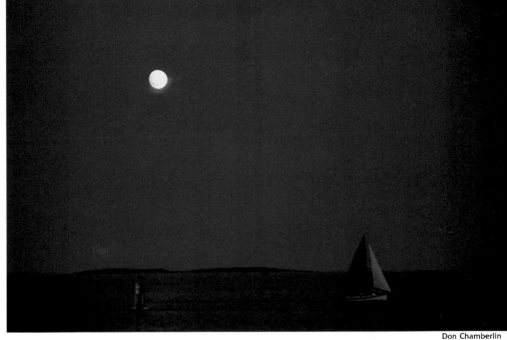

Don Chamberlin

A full moon and a sailboat combine to form a romantic image. For best results, take photographs of the moon at twilight, when it's light enough to easily see the scene yet dark enough so that the moon dominates.

## EXISTING-LIGHT PICTURES OUTDOORS AT NIGHT

Brightly illuminated street scenes, amusement parks, campfires, interesting store windows, and floodlighted buildings and fountains all offer good nighttime picture-taking possibilities. The best time to shoot outdoor pictures at night is just before complete darkness when there's still some rich blue left in the sky. The deep colors of the sky at dusk make excellent backgrounds for your pictures.

Outdoor photography at night is easy, primarily because of the pleasing results you can get over a wide range of exposures. The subject usually consists of large dark areas surrounding smaller light areas. Short exposures leave the shadows dark and preserve the color in the bright areas, such as illuminated signs. Longer exposures tend to wash out the brightest areas, but produce more detail in the shadows.

When your subject is evenly illuminated, try to get close enough to take an exposure-meter reading. Many floodlighted buildings and store windows fall into this category. Night sporting events also are usually illuminated evenly. Before you take your seat at the event, make an exposure-meter reading from a position close to the spot where the action will take place, and set your camera accordingly. When you can't take a meter reading of your subject, use the exposure suggestions in the table on page 218 as a guide. If the idea of existing-light photography really catches your fancy, you may want to read the KODAK Workshop Book *Existing-Light Photography* (KW-17), available from photo dealers.

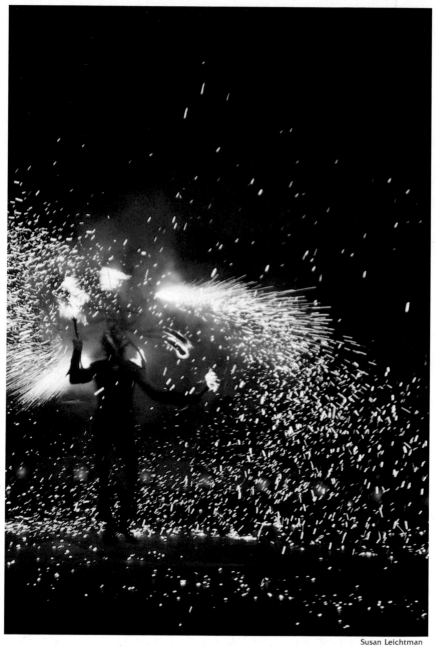

Susan Leichtman

The unusual but colorful streaks from fireworks make them a favorite subject. Although this shot was made on EKTACHROME 160 Film (tungsten), a faster film, such as KODAK EKTAR 1000 Film would be a better choice.

You can use medium-speed film for existing-light night pictures if you put your camera on a tripod and make a time exposure. A long exposure will record only light streaks from moving traffic as it did in this shot made in London, England. The 1-second exposure at f/16 was long enough to capture bright streaks from the fairly dense passing traffic and short enough to preserve sharp details on the brightly lighted buildings. Made on EKTACHROME 100 Film.

Patrick Walmsley

Butch Lunceford

Firefighters silhouetted against a wall of flames is a shot that could only be made at night. The realism of existing-light photos is one of their strengths. Unlike this photojournalistic image, most night subjects allow you to take your time to focus, compose, and determine exposure.

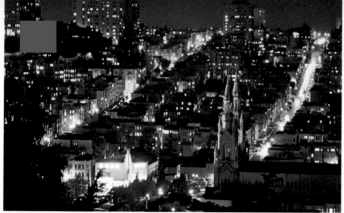

Lighted city streets are dazzling subjects for existing-light pictures. A high location, such as in a building, provides a good viewpoint for taking pictures. KODAK EKTACHROME 200 Film (Daylight), San Francisco, California

Herb Jones

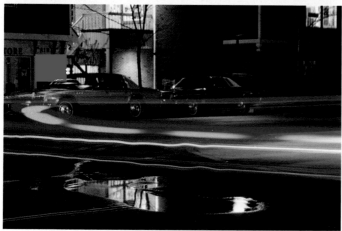

You can record intriguing light patterns from traffic by making long exposures in areas where there is little or low-intensity ambient lighting. It may be helpful to use a low- or medium-speed film, such as EKTACHROME 100 HC Film.

John Menihan

A multi-image device attached to the lens was used to make the explosive montage at left. The conventional photo at right was taken without the multi-image device. Made in London, England.

Patrick Walmsley

Photographing a sidewalk musician at night will be easy if you have KODAK EKTAR 1000 Film in your camera.

Michele Hallen

When you go to see the fireworks, take your camera along. The colorful, striking displays make spectacular pictures. You'll get the best results if you put your camera on a tripod, open the shutter on BULB, and record several bursts before you close the shutter. For KODAK EKTACHROME 200 Film (Daylight), set your camera lens opening on f/11.

If you don't have a tripod you can handhold your camera to take pictures, but you'll have to set the shutter speed on 1/30 second and the lens opening at f/2. With the brief exposure time necessary for handholding your camera, take the pictures when there are many firework bursts in the sky, as during the finale.

Caroline Grimes

# SUGGESTED EXPOSURES FOR EXISTING-LIGHT PICTURES WITH *KODAK* FILMS[*]

| Picture Subjects | KODACHROME 64 (Daylight) EKTACHROME 100 HC (Daylight) KODACOLOR GOLD 100 EKTAR 125 / T-MAX 100 Professional | EKTACHROME 200 (Daylight) EKTACHROME 160 (Tungsten) normal processing KODACHROME 200 KODACOLOR GOLD 200 / PLUS-X Pan | EKTACHROME 400 (Daylight) normal processing / EKTACHROME 200 (Daylight)— EKTACHROME 160 (Tungsten)— with push processing[†] / KODACOLOR GOLD 400 TRI-X Pan T-MAX 400 Professional | EKTAR 1000 EKTACHROME P800/1600 Professional (Daylight) at EI 800[‡] EKTACHROME 400 (Daylight)[†]— with push processing | KODACOLOR GOLD 1600 T-MAX P3200 Professional |
|---|---|---|---|---|---|
| Home interiors at night—<br>Areas with bright light<br>Areas with average light | 1/15 sec *f*/2<br>1/4 sec *f*/2.8 | 1/30 sec *f*/2<br>1/15 sec *f*/2 | 1/30 sec *f*/2.8<br>1/30 sec *f*/2 | 1/30 sec *f*/4<br>1/30 sec *f*/2.8 | 1/60 sec *f*/4<br>1/30 sec *f*/4 |
| Interiors with bright fluorescent light§ | 1/30 sec *f*/2.8 | 1/30 sec *f*/4 | 1/60 sec *f*/4 | 1/60 sec *f*/5.6 | 1/125 sec *f*/5.6 |
| Indoor and outdoor Christmas lighting at night, Christmas trees | 1 sec *f*/4 | 1 sec *f*/5.6 | 1/15 sec *f*/2 | 1/30 sec *f*/2 | 1/30 sec *f*/2.8 |
| Ice shows, circuses, and stage shows—for spotlighted acts only | 1/60 sec *f*/2.8 | 1/125 sec *f*/2.8 | 1/250 sec *f*/2.8 | 1/250 sec *f*/4 | 1/500 sec *f*/5.6 |
| Basketball, hockey, bowling | 1/30 sec *f*/2 | 1/60 sec *f*/2 | 1/125 sec *f*/2 | 1/125 sec *f*/2.8 | 1/250 sec *f*/2.8 |
| Night football, baseball, racetracks, boxing | 1/30 sec *f*/2.8 | 1/60 sec *f*/2.8 | 1/125 sec *f*/2.8 | 1/250 sec *f*/2.8 | 1/500 sec *f*/2.8 |
| Brightly lighted downtown street scenes (Wet streets make interesting reflections.) | 1/30 sec *f*/2 | 1/30 sec *f*/2.8 | 1/60 sec *f*/2.8 | 1/60 sec *f*/4 | 1/125 sec *f*/4 |
| Brightly lighted nightclub or theatre districts—Las Vegas or Times Square | 1/30 sec *f*/2.8 | 1/30 sec *f*/4 | 1/60 sec *f*/4 | 1/125 sec *f*/4 | 1/250 sec *f*/4 |
| Store windows at night | 1/30 sec *f*/2.8 | 1/30 sec *f*/4 | 1/60 sec *f*/4 | 1/60 sec *f*/5.6 | 1/125 sec *f*/5.6 |
| Floodlighted buildings, fountains, monuments | 1 sec *f*/4 | 1/2 sec *f*/4 | 1/15 sec *f*/2 | 1/30 sec *f*/2 | 1/30 sec *f*/2.8 |
| Fairs, amusement parks at night | 1/15 sec *f*/2 | 1/30 sec *f*/2 | 1/30 sec *f*/2.8 | 1/60 sec *f*/2.8 | 1/60 sec *f*/4 |
| Skyline—10 minutes after sunset | 1/30 sec *f*/4 | 1/60 sec *f*/4 | 1/60 sec *f*/5.6 | 1/125 sec *f*/5.6 | 1/125 sec *f*/8 |
| Burning buildings, bonfires, campfires | 1/30 sec *f*/2.8 | 1/30 sec *f*/4 | 1/60 sec *f*/4 | 1/125 sec *f*/4 | 1/125 sec *f*/5.6 |
| Aerial fireworks displays—Keep camera shutter open on BULB for several bursts. | *f*/8 | *f*/11 | *f*/16 | *f*/22 | *f*/22 |
| Niagara Falls—<br>White lights<br>Light-colored lights<br>Dark-colored lights | 15 sec *f*/5.6<br>30 sec *f*/5.6<br>30 sec *f*/4 | 8 sec *f*/5.6<br>15 sec *f*/5.6<br>30 sec *f*/5.6 | 4 sec *f*/5.6<br>8 sec *f*/5.6<br>15 sec *f*/5.6 | 1 sec *f*/8<br>4 sec *f*/5.6<br>8 sec *f*/5.6 | 2 sec *f*/8<br>2 sec *f*/5.6<br>4 sec *f*/5.6 |

[*]These suggested exposures apply to daylight and tungsten color films. When you take color pictures under tungsten illumination, they look more natural when you use tungsten film. Daylight film produces pictures more orange, or warmth, in color. You can use KODACOLOR GOLD Films in both kinds of light.

[†]You can increase the speed of KODAK EKTACHROME 400, 200, and 160 Films in 135 size 2 times by having them push processed when when you return the film for processing. See page 57 for details.

[‡]KODAK EKTACHROME P800/1600 Professional Film (Daylight) can be rated at EI 800 with 1-stop push processing (Push 1), at EI 1600 with 2-stop push processing arranged by your photo dealer, and sometimes even at EI 3200. To use the EI 1600 film speed, merely *decrease* suggested exposure in this column by *one stop*, at EI 3200 *decrease* exposure by *two stops*.

§Tungsten color film is not recommended for use with fluorescent light. Shutter speeds of 1/60 second or longer are recommended for uniform and adequate exposure with fluorescent lighting.

‖Shutter speeds 1/125 second or longer are recommended for uniform and adequate exposure with lighting from multi-vapor or mercury vapor high-intensity discharge lamps.

➡Use a tripod or other firm support with shutter speeds slower than 1/30 second.

Marty Czamanske

# FILTERS AND LENS ATTACHMENTS

In color photography you can use filters to bring lighting and other environmental conditions to realistic terms with the film in your camera. You can also use filters to create dramatic interpretive views, such as the photo above, taken with a split-field sepia filter under hazy, uninteresting lighting in rural Sweden.

## FILTERS FOR COLOR PHOTOGRAPHY

For most color pictures, no filter is necessary when you use a film with the light source for which it is balanced. However, there is one filter that many photographers like to have on hand. This is the No. 1A, or skylight, filter. The skylight filter reduces the bluishness of scenes photographed on overcast days or in the shade. It also helps reduce the bluishness in shots of distant scenes and in aerial pictures. Use a skylight filter only with daylight-type, color-slide films. The printer will correct for excess bluishness in color prints made from color-negative films. No exposure compensation is necessary with the skylight filter.

### CONVERSION FILTERS

When you use a color film with a light source other than the one for which it was designed, you should use a conversion filter over the camera lens. The conversion filter adjusts the color of the light source to match that for which the film is balanced. The chart on page 221 contains film, light source, and filter combinations for Kodak color films.

219

John Menihan, Jr.

A conversion filter adjusts the color of the light source—the sun for these pictures—to match the color balance of the film. The photos were taken on KODACHROME 40 Film 5070 (Type A). The one on the left was taken with a No. 85 conversion filter over the camera lens. The picture on the right, taken without a filter, is too blue.

Patrick Walmsley

These pictures were taken on daylight film with 3400 K photolamp illumination. A No. 80B conversion filter over the camera lens was necessary to adjust the color of the light for the daylight balance of the film. The photo on the right, taken without a filter, is too yellow. KODAK EKTACHROME 200 Film (Daylight)

## CONVERSION FILTERS FOR *KODAK* COLOR FILMS

| Light Source | KODACOLOR GOLD 100, 200, 400, and 1600 (Daylight) EKTAR 25,125, and 1000 (Daylight) KODACHROME 25, 64, and 200 (Daylight) EKTACHROME 100 HC (Daylight) EKTACHROME 200 and 400† (Daylight) EKTACHROME P800/1600 Professional (Daylight) | KODACHROME 50 5070 (Type A) | EKTACHROME 160 (Tungsten) | EKTACHROME Infrared 2236 |
|---|---|---|---|---|
| Daylight | None | No. 85 | No. 85B | No. 12 or 15 |
| Blue Flash | None | No. 85 | No. 85B | No. 12 or 15 |
| Electronic Flash | None* | No. 85 | No. 85B | No. 12 or 15 |
| Photolamps 3400 K | No. 80B | None | No. 81A | No. 12 or 15 plus CC50C-2 |
| Tungsten 3200 K | No. 80A | No. 82A | None | — |

*Use a No. 81B filter if your pictures are consistently too blue.
†For critical use.

## POLARIZING SCREENS

A polarizing screen looks like a simple piece of gray glass. However, you can put this handy screen to work performing such tasks as darkening blue skies and reducing reflections in your pictures.

**Reflections.** You can use a polarizing screen to reduce or eliminate reflections, except those from bare metal. If you look through a polarizing screen at reflections on a shiny surface and then rotate the screen, you'll see the reflections change. At one point they may be completely eliminated. The polarizing screen will have the same effect in your pictures when you use it over your camera lens.

When you're looking through the polarizing screen, if reflections from a shiny surface are not reduced enough, try a different viewpoint or camera

Pictures that include glass surfaces often show distracting reflections or glare.

John Menihan, Jr.

You may be able to remove or reduce the reflection or glare by using a polarizing screen.

The glare of the sun on this glossy tile mosaic has been almost eliminated by using a polarizing screen.

Paul Yarrows

Colors may become more saturated when you use a polarizing screen because reflections are reduced.

With polarizing screen    Barbara Jean

Without polarizing screen

angle. Sometimes this will make the polarizing screen more effective.

You'll obtain the maximum effect with a polarizing screen in reducing reflections when the camera angle is about 35 degrees from the reflecting surface, depending on the surface material. At other angles the polarizing screen is less effective. At 90 degrees a polarizing screen has no effect in controlling reflections.

We mentioned earlier that you can get some great shots with backlighting. But backlighting often creates bright reflections from the sun (or other light sources) on water, foliage, boat decks, etc. You can use a polarizing screen to reduce or eliminate these reflections in your pictures. And since reflections desaturate the colors of a subject, reducing the reflections allows the colors in the photograph to be more saturated.

**Dramatic Skies.** You can make a blue sky darker in a color photograph without affecting the color rendition of the rest of the scene by using a polarizing screen. When you photograph the sky *at right angles to the sun,* you can control the depth of the blue, from normal to dark, simply by rotating the polarizing screen. The sky will look darkest when the indicator handle of the screen (if it has one) points at the sun. If your polarizing screen doesn't have a handle, you can determine the area of the sky the polarizer will darken by forming a right angle with your thumb and index finger. Point your index finger at the sun and as you rotate your hand, your thumb indicates the area in the sky that the polarizer can darken. With black-and-white film you can get night effects by using a red filter and a polarizing screen together. The sky effects created by a polarizing screen appear most striking with a very clear blue sky, but disappear completely with an overcast sky.

Patty Van-Dolson

You can use a polarizing screen to darken a blue sky without darkening other parts of the picture. You can control the degree of darkening by rotating the polarizing screen.

Robert Kretzer

A polarizing screen will darken only that portion of the sky 90 degrees from the sun. This photograph, taken through a polarizing screen, shows the area of the sky on the right that's at the proper angle to darken. The area of the sky to the left near the sun is at an improper angle so it didn't darken. The area in the sky that will darken with a polarizing screen is a large band across the sky. The band is large and wide enough so the edge of it will not usually show in pictures if you take them with your camera aimed away from the edge of the band.

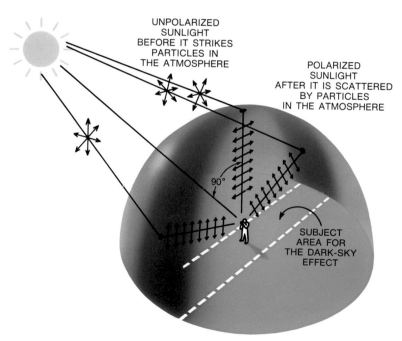

This illustration shows the area or band across the sky that will darken with a polarizing screen when you take pictures at right angles to the sun with the handle of the polarizing screen—if it has one—pointing at the sun.

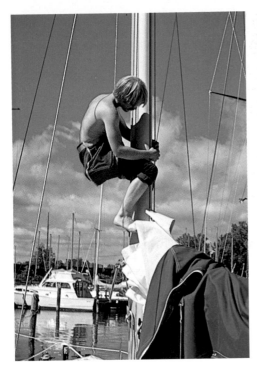

John Menihan, Jr.

This comparison shows the effects of using a polarizing screen. With a polarizing screen on the right, the sky is a deeper blue and the colors of the red tool bag and blue sail cover are more saturated.

# FILTERS

When you use a polarizing filter on a single-lens-reflex camera, you can see its effects through the camera viewfinder as you rotate the filter. But remember, if you are using a lens in which the filter ring on the front of the lens barrel turns as you focus, the polarizing filter will also turn and alter the effect if you change focus. Before you take the picture, be sure to check that the filter is in the proper orientation. With non-SLR cameras, hold the filter and look through it as you rotate it; when you see the effect you want, keep the filter in exactly the same orientation as you slip it over the camera lens.

You can also use a polarizing screen to reduce the appearance of atmospheric haze in distant views.

A polarizing screen has another application you may find useful. Since you have to increase exposure with a polarizer over the lens (see page 227), you can use a larger lens opening to reduce depth of field, such as when you want the background out of focus to concentrate attention on the subject. This is especially helpful when you take pictures on a high-speed film in bright sunlight and you want less depth of field.

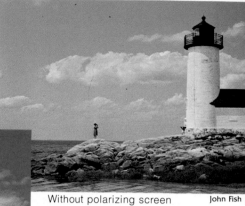

Without polarizing screen          John Fish

When the color of the sky is a lighter blue and not as saturated in color as it sometimes is, a polarizing screen will not darken the sky as much as when it's a deeper blue to begin with. When the sky is white as on an overcast day, a polarizing screen will have no effect. Annisquam Light. Cape Ann, Massachusetts.

With polarizing screen

Here the sky is a clear blue so the polarizing screen has darkened it considerably in the bottom photo. Capitol Reef National Park, Utah

Caroline Grimes

226

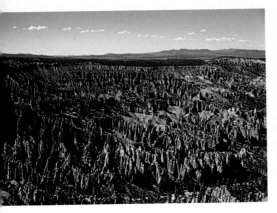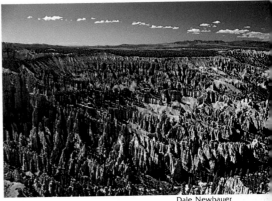

Dale Newbauer

The use of a polarizing screen for the slide on the right has increased the brilliance of the eroded rock formations in Bryce Canyon, Utah.

**Exposure.** When you use a polarizing screen, you must compensate for the light it absorbs. For a normal frontlighted subject, increase the exposure by $1^1/_2$ stops. This exposure increase applies regardless of the rotation of the polarizing screen. If your subject is sidelighted or toplighted, as it will be when you are using the screen to get a dark-sky effect, give it $^1/_2$ stop more exposure, or a total of 2 stops more than for a normal frontlighted subject. The extra $^1/_2$ stop usually is not necessary with a distant subject or a landscape where shadows are only a tiny part of the scene.

When you determine the exposure for subjects with bright reflections, remember that removing the reflections with a polarizing screen will make your subject appear darker than it was before. So in addition to the $1^1/_2$ stops more exposure required to compensate for the polarizing screen and any exposure increase necessary for the direction of the lighting, increase the exposure by another $^1/_2$ stop when bright reflections will be removed from the subject.

Calculating the exposure increase to compensate for a polarizing screen on the camera lens is more effective in obtaining correct exposure than using an

exposure meter to make the reading through the polarizing screen. A reading made through a polarizing screen with a built-in meter or with a separate exposure meter varies with the rotation of the polarizer. Such a meter reading can indicate the wrong exposure because the exposure increase required for a polarizing screen is the same regardless of the rotation of the polarizer. For example, when you use a polarizing screen to darken a blue sky, the meter reading would be affected by the darkened sky; however, you really don't want to make the adjustment the meter indicates because you want the sky to be darker than normal.

Also, because of the semi-silvered mirrors used in auto-focus (and some auto-exposure) cameras, the normal "linear" polarizing filters used for manual-focus cameras can cause problems with the exposure systems and even with auto-focusing. With most auto-focus cameras, you should use a **circular** polarizing filter—one that has its crystals arranged in a circular rather than linear pattern. See which type of filter your manual recommends before buying a polarizing filter.

Although a red filter is commonly used to dramatize blue sky, the photographer realized that a red filter would make the red stripes of the flag virtually invisible. However, the yellowish-green No. 11 filter darkened both the sky and the red stripes of the flag.

Derek Doeffinger

# FILTERS FOR BLACK-AND-WHITE PHOTOGRAPHY

The two basic classes of filters for black-and-white photography are correction filters and contrast filters.

## CORRECTION FILTERS

Panchromatic films respond to all the colors that the human eye can see but they don't reproduce them in the same tonal relationship that the eye sees. For example, although blue and violet normally look darker to the eye than

green does, black-and-white panchromatic film is very sensitive to blue and violet. Consequently, these colors will be lighter than green in a black-and-white print.

Fortunately, you can easily change the response of the film so that all colors are recorded with approximately the same tonal relationship that the eye sees simply by your using a correction filter over the camera lens. To get this natural tonal relationship with Kodak panchromatic films, use a No. 8 filter in daylight or a No. 11 filter in tungsten light.

# DAYLIGHT FILTER RECOMMENDATIONS FOR BLACK-AND-WHITE FILMS IN DAYLIGHT

| Subject | Effect Desired | Suggested Filter | Increase Exposure by This Many Stops for | |
|---|---|---|---|---|
| | | | TRI-X and PLUS-X Films | T-MAX 100 T-MAX 400 Professional Films |
| Blue sky | Natural | No. 8 Yellow | 1 | $2/3$ |
| | Darkened | No. 15 Deep Yellow | $1^1/3$ | 1 |
| | Spectacular | No. 25 Red | 3 | 3 |
| | Almost black | No. 29 Deep Red | 4 | 4 |
| | Night effect | No. 25 Red, plus polarizing filter | $4^1/2$ | $4^1/2$ |
| Marine scenes when sky is blue | Natural | No. 8 Yellow | 1 | $2/3$ |
| | Water dark | No. 15 Deep Yellow | $1^1/3$ | 1 |
| Sunsets | Natural | None or No. 8 Yellow | 1 | $2/3$ |
| | Increased brilliance | No. 15 Deep Yellow or No. 25 Red | $1^1/3$ <br> 3 | 1 <br> 3 |
| Distant landscapes | Increased haze effect | No. 47 Blue | $2^3/3$ | 3 |
| | Very slight addition of haze | None | | |
| | Natural | No. 8 Yellow | 1 | $2/3$ |
| | Haze reduction | No. 15 Deep Yellow | $1^1/3$ | 1 |
| | Greater haze reduction | No. 25 Red or No. 29 Deep Red | 3 <br> 4 | 3 |
| Foliage | Natural | No. 8 Yellow or No. 11 Yellowish-Green | 1 <br> 2 | $2/3$ <br> $1^2/3$ |
| | Light | No. 58 Green | $2^2/3$ | $2^2/3$ |
| Outdoor portraits against the sky | Natural | No. 11 Yellowish-Green No. 8 Yellow | 2 <br> 1 | $1^2/3$ <br> $2/3$ |
| Architectural stone, wood, sand, snow when sunlit or under blue sky | Natural | No. 8 Yellow | 1 | $2/3$ |
| | Enhanced texture rendering | No. 15 Deep Yellow or No. 25 Red | $1^1/3$ <br> 3 | 1 <br> 3 |

## CONTRAST FILTERS

A filter lightens its own color in a black-and-white print and darkens the complementary color. For example, a yellow filter lightens yellows and darkens blues.

You can use contrast filters to lighten or darken certain colors in a scene to create brightness differences between colors that would otherwise be reproduced as nearly the same shade of gray. For example, a red apple and green leaves that are equally bright would reproduce as about the same tone of gray in a print. To provide separation between the apples and leaves, you might shoot through a red filter. This would lighten the red apple in a print and darken the green leaves.

Paul Kuzniar

This photo shows the color and tone rendition of the original scene.

Exposed without a filter

Exposed through a No. 11 yellowish-green filter

Exposed through a No. 8 yellow filter

Exposed through a No. 15 deep-yellow filter

Exposed through a No. 25 red filter

Most SLR cameras automatically indicate the correct exposure when reading light passing through a colored filter. Check your camera manual to see if your camera does. A No. 25 red filter was used to darken the blue sky in this photo.

Derek Doeffinger

## EXPOSURE COMPENSATION WITH FILTERS

Since colored filters absorb some of the light that would normally reach the film, you must compensate for the light lost by using a larger lens opening or a longer exposure time. This extra exposure, which is different for each type of filter, is based on a filter factor. A filter factor is a number that tells you how much to increase the exposure when you use that filter.

In practice, however, you probably won't have to concern yourself with filter factors too often, because most cameras with built-in TTL meters will measure the light through a lens-mounted filter. Simply set the speed for the film you're using and, put the filter on the lens; the meter will automatically make the adjustment for the light loss.

If you want to use a filter factor, take your meter reading through the lens without the filter (or use a handheld meter), calculate the extra exposure needed, set the adjusted exposure on the camera, and then mount the filter. For example, a filter with a factor of 2 means that you need twice as much or one stop more exposure. After you make your meter reading, you can either open the lens by one stop or use an exposure time twice as long (the next slower speed). A filter with a factor of 4 would mean you need four times as much light—or two stops. (Just remember that each time the factor doubles, you have to add another stop.)

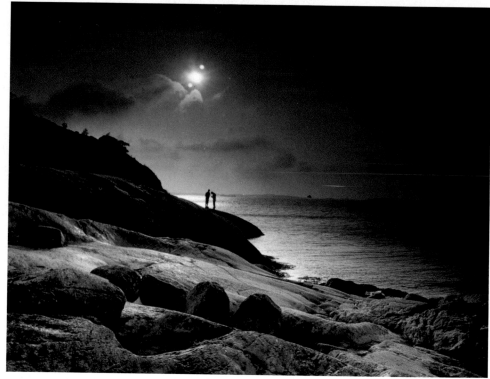

Marty Czamanske

For a stimulating, fresh approach to your picture-taking you can take advantage of filters and lens attachments to enlarge your creative experience. This picture was taken through a split-field sepia tone filter and vignetted by hand to frame the couple on the beach.

## USING FILTERS AND LENS ATTACHMENTS FOR CREATIVE PICTURES

There are many dramatic effects you can obtain in your pictures by using filters and other lens attachments creatively. The use of color filters with color film can enhance or change the mood of a picture. You can use an orange or magenta filter to suggest rich, warm sunlight of late afternoon in your color pictures. With a blue filter you can portray the somber, cool effect of twilight or moonlight while the sun is

still above the horizon. You can also use filters of other colors depending on the effect you want to create. Just look through the filter for a preview of how the scene will look in the picture.

Determining the exposure is easy when you use filters to give the picture an overall cast of color. Since you are altering the appearance of the original scene and orange and blue filters are suggesting early or late times of day,

Herb Jones

Normal scene—
no filter

Blue filter

Orange filter

You can use filters with color film to change the mood of a scene and its overall appearance. You can use a blue filter, such as a No. 80A filter, to suggest twilight of dawn or dusk or an orange filter, such as a No. 21 filter, to suggest the orange light from the setting sun. The hues of blue and orange filters seem to work best because these colors sometimes naturally appear to a limited extent during periods of dawn or dusk. As a result, scenic pictures with blue or orange tones are somewhat believable. KODACHROME 64 Film (Daylight)

the exposure is not critical. Less exposure, which gives darker pictures, implies dimmer lighting while more exposure, which produces lighter pictures, implies brighter lighting. Usually you can just follow the exposure indicated by a meter reading made through the filter. You may want to bracket your exposures so that you have a choice of brightness in your pictures.

Dark-colored filters block a lot of light. These filters can interfere with the focusing of auto-focus cameras. If this is the case, you must switch to manual focusing when you use these filters.

Most filters produce only one color. But variable-color filters are available that let you adjust the intensity of the color from light to dark. Other variable-color filters produce either of two colors or various shades in between—for example, yellow or red with shades of orange between the two extremes. Once you have a variable-color filter adjusted for the color you want, you can use it just like a conventional color filter.

You can obtain still other filters that are similar to conventional filters except that only half of the filter is colored while the other half is clear. This feature lets you change the color in only part of the scene, like the sky.

Rather than using color filters, you can use other kinds of filters over your camera lens for a different approach to creative pictures. These filters are constructed with various optical properties that produce effects such as diffusion, pointed-star images, and streaks of light with bands of color in them. It's easy to use these filters because you can see the effects you'll obtain when you view the scene through the filter. When you use the filter over the lens on a single-lens reflex camera, you can see the effect through the camera viewfinder. With a camera that has a direct optical viewfinder (non-single-lens reflex), you'll have to view the scene through the filter first before putting it on your camera.

Herb Jones

An orange filter is good for scenes which include sand because this color effectively portrays the hot broiling rays of the sun. KODACHROME 64 Film (Daylight)

A diffusion filter will give you a soft-focus, diffused image which portrays a subdued dreamlike effect. These filters come in various degrees of diffusion which produce effects ranging from a slight haziness to pronounced diffusion with a misty appearance, soft highlights, and merging colors. Diffusion filters do not usually require any change in exposure unless you want to produce a light, misty, or fog effect with a minimum of dark tones. Then you should try from 1/3 to 1-stop more exposure depending on the degree of diffusion in the filter. See the manufacturer's instructions for your filters.

Star-effect filters produce pointed starlike images of light sources and specular reflections that look like points of light in the original scene. These filters create streaks of light that radiate outward from the point of light. You can get 4-, 6-, and 8-pointed stars depending on the construction of the filter. By rotating the filter, you can change the direction of the streaks of light. Usually no exposure increase is required.

A diffraction filter is another filter you'll find useful for creating pictures that are out of the ordinary. Diffraction filters separate the light from light sources and specular reflections in the picture into a rainbow of colors in exotic patterns. Diffraction filters are available from your photo dealer that form multicolored linear streaks of light in two, four, or several directions. Other diffraction filters form different multicolor patterns, such as a circular one. These filters too are easy to use since you can see the optical effect when you look through the viewfinder of a single-lens reflex camera with the filter over the lens. With nonreflex cameras, look at the scene through the filter while rotating the filter. When you see the effect you want, keep the filter oriented in that position as you put it on your camera. No exposure increase is required with diffraction filters.

For a different avenue to exciting and spectacular pictures, experiment with multi-image lenses. These lenses with multifaceted surfaces fit on the front of your camera lens. The facets

Keith Boas

Here an orange filter has created the warm color of a setting sun. For exposure with the filter you can usually just go by the meter reading made through the filter. KODACHROME 64 Film (Daylight)

produce multi-images of the scene repeated in a straight row or arranged in a circular pattern. The number of images transmitted to your film may be 3, 5, or 6. These variations in pattern and number of images produced depend on the construction of the multi-image lens. You can rotate these lenses to obtain the most pleasing arrangement of the images in the picture. Since details surrounding the subject are also repeated, multi-image lenses work best with subjects against plain backgrounds like the sky, water, or a dark background with little detail.

Also, if you are using an auto-focus camera, keep in mind that since multiple-image or other optical-distortion filters distort the light entering the lens, they will probably interfere with the ability of the camera to focus correctly. Therefore, you may find that both the camera and the visual effect are more easily controlled if you switch to manual focusing.

Creative uses of filters and lens attachments to make intriguing pictures are limited only by your imagination. When you take creative pictures, there

are no definite rules. Anything you find pleasing can be a rewarding picture. Many types of filters and lens attachments are available, so it's a good idea to explore the selection of this equipment at your photo store.

One fairly recent addition to the world of creative filtering that you might want to investigate are filter systems. With these systems, you buy a screw-on adapter bracket that fits your lens and a filter holder that mounts on the adapter. The filters that go into these systems are usually acrylic squares that give a wide range of creative effects, including all of those mentioned in this chapter and more. The big benefit of using these systems is that even if you have several lenses with different filter diameters, you need only an adapter for each lens. Since the filters themselves are all the same size, you can use them on any lens. This will save you a lot of money if you have a variety of lenses with different filter sizes.

If you want to learn more about the subject, you may want to purchase the KODAK Workshop Book, *Using Filters* (KW-13), sold by photo dealers.

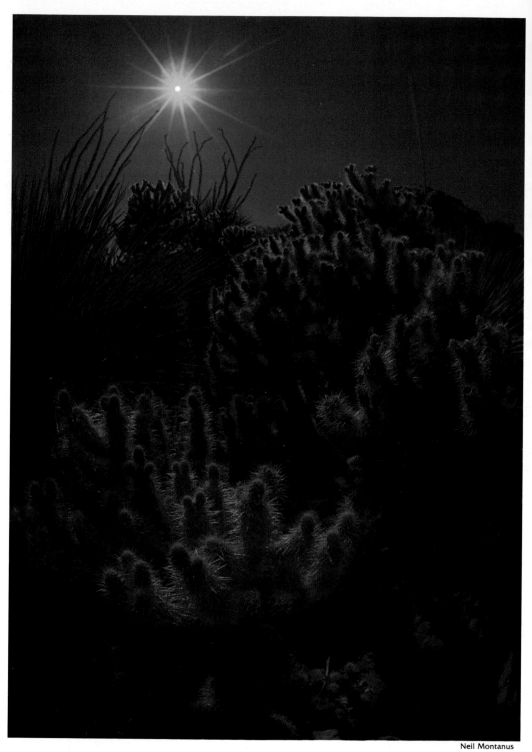

Neil Montanus

Choose the color of the filter to reinforce the mood of the scene. Here an orange filter exaggerates the heat implied by the presence of the cactuses. A star filter makes the sun seem even more blinding. Photo made on EKTAR 25 Film.

Herb Jones

For a surrealistic rendition, you can use a red No. 25 filter. The use of color filters to alter the normal appearance of the scene is more effective with backlighting, sunsets or sunrises, overcast skies, and misty or foggy days.

 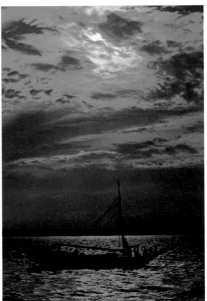

Neil Montanus

When you want just a slight amount of orange, you can use a No. 85 amber filter with daylight film.

You can use a deep-blue filter with a backlighted scene to create a moonlight effect. Try underexposing by 1 stop to produce the proper mood.

The atmosphere or mood suggested by an overcast day can be made even more somber when you photograph the scene through a blue filter.

Paul Kuzniar

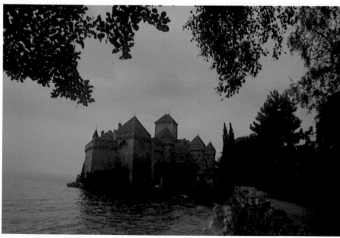

Paul Kuzniar

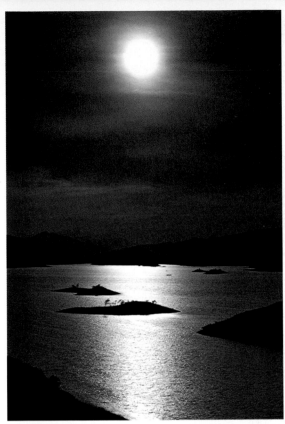

The appearance of the original scene has been altered only slightly by the use of a very faint, magenta filter—KODAK Color Compensating Filter, CC10M. KODACHROME 64 Film (Daylight)

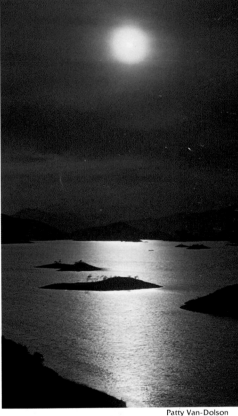

Patty Van-Dolson

Only an orange filter was used for this picture. Compare the results here with the bottom photo.

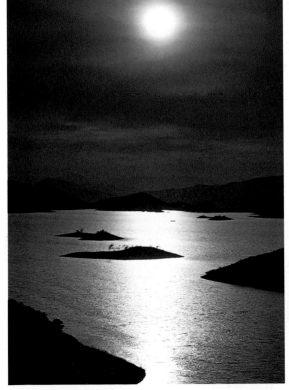

A No. 85 amber filter was used for the overall scene while an orange filter, such as a No. 21 filter, was used for only the top part of the picture from the horizon up. Photo dealers sell filters with the color in only half of the filter, the other half being clear. Or you can use a square piece of gelatin filter and hold it over part of your camera lens for the effect you want. You can see the results you'll get with a single-lens reflex camera when you look through the viewfinder with the filters in place.

Herb Jones

A diffusion filter softens tones and produces haziness to give the scene a dreamlike quality when recorded on color or black-and-white film. You can improve informal portraits with a diffusion filter by reducing contrast and harshness which smoothes and flatters complexions. The amount of diffusion varies depending on the construction of the filter. A filter that produced minimum diffusion was used to make the illustration above. Below, a different filter produced a greater degree of diffusion.

Herb Jones

Herb Jones

Herb Jones

Without filter

Although intended for scenic photos, a fog filter is also effective for portraits. Similar to a diffusion filter, you can see the effect of the fog filter in this comparison.

With fog filter

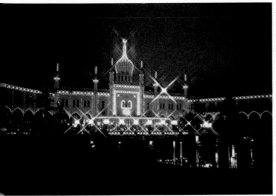

With star-effect filter                              Without filter          Robert Harris

A star-effect filter creates starlike images of point-light sources. Tivoli Gardens, Copenhagen, Denmark

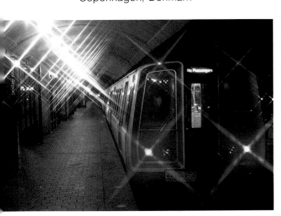
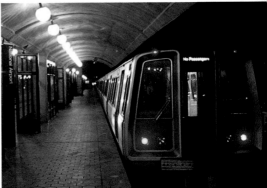

John Fish

You can make some night scenes more interesting by using a star-effect filter. Usually no exposure increase is required with this filter. KODAK EKTACHROME 400 Film (Daylight)

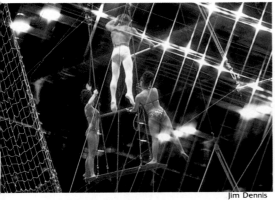

Jim Dennis

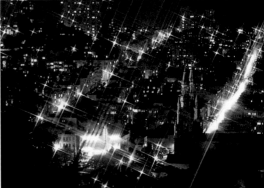

Herb Jones

The spectacular lighting used to illuminate performers often presents a good opportunity to improve the lighting effects even more by using a star-effect filter. Damascus Temple, Shrine Circus

A star-effect filter is particularly effective for outdoor night scenes.

243

Herb Jones

A starlike image of the sun masked by trees was produced by a star-effect filter.

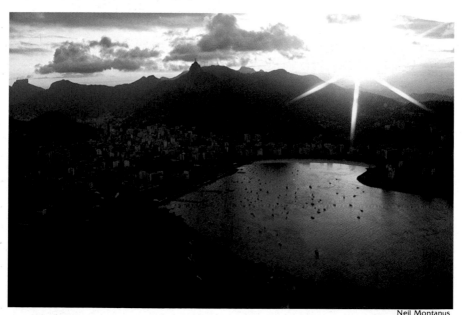

Neil Montanus

You can use a star-effect filter to create rays from the setting sun which can make a sunset picture even more appealing. Rio de Janeiro, Brazil, KODACHROME 64 Film (Daylight)

Steve Kelly

A star-effect filter will also create star-ray images from specular reflections in the scene.

Neil Montanus

Diffraction gratings produce various multicolored patterns depending on the filter. For you to see the effect, the scene must include a light source or specular reflections. You don't have to change the exposure for this filter.

Herb Jones

John Fish

The photographer recorded an interesting light fixture with a diffraction grating over the camera lens which produces a vertical color pattern. In the slide on the bottom, he combined a star-effect filter with the diffraction grating for an even more bizarre result.

When you see a photogenic light source that may be a good opportunity for an exciting picture with a diffraction grating filter, you can see the result you'll get by looking through the diffraction filter. You can rotate the filter to change the position of the pattern for the most pleasing arrangement.

Robert Fish

A multi-image lens repeats the image of the scene in a circular or straight-line pattern. The design of the multi-image lens determines the shape of the pattern.

Norm Kerr

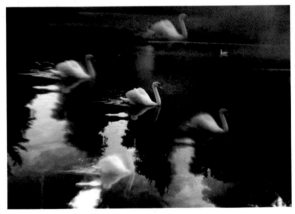

To avoid confusing clutter, use a subject with a plain background.

Norm Kerr

To use a multi-image lens, you fit it over the front of your camera lens. You can rotate the multi-image lens to position the images for the composition you like best. These lens attachments do not require any exposure compensation.

Jerry Antos

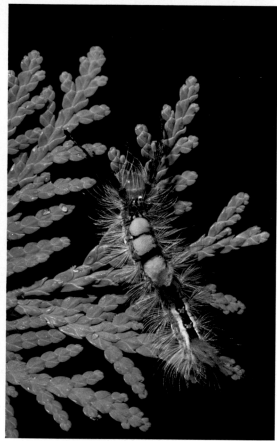

Robert Kretzer

The world of close-up photography lets you show the intricate detail of small subjects.

# CLOSE-UP PHOTOGRAPHY

Most 35 mm cameras will focus on subjects as close as 1½ to 2 feet without any special equipment. Although this is close enough for many subjects, you can find a whole new world of fascinating and unusual picture opportunities at closer distances. With

close-up equipment, you can take compelling photographs of flowers, small animals, insects, coins, stamps, and scale models and more. You can make tabletop pictures and copies of pictures or documents. The world of close-up photography can keep your imagination occupied for some time.

## CLOSE-UP LENSES

You can get into the close-up league with *any* camera simply by using close-up lenses. These are positive supplementary lenses that let you take sharp pictures at distances closer than those at which your lens would normally focus. Close-up lenses fit over your camera lens like a filter. They're available in different powers such as +1, +2, and +3. Each close-up lens is good for a limited range of close-up distances. The higher the number, the stronger the close-up lens and the closer you can get to your subject. The instructions that come with the lenses tell you what your subject distances should be at various focus settings and what area you'll be photographing at those distances.

You can use two close-up lenses together to get even closer to your subject. For example, a +2 lens and a +3 lens equals a +5 lens. Always use the stronger close-up lens next to the camera lens. Never use more than two close-up lenses together since this may affect the sharpness of your picture.

One benefit you have when you use close-up lenses is that no exposure compensation is necessary. Just expose as you would if you were photographing the same subject without a close-up lens.

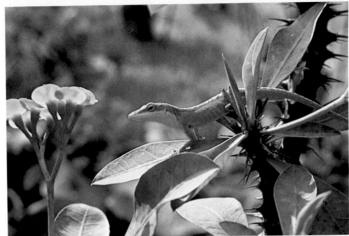

Art Trimble

An easy way to get into close-up photography is to use close-up lenses. You can use them with both rangefinder and single-lens reflex cameras. Close-up lenses fit on the front of the camera lens in the same way as a filter.

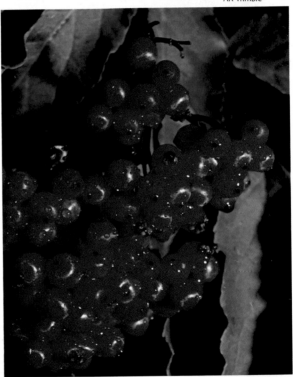

Close-up lenses are convenient to carry with you when you take pictures so they're available whenever you see a good subject for close-ups.

Robert Kretzer

Close-up lenses are made in various powers. The higher the number, the greater the magnification of the subject. These lenses are light, compact, and relatively inexpensive. The image quality they produce is acceptable but not as good as that of camera lenses specially designed for optimum close focusing. Therefore, you'll get better sharpness if you use lens openings of f/8 and smaller when you use close-up lenses. You'll also obtain better depth of field using a small lens opening.

Art Trimble

The requirements for a steady camera for sharp close-up photography are similar to those for telephoto lenses. Since the image is magnified in close-ups, so is any un-sharpness caused by an unsteady camera. You should use a shutter speed of at least 1/125 second or higher for sharp pictures with a handheld camera. A high shutter speed is also beneficial for stopping subject motion like live subjects or plants disturbed by a breeze.

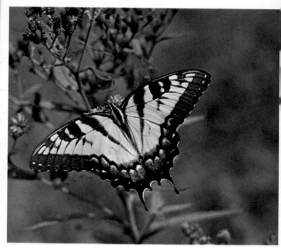

Lynn M. Stone

A close-focusing camera lens lets you take close-up pictures without using close-up lenses or lens-extension devices. Close-focusing lenses focus at shorter camera-to-subject distances than normal lenses.

Herb Mitchell

You'll get better pictures of close-up subjects near the ground if you take your pictures from a low camera angle. Since framing the subject in the viewfinder and focusing are more critical for close-ups, a tripod that will hold your camera firmly in the right position is a big help.

Because so many nature subjects are close to the ground, you should use a tripod adaptable to low-level photography. With this tripod, you can remove the lower half of the center post and then spread the legs wide to reach a low level. With some tripods, you can remove the "head" from the center post and attach it anywhere along one of the legs.

# CLOSE-FOCUSING LENSES

Some lenses, called macro or micro lenses, are designed for close-up photography. They let you focus at distances as close as 4 or 5 inches from the subject and obtain life-size images on your film without using a supplementary close-up lens. Macro lenses typically come in focal lengths of 50 mm and 100 mm. The longer focal length allows you to focus on small subjects from farther away— you don't have to get right on top of your subject, where you might block existing light or frighten it if it's an animal. Macro lenses are convenient because you can use them for close-ups one moment and for distant subjects the next without special attachments.

Most manufacturers of auto-focusing SLR cameras also make at least one auto-focusing macro lens. Some compact auto-focus cameras have a close-up switch that allows you to work at closer distance than the normal close-focusing distance. Auto-focus cameras are an ideal tool for close-up work because they let you choose your point of focus very precisely. Simply center the area that you want in sharp focus in the viewfinder and then use your focus lock to hold that focus. If you work in the single-shot auto-focus mode, you'll always be guaranteed a sharp image, since in this mode most auto-focus cameras won't allow you to trip the shutter unless the image is sharp.

A zoom lens that includes a telephoto range usually has a "macro" setting that allows you to take close-ups as well. With most of these zooms, the macro range functions at the telephoto end of the zoom, which means you can be fairly far away from your subject and still get a close-up image. However, at its closest focus, the macro setting of a zoom lens will yield an image smaller and less sharp than a true macro lens.

Because of the added lens extension required for close-up focusing, macro lenses may require an exposure increase

Sam Dover

Depth of field is very limited in close-up photography. Even with a small aperture such as f/16, depth of field will seldom exceed a few inches and for extreme close-ups may be less than an inch. By positioning the camera so its back is parallel to the subject you can align the plane of focus to the subject plane, thereby making the whole subject sharp.

at close subject distances. If you use a macro lens on a camera with a through-the-lens (TTL) meter, the meter will make the exposure compensation automatically. But if you are using a separate handheld meter or working with a manual flash unit, you will have to make the exposure compensation yourself. See the methods described under "Lens-Extension Devices" and "Lighting for Close-ups Outdoors."

251

There are many varied subjects that make good close-up pictures like this kachina doll. The photographer positioned the doll in the soft light of open shade. A *slight* amount of weak sunlight filtered by trees adds highlights to the feathers on the doll.

Gary Whelpley

Herb Jones

Bob Clemens

Learn to look at small segments of the overall scene for eye-catching close-up pictures.

Herb Jones

You can take extreme close-ups with an extension tube or bellows to extend the lens.

Norm Kerr

A bellows unit, shown here, or extension tubes provide another method of taking close-up pictures. These devices fit between the camera body and the camera lens. They extend the lens-to-film distance to permit close focusing. Depending on the lens extension you use, you can obtain image sizes larger than life size with this equipment.

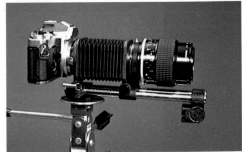

Jerry Antos

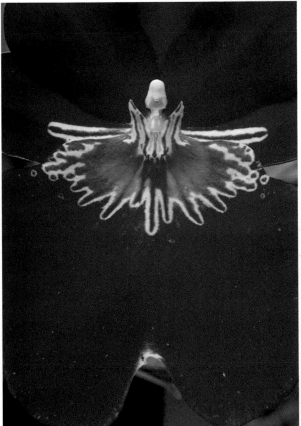

John Fish

When you use an extension tube or bellows to extend the lens, an increase in exposure is necessary. If your camera has a through-the-lens exposure meter that will make the meter reading with a lens extension device attached to the camera, the exposure increase will be made by the meter.

## LENS-EXTENSION DEVICES

Another common method of taking close-up pictures involves extension tubes or a bellows. Such a device fits between the lens and the camera body to let you make sharp pictures at close distances. Since an extension device fits between the lens and the camera body, you can use it only on a camera that accepts interchangeable lenses, which includes most SLR cameras.

Since the tubes or a bellows moves the lens farther from the film than it would be for normal picture-taking, you must compensate for the light loss by using a larger lens opening or a slower shutter speed. Cameras with built-in meters do this automatically. The longer the extension, the greater the exposure increase.

If you have an older camera that lacks a built-in meter, you can use the table below to determine how much to increase the exposure.

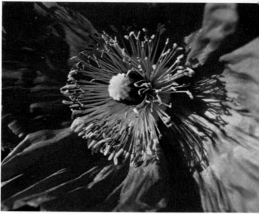

Gary Whelple

A high-speed film is a good choice for taking pictures with an extension tube or bellows attached to your camera. The high film speed allows both a high shutter speed and a small lens opening for improved sharpness and depth of field. The larger the magnification of the image, the higher the shutter speed required for handholding your camera. For life-size images and larger magnifications, shutter speeds of 1/250 second and higher are necessary.

To use the table:

1. Measure the field size—long dimension for 35 mm—at the subject distance you've focused upon.

2. Increase the lens opening by the amount shown, **or**

3. If you want to keep the lens opening constant, multiply the exposure time by the amount shown.

### Exposure Increase for Extended Lens—35 mm Cameras with Lens of Any Focal Length

| Field Size Long Dimension (inches) | 11 | 5⅛ | 3¼ | 2¼ | 2 | 1¾ | 1⅜ | 1 |
|---|---|---|---|---|---|---|---|---|
| Open Lens by (f-stops) | ⅓ | ⅔ | 1 | 1⅓ | 1½ | 1⅔ | 2 | 2½ |
| Or Multiply Exposure Time by | 1.3 | 1.6 | 2 | 2.5 | 2.8 | 3.2 | 4 | 5.7 |

## DEPTH OF FIELD IN CLOSE-UPS

No matter what method you use to make your close-up pictures, you'll find that depth of field is very shallow. Since small lens openings increase depth of field, it's a good idea to use the smallest lens opening that the lighting conditions will allow. For optical as well as depth-of-field considerations, it's wise not to use lens openings larger than $f/8$ with $+1$, $+2$, and $+3$ close-up lenses, or larger than $f/11$ with more powerful lenses. You can compute depth of field for $+1$, $+2$, and $+3$ close-up lenses with the Depth-of-Field Computer in the KODAK *Pocket Photoguide.*

Programmed-exposure cameras that have depth-of-field modes are useful in close-up work since they will automatically give preference to small apertures. Similarly, auto-exposure cameras with an aperture-priority mode allow you to pick a small aperture to increase depth of field in close-ups.

Sam Dover

A bedspread draped across a window creates a colorful backdrop for this close-up of a still life. Photo made on EKTACHROME 100 HC Film.

# LIGHTING FOR CLOSE-UPS OUTDOORS

For most of your outdoor close-ups you'll probably use the natural lighting on the subject. If part of your subject is in sunlight and part in shadow, you can use a reflector, such as crumpled aluminum foil or white cardboard, to reflect the sunlight into the shadow areas.

Backlighting and sidelighting can be quite effective for making close-ups of subjects like flowers and foliage. These types of lighting bring out the texture and emphasize the translucency and delicate qualities of such subjects.

Many advanced photographers like to use flash for their outdoor close-ups. Flash close to the subject allows you to use small lens openings to get the depth of field you need for close-ups. When using flash, it's a good idea to use the fastest sync speed available on your camera. Using a combination of a fast shutter speed and small lens opening with flash lets the background go very dark because there is so little exposure from the daylight. You can use this technique to tone down a distracting background or to make a bright, colorful subject stand out against a dark background. Shooting at fast shutter speeds also minimizes subject movement, such as the swaying of flowers on a windy day.

When you make extreme close-ups with flash, it simplifies exposure calculation if you can use your flash off the camera, always at the same distance from the subject. Then regardless of your subject distance, your basic flash exposure with a specific film and flash combination will always be the same. Keep in mind, however, that a dark subject, such as a black woolly caterpillar, requires more exposure than a light subject, like a white moth.

If you can't use an extension flash to move the flash farther away from the subject, don't use regular guide numbers to calculate exposure for close-ups. The inverse-square law, on which guide numbers are based, doesn't work when you use flash at extreme close-up distances. You can use the table on page 262 as a guide in determining exposure. Or you may want to run your own exposure tests to determine the best exposure setting for your film and flash combination at various subject distances. Make exposures at half-stop increments from $f/8$ to $f/22$. Use one layer of white handkerchief over the flash to diffuse the light and to reduce its intensity. Keep a record of your exposures so that you can determine which lens opening produced the best exposure. Use that lens opening for any close-up pictures taken from the same subject distance.

If you're using an automatic electronic flash for close-up pictures, you may be able to let it determine the exposure automatically, or you may have to set it on manual, depending on the flash-to-subject distance. See your flash instruction manual. To use the flash unit on automatic, it may help to cover the flash reflector with one layer of handkerchief, but make sure that the handkerchief does not cover the light-sensitive cell in the flash unit. Take some trial pictures to see if your automatic electronic flash will produce good exposure for close-ups. If the trial pictures are too light—overexposed—use a smaller lens opening; if they are too dark—underexposed—use a larger lens opening.

Another way to use automatic flash effectively, even at very close distances, is to bounce the flash onto a white card held above the subject. This diffuses the light to create softer illumination. Some flash manufacturers sell bounce-card brackets for this purpose. Exposure will remain automatic provided the flash sensor is pointing at the subject.

Dedicated flash/camera combinations that measure the light through the lens or off the film plane are the ideal source for close-up flash. Dedicated flash will provide accurate exposure regardless of what type of close-up device you are using, and regardless of whether you are using the flash on or off camera.

Herb Jones

You can usually rely on frontlighting from sunlight to give you good close-up photos. You'll get better modeling on your subjects if you use a camera angle where the sun is off to the side at approximately a 45-degree angle. The highlights and shadows from this 45-degree lighting help give the picture a three-dimensional quality.

The cactus spines, highlighted by backlighting, stand out in sharp relief against the shadowed background.

The photographer moved around the flower to get backlighting from the sunlight. Backlighting is very effective for flower photography. Compare the lighting here with that in the photo on the left.

If this foliage had been photographed with frontlighting, the picture would be just ordinary. But the sunlight filtering through the green leaves has brightened them considerably and contributed to an attractive design with a plain dark background.

Herb Jones

Herb Jones

KODAK EKTACHROME
400 Film (Daylight)

Gary Whelpley

Backlighting brings
out the texture and
emphasizes the del-
icate, translucent
quality of the flowers.
KODACHROME 64 Film
(Daylight)

John rish

Art Trimble

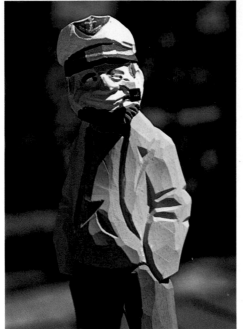

Herb Jones

Sidelighting combines some of the qualities of both frontlighting and backlighting. When the lighting comes from the side, it forms highlights similar to those from frontlighting on the side of three-dimensional subjects near the light source and shadows similar to those from backlighting on the opposite side of the subject. Sidelighting has the advantage of causing only part of the subject facing the camera to be in shadow.

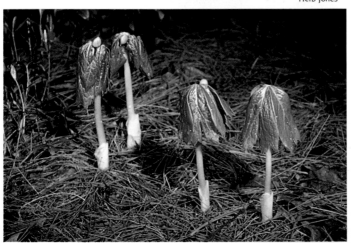

John Fish

When your close-up subjects are in deep shadows or in an outdoor location at night, you can take the picture with flash. The lighting will look more natural if you position the flash off camera at an angle to simulate the appearance of sunlight. In dim outdoor lighting you use flash just as you would indoors.

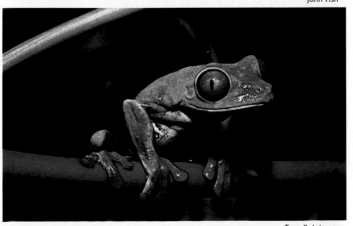

Tom R. Johnson

Electronic flash is excellent for close-ups of live subjects to stop motion. Outdoors though, your subject must be in dim lighting, such as in deep woods, in order to use electronic flash to stop the action. Dim light is necessary so the flash will overpower the natural lighting and become the main light source. Determine the exposure the same way as you would indoors.

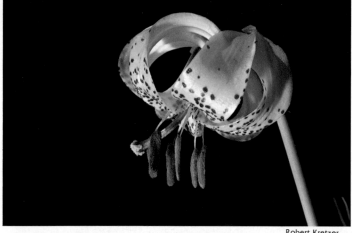

When you take close-up photos with a manual flash unit, guide numbers will not indicate the correct exposure. Try the lens openings in the table on p. 262. With automatic or dedicated flash, see your instruction manual. For this photo, the photographer used his flash unit off the camera, low, with the flash aimed up to illuminate the stamens and pistil as well as the petals.

Robert Kretzer

Patty Van-Dolson

Patty Van-Dolson

The soft lighting from overcast days is good for nature pictures. With this shadowless lighting, you don't have to concern yourself with the possibility of confusing shadows in the background.

When the sky is overcast, you can use flash to add brilliance to the colors of your subject. Set your camera shutter speed and lens opening the same way as for indoor close-up pictures with flash. Since the flash is so close to the subject you'll be able to use a small lens opening which increases depth of field. The photographer used a piece of black cloth to isolate the blossom from the background. Compare this shot with the one on the left.

Toni LoSapio

The advantages of using a flash for close-ups are that you can easily obtain a small aperture, a plain dark background, and eliminate any blur that might result from using a slow shutter speed. A dedicated flash unit that meters light at the film plane simplifies close-up flash work and gives outstanding results. If you do not have a dedicated flash, use a manual flash (or automatic flash set to manual) and make tests to determine the guide number to use.

## FLASH EXPOSURE INFORMATION FOR CLOSE-UPS

This table applies directly to KODACOLOR GOLD 100 and EKTAR 125 Films. Put one layer of white handkerchief over the flash. If you use KODAK EKTACHROME 100 Film (Daylight), set a lens opening 1 stop smaller than the table indicates or add an extra layer of handkerchief. If you use EKTAR 25 or KODACHROME 25 Film (Daylight), set a lens opening 1 stop larger than the table indicates. With electronic flash and a focal-plane shutter, use the shutter speed recommended in your camera manual; with a between-the-lens shutter, use any shutter speed recommended for flash.

## LIGHTING FOR CLOSE-UPS INDOORS

While your outdoor close-up pictures might be of moving subjects, such as butterflies or buttercups swaying in the breeze, chances are that indoors you'll be photographing objects like coins, model cars, and still-life setups. Since you don't need to be concerned with stopping action with this type of subject, short exposure times and bright flash aren't necessary. Consequently, you can use photolamps including spotlights to see the effect of the lights on your subject before you take the picture. These lamps are sold by photo dealers.

If you're using color-slide film balanced for 3400 K illumination, such as KODACHROME 40 Film 5070 (Type A), you should use 3400 K photolamps. If the film is balanced for 3200 K tungsten illumination, such as KODAK EKTACHROME 160 Film (Tungsten), you should use 3200 K tungsten lamps. You can also use each of these films with both 3400 K and 3200 K light sources when you use the appropriate filter. See the table that follows this section.

With KODACOLOR GOLD Films and daylight color-slide films, you can use either 3400 K photolamps or 3200 K tungsten lamps when you use the filter recommended in the table. When you

### LENS OPENINGS FOR CLOSE-UPS WITH FLASH

| Type of Flash with one layer of handkerchief | | Lens Opening* | |
|---|---|---|---|
| | | Subject Distance 10–20 inches | Subject Distance 30 inches |
| ELECTRONIC FLASH For manual electronic flash units and automatic electronic flash units set on manual. | 700—1000 BCPS 1400—2000 BCPS 2800—4000 BCPS 5600—8000 BCPS | f/11 f/16 f/22 f/22 with two layers of handkerchief | f/8 f/11 f/16 f/22 |

*For very light subjects, use 1-stop less exposure or place two layers of handkerchief over the flash reflector.

262

Ray Cooper

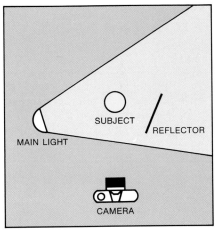

Photolamps are convenient to use for indoor close-up subjects because you can see the lighting effects before you release the shutter. Another benefit is that you can use your exposure meter to determine the exposure. You don't have to have a complicated lighting arrangement to get good pictures. A simple one-light setup was used to photograph this toy soldier. The light was higher than the camera, off to the side at about a 60-degree angle to the camera-subject axis. A small reflector was used on the right side to bounce light into the shadows.

want to take black-and-white pictures, you can use either light source with no filter.

You can take fine indoor close-ups by using only one, two, or three photolamps. The diagrams above and on the following pages illustrate some basic lighting setups.

When you want to emphasize the contours and shape of a subject, you can photograph the subject against a relatively dark background and rimlight it by placing lights slightly behind the subject. When you do this, make sure

the camera lens is shielded from the direct light of the lamps. You can emphasize surface textures by skimming the light across the surface of the subject.

When you make a reflected-light exposure-meter reading of a small subject, the meter reading will be influenced by a bright or a dark background. For this reason, it's a good idea to make reflected-light readings from a KODAK Gray Card. Or you can use an incident-light exposure meter to make a reading from the subject position.

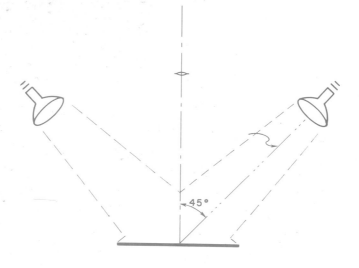

STANDARD SETUP

Use two photolamps to copy flat objects like stamps or paintings.

## FILTERS AND ISO (ASA) FILM SPEEDS FOR PHOTOLAMPS

| KODAK Color Film | 3400 K<br>Photolamps | 3200 K<br>Tungsten Lamps |
|---|---|---|
| KODACHROME 40 5070 (Type A) | None<br>**40** | No. 82A<br>**32** |
| EKTACHROME 160 (Tungsten) | No. 81A<br>**125** | None<br>**160** |
| EKTAR 25<br>KODACOLOR GOLD 100<br>EKTAR 125<br>KODACOLOR GOLD 200 | No. 80B<br>**8**<br>**32**<br>**40**<br>**64** | No. 80A<br>**6**<br>**25**<br>**30**<br>**50** |
| KODACOLOR GOLD 400<br>EKTAR 1000<br>KODACOLOR GOLD 1600 | No. 80B<br>**125**<br>**320**<br>**500** | No. 80A<br>**100**<br>**250**<br>**400** |
| KODACHROME 25 (Daylight) | No. 80B<br>**8** | No. 80A<br>**6** |
| KODACHROME 64 (Daylight) | No 80B<br>**20** | No. 80A<br>**16** |
| EKTACHROME 100 HC | No. 80B<br>**32** | No. 80A<br>**25** |
| KODACHROME 200 (Daylight)<br>EKTACHROME 200 (Daylight) | No. 80B<br>**64** | No. 80A<br>**50** |
| EKTACHROME 400 (Daylight) | No. 80B<br>**125** | No. 80A<br>**100** |
| EKTACHROME P800/1600<br>Professional (Daylight) | No. 80B<br>**250***<br>**500**** | No. 80A<br>**200***<br>**400**** |

*With push processing (Push 1) available from your photo dealer.
**With push processing (Push 2) available from your photo dealer.

# Stockhölm

Marty Taylor/Marty Czamanske

Gary Whelpley

Use close-up techniques to create titles for slide shows. This subject was made by laying clear acetate with transfer letters over an 8 x 10-inch enlarged aerial of Stockholm, Sweden. Two 3200 K tungsten lamps (one on each side) held at 45° angles to the subject provided relatively glare-free illumination while a polarizing filter helped to eliminate reflections and tone down the highlighting of dust specks and minute scratches in the acetate. Made on EKTACHROME 160 Film (Tungsten).

Sometimes you can use the existing lighting for a close-up view of a fascinating activity, such as this model ship nearing completion for insertion into a bottle. The photographer took the picture on KODAK EKTACHROME 160 Film (Tungsten) which was appropriate for the existing tungsten lighting over the workbench area.

Gary Whelpley

This hand-crafted jewelry was photographed in the existing lighting of the craftsman's workshop. The lighting is a combination of the tungsten lighting from the overhead shop lights and daylight on the front of the objects from a window behind the photographer.

Neil Montanus

You can also use outdoor lighting to photograph close-up subjects that you normally expect to see indoors. Here this gem display was illuminated by the shadowless lighting of an overcast sky.

The pottery was photographed outdoors under a weak hazy sun. A piece of red cloth draped over a table and up over a fence behind the table forms the colorful background.

Neil Montanus

It's easy to use photolamps to illuminate three-dimensional subjects like a flower arrangement. You can make the lighting as simple or elaborate as you want. These are only basic lighting setups. You can move the lights to illuminate your subject to suit your needs or personal taste.

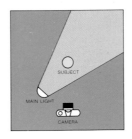

This picture was taken with just one light, the main light close to the subject, higher than, and away from the camera position.

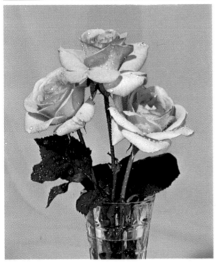

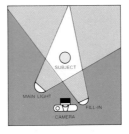

A second light was added as a fill-in for this photo to lighten the shadows. The fill-in light was placed near the camera position at the same height as the camera, but on the opposite side from the main light.

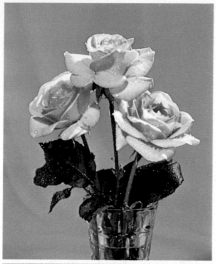

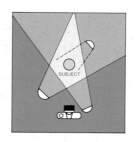

In addition to the main light and fill light, a backlight was used here to put rim-lighting on the rose petals. The backlight was placed high behind the subject, somewhat off to the side.

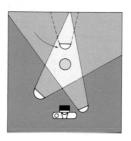

If you have only three lights, instead of using a backlight you can use the third one to brighten the background which helps separate the flowers from it. The background light should be close enough to the background to lighten it but not so close as to overexpose it so that the background looks too light in the picture.

John Menihan, Jr.

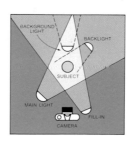

With four lights, the subject can benefit from both backlighting and a background light.

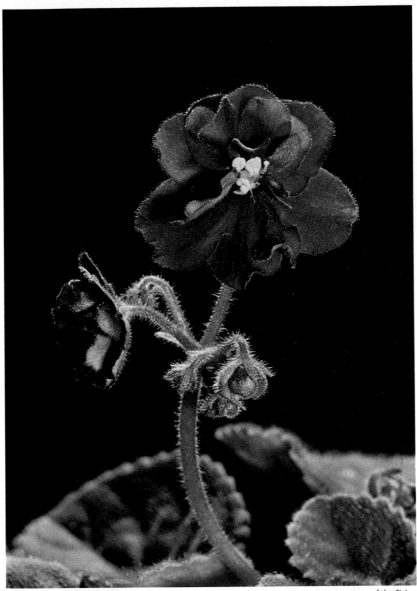

John Fish

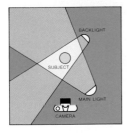

This exquisite shot shows what you can do with just two lights. A main light illuminates the front of the subject while a backlight creates rim-lighting which emphasizes the hairlike detail of the plant so effectively.

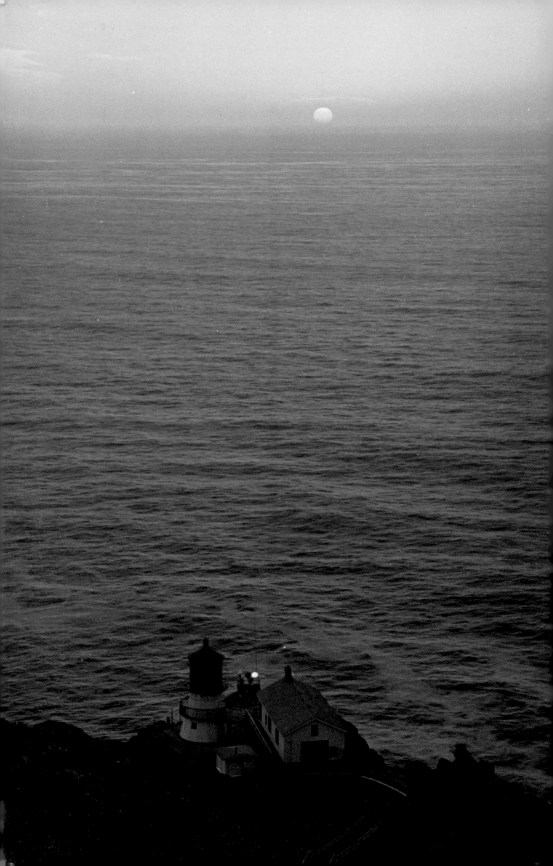

# INDEX

Opposite: The micro-fine grain and medium speed of KODAK EKTAR 125 Film
make it a good choice for landscape photography.

Many of the photographs in this book are winners from the KODAK International Newspaper Snapshot Award (KINSA) contest. This contest runs annually each summer throughout the United States and many other countries. Check with your local newspaper for availability and details on entering the contest. In the past, the grand prize has been $10,000.